Illustrated
PERIODICALS
of the 1860s

Contexts & Collaborations

Simon Cooke

PRIVATE LIBRARIES ASSOCIATION

THE BRITISH LIBRARY

OAK KNOLL PRESS

Published by the Private Libraries Association,
Ravelston, South View Road, Pinner, Middlesex HA5 3YD, England

The British Library,
96 Euston Road, London NW1 2DB, England

Oak Knoll Press,
310 Delaware Street, New Castle, Delaware 19720, USA

ISBN
978 0 900002 28 x (Private Libraries Association)
978 0 7123 5095 2 (The British Library)
978 1 58456 275 7 (Oak Knoll Press)

A CIP record for this book is available from
The British Library and the Library of Congress

1,300 copies of which 600 for sale

Designed and typeset by David Chambers

Printed in Great Britain
by the Dorset Press, Dorchester, Dorset DT1 1PT

In loving
celebration of my sons
Robin James
Timothy Ewan
Laurence David

Contents

List of Illustrations

12

Acknowledgements

It is appropriate for a book about collaborations to be built on a series of partnerships, and the following pages could not have been written without the assistance of a number of experts in the field. Special thanks are due to Ms Tessa Sidey, Keeper of Prints and Drawings at Birmingham City Art Gallery and Museum, and to Mr John Pulford, Librarian, of the Barber Institute. Dr Christine Faunch and Dr Jessica Gardner were similarly helpful, offering advice and guidance on the little known but important du Maurier Archive, Special Collections, University of Exeter. I would also like to acknowledge the guidance of Dr Declan Kieley (Pierpont Morgan Library, New York); Mr John Hodgson (John Rylands Library, University of Manchester); Michael St. John-McAlister (Department of Manuscripts, British Library); and Ms Helen Walasek (*Punch* Cartoon Library). More general assistance was offered by professional staff at the National Library of Scotland, Edinburgh; the Victoria and Albert Museum, London; the British Library, London; the Hartley Collection, Museum of Fine Arts, Boston; Ian Hodgkins and Co, Stroud; Warwick University Library, Coventry; and Birmingham Central Reference Library. I am grateful to Mr Geoff Greene for his help in seeing the volume through the press; and especially indebted, finally, to the generosity of Professor Paul Goldman, the leader of the field; and to Mr David Chambers, a creative editor with a sharp eye for detail and a scrupulous approach to the business of making books.

13

Note: References to earlier or later illustrations are cross-referenced in the margins.

Preface

The period described as 'The Sixties' is a well-known field, and numerous writers have explored its complexities. Several analyses have been published in the last thirty years, although the most interesting treatments, it seems to me, are Paul Goldman's. Continuing a tradition that was inaugurated by Gleeson White (1897)[1] and Forrest Reid (1928),[2] Goldman provides a modern critique of the Sixties style. His book of 1996, *Victorian Illustration: The Pre-Raphaelites, the Idyllic School and the High Victorians*,[3] is especially far-reaching: setting out to examine the period as a whole, it ranges from the early experiments of the fifties to the mature achievements of the sixties and early seventies. Encyclopaedic in range and effect and written in elegant prose, Goldman's work is the cornerstone of modern scholarship; richly illustrated and widely cited, it informs all subsequent analysis.

The present publication is deeply indebted to Goldman's meticulous research, but does not revisit the same territory. It would be pointless to do so. Moving on from Goldman's broad analysis, my focus is the production of Sixties magazines. Earlier criticism has noted the difference between journals and books, but the present investigation is the first, I believe, to offer an extended investigation of 'the illustrated magazine' as a distinct form in its own right. I also offer a new critical perspective. Proceeding from the idea that the images' artistic value is well established, and needs no further justification, I focus instead on the collaborative nature of periodical illustration. The main emphasis is on relationships, economics and publishing contexts, and I explore the ways in which artists produced their work in partnership with a number of other professionals, under the influence of a series of creative pressures. In so doing I set out to provide a detailed, historical reconstruction of the essential character of the illustrated journal: how and why it came into being, the sharing of contributions, the working negotiations, the limitations of employment as they were applied to the artists who worked on the magazines, the technical opportunities, and the professional problems. This pragmatic investigation is supported by printed material and especially by manuscript and original art work, some of which is published here for the first time.

1 *English Illustration, 'The Sixties': 1855–70.* London: Constable, 1897.
2 Forrest Reid, *Illustrators of the Sixties.* London: Faber & Gwyer, 1928.
3 Aldershot: Scolar, 1996. Revised and enlarged. London: Lund Humphries, 2004.

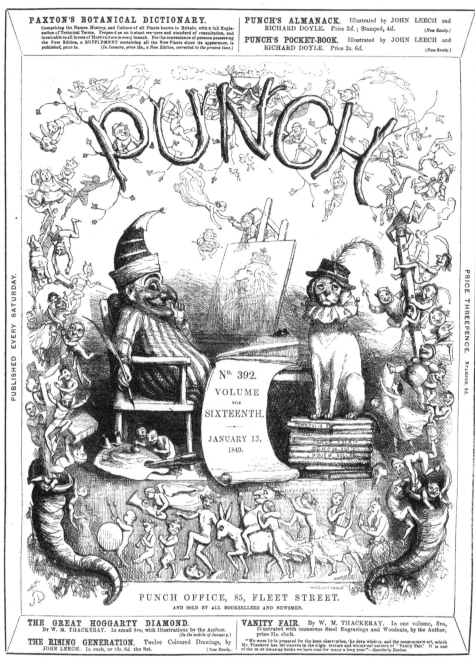

1. Doyle, front cover to *Punch*, 13 January 1849. Engraved by Swain. (Reduced to 72%.)

CHAPTER ONE

Criticism and the Illustrated Periodical

Sometimes described, in the words of Eric de Maré, as 'the Boxwood Age',[1]
but more usually classified as 'The Sixties', the period from 1855 to the
middle of the 1870s is one of the most productive epochs in the history of
British illustration. Enshrined in a series of important archives – notably
the de Beaumont Collection in the British Museum – the images produced
during this period have always been popular and widely collected. Scholar-
ship has been similarly attentive and wide reaching, offering several ways
in which to interpret this 'golden age'. Most attention has been directed
at the artists' individual contributions, although Julia Thomas has recent-
ly re-read Sixties designs as visual texts in which it is possible to detect a
mid-Victorian 'inscription of value'.[2] The illustrations can also be read as
embellishments for literature, or, in the terms of Geoffrey Wakeman, as the
products of a 'technical revolution' in the art of printing.[3] All of these per-
spectives are important, and explain key aspects of what is undoubtedly a
complex phenomenon. However, a broader view is obtained if we consider
the period historically, as part of the wider traditions of graphic art.

Located in a nexus of styles, the 'golden age' was unquestionably a break
with the past, and revolutionised the aesthetics of the printed page. In one
sense, the 'new' design was a complete change from the style of Germanic
artists such as Selous, Franklin and Tenniel, whose dramatic compositions
dominated the forties; but the greatest contrast was between the Sixties
and the 'knockabout' humour of Cruikshank, Doyle, Leech and Phiz. The
comic modes employed by these designers were comprehensively replaced by
the art of the mid-Victorians. Of special significance were Rossetti, Millais,
Holman Hunt, Sandys, Pinwell, du Maurier, Houghton and Walker, although
we should also remember the impressive talents of Burne-Jones, Simeon
Solomon, J. D. Watson, Small, Hughes, Lawless, Barnes and Pettie. Dividing
their time between painting and graphic design, these masters of black and
white offered a distinct body of images and themes which transformed the
'look' of British illustration.

There was a radical change, as one might predict, in the quality of draw-
ing and composition. Trained as painters, the artists of the Sixties greatly

1 *The Victorian Woodblock Illustrators.* London: Gordon Fraser, 1980, p. 7.
2 *Pictorial Victorians: The Inscription of Values in Word and Image.* Columbus: Ohio University Press,
2004.
3 *Victorian Book Illustration: The Technical Revolution.* Newton Abbot: David & Charles, 1973.

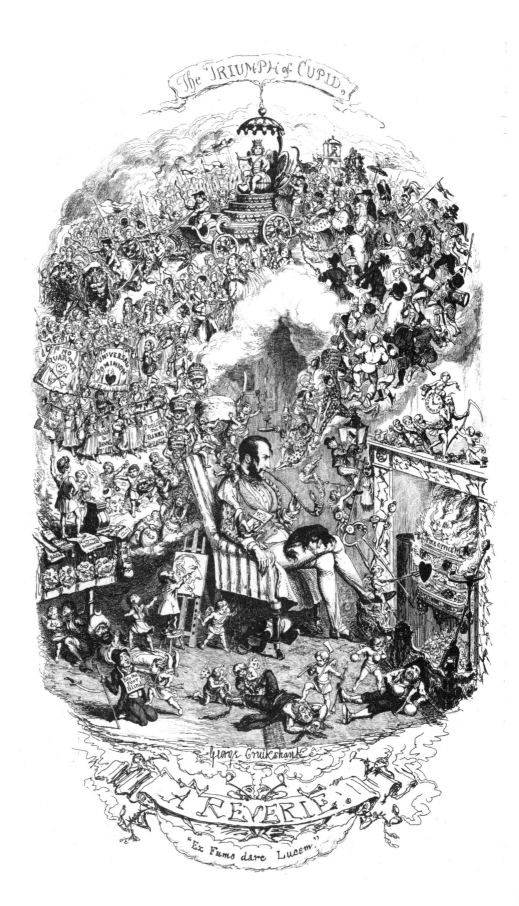

improved the formal standards of illustration by applying the 'academic' draughtsmanship of fine art to the smaller domain of the book or periodical. Painting became the standard by which excellence was judged, not the satirical print. The intricate, scratchy style of caricaturists such as Doyle (fig. 1) was replaced by 'correct' drawing and perspective, and this formality produced an effect in which the illustration is figured as a miniature oil in black and white.

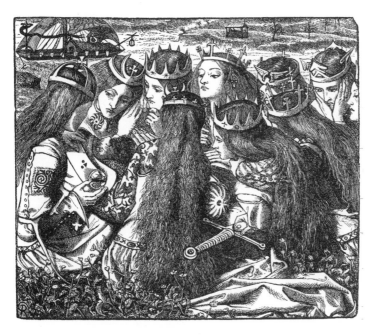

3. Rossetti, 'The Weeping Queens'. Tennyson, *Poems.*
London: Moxon, 1857, p. 119.
Engraved by the Dalziels.

The illustrations' expressive range, so often confined to the comic grotesque or the satiric hit, was similarly enlarged. Cruikshank's febrile imagery had dominated the long period from the twenties to the forties (fig. 2); artists of the mid-nineteenth century, on the other hand, were far broader in scope. Difficult to pin down to a single formulation, the Sixties style can be traced from the medievalism of Rossetti (fig. 3) and Sandys (fig. 4), with its yearning figures and extravagant costumes, to the idealised domesticity of Millais (fig. 5) and the barbed lyricism of Houghton (fig. 6). It also includes the social observation of du Maurier (fig. 7) and Keene (fig. 8); the picturesque landscapes of Birket Foster (fig. 9); and the poetic ruralism of the Idyllicists, Pinwell (fig. 10) and Walker (fig. 11). By turns sentimental and realistic, medievalist and mid-Victorian, the designers of the Sixties offered a rich imagery which is both escapist and satirical, highly moral and overwhelmed with a sense of archaic dreaminess.

Opposite: 2. Cruikshank, 'A Reverie'. *George Cruikshank's Table Book.*
London: The Punch Office, 1845, facing p. 1. Steel engraving.

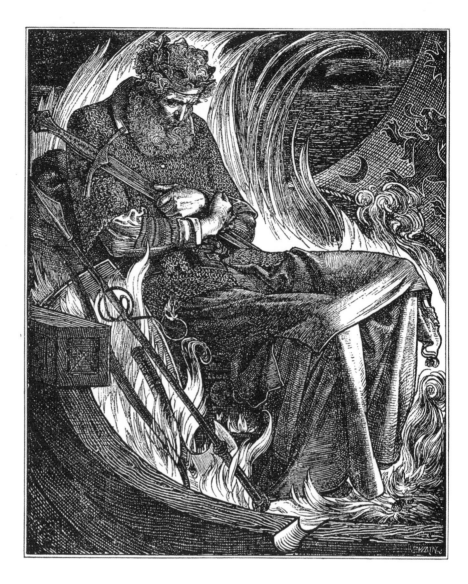

4. Sandys, 'The Death of King Warwolf'.
Once a Week, 30 August 1862, p. 266.
Engraved by Swain.
Image taken from *Reproductions of Woodcuts by F. Sandys*. London: Hentschel, n.d.

5. Millais, 'The Small House at Allington', by Trollope,
The Cornhill Magazine, June 1864, facing p. 1.
Engraved by the Dalziels.

6 Houghton, plate 11 from *Home Thoughts and Home Scenes*.
London: Routledge, Warne & Routledge, 1865.
Engraved by the Dalziels.

7. du Maurier, 'Eleanor's Victory', by M. E. Braddon,
Once a Week, 27 June 1863, p. 15.
Engraved by Swain.

8. Keene, 'Evan Harrington', by George Meredith,
Once a Week, 7 July 1860, p. 29.
Engraved by Swain.

9. Birket Foster, plate 6 from *Pictures of English Landscape*.
London: Routledge, Warne & Routledge, 1863.
Engraved by the Dalziels.

10. Pinwell, *Dalziels' Illustrated Goldsmith: Vicar of Wakefield*.
London: Ward & Lock, 1865, p. 113.
Engraved by the Dalziels.

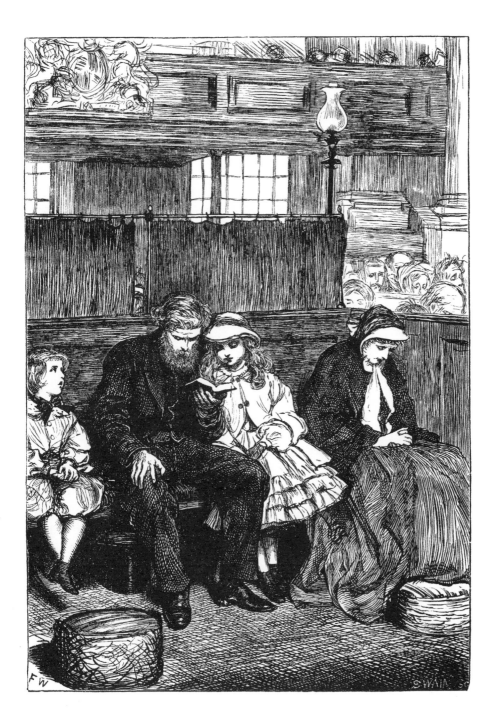

11. Walker, 'Philip', by Thackeray,
The Cornhill Magazine, August 1862, facing p. 217.
Engraved by Swain.

At the same time, the work was always put at the disposal of illustration, and invariably matched to the requirements of the text. Approaching each commission as a new challenge, Sixties artists typically provided a novel re-visualisation of the written word. Indeed, the art of the period is generally underpinned by a marked sense of purpose, a high-minded seriousness and dramatic intensity which represents a radical shift from the travesties of the earlier period. Cruikshank, Doyle, Leech and Phiz are always humorous, the masters of caricature and social *faux pas*; but there are few laughs – with the exception of the sophisticated drolleries of Keene – in the intense world of Sixties design. Usually reflective and always emotionally engaging, the illustrations of Rossetti, Millais and the others could never be described as 'quaint' or 'curious' in the way that Phiz or Doyle could be; rather, their images infuse the page with a psychological depth that makes the work of the earlier artists seem at least childlike, and sometimes positively juvenile.

These stylistic changes were similarly matched by a shift in technique. Most earlier design was on the intransigent surface of steel or copper; in the Sixties, however, the principal medium is the engraving on wood. This technique produces a wide range of tones: figured as a relief process in which the design is drawn on the fibrous end-grain, it allowed its practitioners to transfer their intense treatments of modelling and line to the printed page. Interpreted by craftsmen such as Swain, Linton and the Dalziels, who were the dominant concern of the period, the sensitive art of the 'golden age' was predominantly registered in the form of engravings, or, as the Victorians misleadingly called them, 'cuts'.

The Sixties might thus be described as a complicated mix of changing aesthetics and new technologies. In one short step, we are taken from the Regency world of social satire and re-located in the poetic milieu of the art of the mid-nineteenth century. This movement is clear, if difficult to quantify, and it is important to point out that the older styles of Doyle and Cruikshank were still being offered when Rossetti and the others were at the height of their success. As in all revolutions, the old powers lingered on, and continued to appeal to a wide audience. The Sixties style was essentially an *avant garde*, a new style; but many preferred the old. Its reception was a complicated issue, and the presence of the older traditions skewed the pitch.

More straightforward, perhaps, is the publishing context in which the illustrations appeared. This divides fairly neatly into books and periodicals. The outstanding books are William Allingham's *The Music Master* (1855), with Rossetti's celebrated illustration of 'The Maids of Elfen-Mere'(fig. 12), and the 'Moxon' Tennyson (1857), which includes striking designs by the principal Pre-Raphaelites. These publications inaugurated the period and are justly prized as the exemplars of their type. Others develop the style in more detail. Millais's art is given full rein in his illustrations for Trollope,

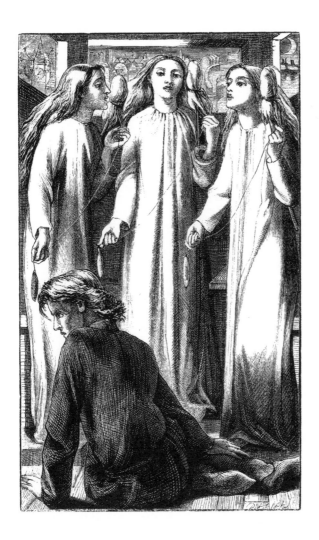

12. Rossetti, 'The Maids of Elfen-Mere'. *The Music Master*, by William Allingham.
London: Routledge, 1855, facing p. 202.
Engraved by the Dalziels.

13. Millais, 'Was It Not a Lie?' from 'Framley Parsonage', by Trollope,
The Cornhill Magazine, June 1860, facing p. 691.
Engraved by the Dalziels.

14. Millais, 'The Hidden Treasure'. *Parables of Our Lord*, 1864.
First published in *Good Words*, 1863, facing p. 461.
Engraved by the Dalziels.

'Framley Parsonage' (1861: fig. 13), *Orley Farm* (1862) and 'The Small House at Allington' (1864, fig. 5), and again in his Biblical epic, 'The Parables of Our Lord' (1864: fig. 14). The Sixties school is more generally represented by a series of gift-books, notably *The Poets of the Nineteenth Century* (1857), *Home Thoughts and Home Scenes* (1865), *A Round of Days* (1866) and *Pictures of English Landscape* (1863). Designed to be looked at rather than read, these publications present a body of images to be treasured, pondered, discussed, and endlessly turned over by the fireside. Yet books only represent a part of the whole picture; in fact, most Sixties designs appeared in magazines, rather than their more formal counterpart, and it was here, as Gleeson White and others have argued, that the most characteristic works were published.

Of course, the designation 'magazine' seems uncomplicated, but it is important to be absolutely clear as to what constitutes an 'illustrated periodical of the Sixties'. In fact this definition is more difficult to establish than one might expect. In a general sense, the Sixties magazine can be explained as a literary periodical, aimed at a large middle-class audience, which uses illustration as an accompaniment to serials, poetry, histories, discussion pieces and other articles of a more general interest. Their range was from the purely literary to the 'improving', evangelical and doctrinaire, but their focus, as *The Leisure Hour* puts it, was always on 'recreation' and 'instruction'.[4] The illustrations played a central part in entertaining the eye and improving taste, and a key characteristic of all of the magazines is the symmetry of word and printed image, with equal value being given to each.

This winning formulation was embodied in a number of outstanding publications, the most notable being the mighty triumvirate that de Maré describes as the 'Big Three':[5] *Once a Week*, published by Bradbury and Evans, established in 1859 and on sale for 3*d*.; *The Cornhill Magazine*, the brainchild of George Smith of Smith Elder, which sold for a shilling and was published monthly (1860); and Alexander Strahan's sixpenny *Good Words* (fig. 17), a magazine set up in direct challenge to *The Cornhill*. These periodicals established the tone and form, and others quickly followed suit. Characteristic examples are *The Leisure Hour*, which had appeared in the fifties, and was reissued in a Sixties format by The Religious Tract Society; *The Quiver*, an evangelical organ published by Cassell; *The Argosy* and *The Sunday Magazine*, both the work of Strahan; *The Churchman's Family Magazine*; and *London Society*.

By turns pious and purely recreational, each of these contains wood-engravings of the highest quality, and, as noted above, their value has long been recognized. Gleeson White dedicates six of his twelve chapters

4 Legend given under title in first page of serial parts.
5 de Maré, p. 86.

15. Original part, *The Cornhill Magazine*, August 1862. (Reduced to 81%)

15. Original part, *Good Words*, May 1864. (Reduced to 68%.)

15. Binding, *Good Words*, 1862. (Reduced to 68%.)

15. Binding, *London Society*, 1863. (Reduced to 79%.)

to listings of work (1897),[6] and Paul Goldman offers a definitive catalogue in his monumental *Victorian Illustration, The Pre-Raphaelites, the Idyllic School and the High Victorians* (1996, 2004).[7] Other discussions appear in Forrest Reid's idiosyncratic study, *Illustrators of the Eighteen Sixties* (1928); Goldman's lucid analysis of the de Beaumont collection, *Victorian Illustrated Books: The Hey-Day of Wood Engraving* (1994); Gregory Suriano's *The Pre-Raphaelite Illustrators* (2002); and de Maré's all-embracing survey, *The Victorian Wood-Block Illustrators* (1982). All of these commentators point to the primary characteristics of magazine illustration, and provide a clear explication of the artists and their principal works. At the same time, analysis of the subject has been hampered by a number of critical problems.

Issues and Problems

A major obstacle in the way of modern criticism is the issue of accessibility. Printed in large runs, which in the case of *The Cornhill* regularly exceeded more than a hundred thousand issues per month, Sixties periodicals are now surprisingly rare. Never intended to last, designed as ephemera and consigned (as one contemporary observed) to 'oblivion'[8] once they had been read, many have not survived. Only the primary journals can still be found in any numbers; the rarer titles – notably *The Argosy, The Churchman's Family Magazine, Good Words for the Young* and *The Shilling Magazine* – have virtually disappeared, and the collector will only be able to see them, in all likelihood, in the specialised archives of the British Library or in parallel collections elsewhere. Studying the field as a whole is in this sense a complicated task, and few (if any) collectors can lay claim to a comprehensive library.

The magazines' visual and aesthetic impact is similarly complicated by the fact that few have endured in their original form, as the Victorian reader would have seen them. Most of the surviving magazines are bound into half-yearly or yearly volumes, and the interpreter of the twenty-first century will be hard pressed to find individual issues. It is still possible to acquire single numbers of *The Cornhill Magazine* (fig. 15), *Once a Week* (fig. 16) and *Good Words* (fig. 15), but in almost thirty years of collecting I have *never* seen parts of *The Shilling Magazine, The Quiver, The Churchman's Family Magazine* or any of the rarer publications. At best, the scholar has to work with the bound-up copies (fig. 15), yet even these present a critical problem. Dense, congested and sometimes containing as many as a thousand pages, the magazines are difficult to handle, concealing their illustrations in tightly formed

6 White, pp. 16–94.
7 Goldman, pp. 264–318.
8 'The Cornhill Gallery', *The Art Journal*, 1865, p. 32.

Overleaf: 16. Original part *Once a Week*. Engraved by Swain.
17. Title-page *Good Words*. Engraved by the Dalziels.

Nº. XVII.

PRICE 3*d*.

Once a Week!

Nº. XVII.—SATURDAY, OCTOBER 22, 1859.

CONTENTS.

BRADBURY AND EVANS.
11, BOUVERIE STREET, LONDON.

Printed by WILLIAM BRADBURY, of No. 13, Upper Woburn Place, and FREDERICK MULLETT EVANS, of No. 19, Queen's Road West, Regent's Park, both in the Parish of Saint Pancras, in the County of Middlesex, Printers, at their Office in Lombard Street, in the Precinct of Whitefriars, in the City of London, and Published by them at No. 11, Bouverie Street, in the Precinct of Whitefriars, as aforesaid.—Saturday, October 22nd, 1859.

"Good Words are worth much and cost little."—Herbert.

GOOD WORDS

FOR 1862.

EDITED BY

NORMAN MACLEOD, D.D.

ONE OF HER MAJESTY'S CHAPLAINS FOR SCOTLAND.

And illustrated by

J. E. MILLAIS, HOLMAN HUNT, JOHN TENNIEL, CHARLES KEENE,
FREDERICK WALKER, J. D. WATSON, AND OTHERS.

London:

ALEXANDER STRAHAN AND CO.

32, LUDGATE HILL.

columns of miscellaneous text. The process of locating the designs *has* been assisted by modern scholarship, principally in the form of Goldman's comprehensive listings, but wading through so many pages can be a 'daunting'[9] task for all but the most dedicated of researchers; as Goldman remarks, the volumes' 'sheer bulk'[10] is irksome and difficult to manage.

There are other, more pressing, difficulties as well. One of the main problems is the bias of earlier criticism. We no longer read the illustrations as exemplars of national pride, as Reid, White and Hartley did, but modern critics have accepted many of their forebears' judgements. This undiscerning acceptance of comments, principally those by Forrest Reid, has distorted modern commentaries, and there are many examples of homage, I would suggest, where there should have been rigorous interrogation. A dominant view, and one which has barely been challenged, is the emphasis on aesthetics, on judging the illustrations as they were 'superior works of art in themselves',[11] small pictures in black and white which *only* need to be assessed in terms of their enduring 'beauty'. This position was originally expressed by the publishers, who re-issued the designs in the form of 'collected editions' such as *Touches of Nature* (1867), *The Cornhill Gallery* (1865) and *Pictures of Society Grave and Gay* (1866); and it was further consolidated in the writings of White and Reid, Gray and McLean. Describing the illustrations as 'fine art', these commentators emphasised the status of the artist. The argument is clearly voiced by White. According to his line of reasoning, the print can function independently and so can its creator, who is represented as an autonomous designer, making use of the magazines, so he implies, as a sort of exhibition space. This emphasis on artistic autonomy influenced generations of scholars, and was also promoted by White and Reid's approach to collecting. Bored by the idea of contexts, these critics encouraged collectors to convert the images into unique objects, infamously suggesting that the best way to appreciate the designs was to 'extract the prints worth extracting' from the 'unattractive slabs of letterpress' and mount them, like artists' proofs, on 'white boards',[12] to be kept in a portfolio.

Such an approach certainly highlights the illustrations' aesthetic qualities, yet Reid and White's emphasis on beauty – itself the product of the outdated criticism of the 1890s – is far from gainful. It has distorted our understandings of Sixties design and it creates numerous inconsistencies. Their argument does not consider the many other factors at work as the illustrator struggled to produce his design; it tells us nothing of the magazines' cultural context; and it entirely fails to see that, rather than being the

9 Goldman, *Victorian Illustration*, p. 264.
10 ibid.
11 Ruari McLean, *Victorian Book Design*. London: Faber & Faber, 1963, p. 160.
12 Reid, p. 11.

18. Leighton, 'Romola', by Eliot, *The Cornhill Magazine*, January 1863, facing p. 1.
Engraved by Swain.

product of one person – the model 'inspired artist' – the illustrations appearing on the pages of the periodicals were the result of a series of collaborations. My own view is that Sixties journals are better understood *not* as autonomous designs, but as works in which the artists produced images for specific texts, working under guidance and direction from a number of other professionals, under pressure of time. Placed at the centre of a complex web of working relationships, the artist was constrained by circumstance, practice and the conventions of employment in a capitalist society. Never an aesthete in pursuit of independent aims, the illustrator was always a professional, compelled to work as part of a team. As Rosemary Mitchell explains,

In the study of [illustrated books and periodicals], the circumstances of the publication should not be neglected. Such variables as the relationship of author, illustrator, engraver and publisher … all contributed to the formulation of an illustrated text.[13]

Naturally, it would be unwise to suggest that the artist was merely a team player, producing work on demand, as an impersonal agent of employers or collaborators. The idiosyncratic brilliance of the work refutes any such allegation: Leighton's designs for 'Romola' (*The Cornhill Magazine*, 1862–3: fig. 18) could never be produced as the uninspired offspring of others' directions, nor could the designs of Sandys, du Maurier, Millais, or any of

13 Rosemary Mitchell, *Picturing the Past: English History in Text and Image*. Oxford: OUP, 2000, p. 25.

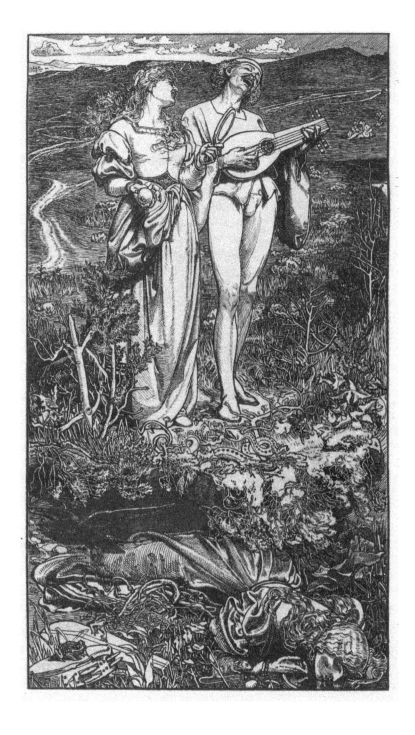

19. Sandys, 'Amor Mundi', by Christina Rossetti,
The Shilling Magazine, June 1865, facing p. 193.
Engraved by Hooper under auspices of Swain.
Image taken from *Reproductions of Woodcuts by F. Sandys.*

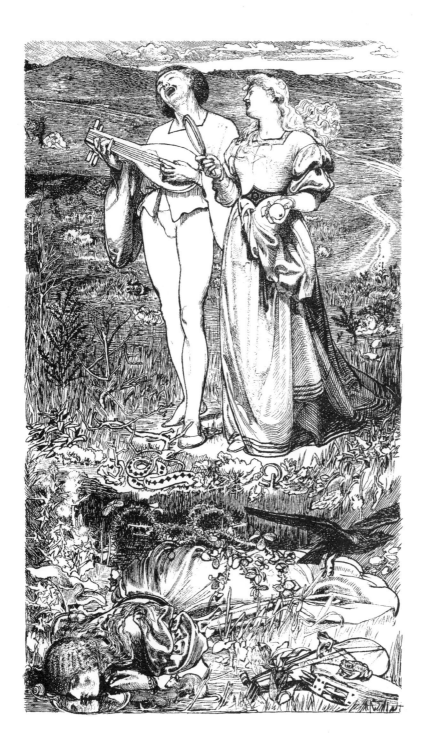

20. Sandys, 'Amor Mundi'.
Original drawing, brush and black ink over pencil on off-white paper, 1865.
Reproduced with permission of National Gallery of Canada, Ottawa.

the outstanding artists of the period. Sixties design is not of the journeyman variety, in the proper sense of the term, nor should the illustrator be reduced to the status of craftsmen. However, their work was heavily *influenced* by their working relationships, each of which had an affect on how the artist worked and so, ultimately, on the finished design that appeared in the pages of the magazine. Sometimes the illustrator would have his way in all matters; and sometimes he would work predominantly under the direction of a publisher, editor or author. More often, the end result was the product of negotiation in which the original aims, developed through the medium of drawings and studies, were re-thought, revised, modified or moderated by the impact of collaborators. The artist produced the work, but its contexts were inclusive and sometimes imposed significant demands.

Of course, this 'collaborative' perspective has been touched upon elsewhere. The 'substantial contributions'[14] made by the various partners has been considered by Goldman in his guide to the de Beaumont collection, *Victorian Illustration: The Hey-Day of Wood Engraving*, and the same issue is mentioned in passing in most of the primary textbooks. But analysis of Sixties magazines as the fruit of collaborations – and conflicts – can be taken much further. The role and impact of the publisher, editor, author and engraver can be traced in detail, and we can use this methodology as a means of developing new understandings of how and why the illustrations were produced, the frameworks in which the artists functioned, and, most interestingly of all, the vital changes that were made as the illustrators struggled to accommodate the demands of sometimes conflicting interests.

Working Collaborations: a case study and its implications

The value of this contextual approach can be demonstrated by examining 'Amor Mundi' (fig. 19), a design by Sandys which illustrates a lurid and disturbing poem by Christina Rossetti. Published in *The Shilling Magazine* in May 1865, this image is usually described as a suggestive drawing of great originality, perhaps the illustrator's best. Idiosyncratic and hard-hitting, it is certainly a virtuoso composition, and was one of the first of the Sixties designs to be extracted by enthusiastic amateurs and admired as an independent print. Unmistakably the work of its creator, 'Amor Mundi' was nevertheless a product of compromise, created as part of a process in which the artist imposed his will on aspects of his interpretation, but still had to accommodate the requirements of his working partners.

14 Paul Goldman, *Victorian Illustrated Books, 1850–1870*. London: British Museum, 1994, p. 45; see more generally pp. 45–60.

A prime influence was the editor, Samuel Lucas (1818–68), with whom Sandys had earlier worked during his time at *Once a Week*. Lucas was a hard task-master who liked to keep his artists on a tight rein. His demands, as a critic with a sharp eye and well-developed taste, were two-fold: he wanted his illustrators to produce work of a high artistic quality, and he expected them to offer visualisations that were faithful to the text. Both directives are embodied in the finished design for 'Amor Mundi'. The illustration underwent a detailed development in the form of sketches and studies, several of which were scrutinised by the editor as the work progressed, and it was also subject to editorial criticism as the artist struggled to create a correspondence between his image and Rossetti's verse.

Lucas's guiding hand is clearly reflected in the artist's literal showing of the poem's curious patterns of realistic detail, emblem and symbol. It is noticeable, for example, that Sandys represents Rossetti's atmospheric and topographical details: the 'honey-breathing heather' is registered in the form of a cloying field of grasses and 'velvet flowers', and the 'glowing August weather' is suggested by the clouds in the background. The 'valley track' is shown, reaching off into the background, and so is the 'west wind blowing', which subtly moves the hair of the female lover. At the heart of the illustration, however, is a close adherence to the poem's central contrast between life and death, 'love-locks' and 'hooded worm'. This concern is embodied in the form of a visual juxtaposition between the two living figures, who are shown as a pair of 'soft twin pigeons', and the 'thin dead body', the emblem of wretched mortality lying beneath their feet. Motivated by the need to find an image that would embrace the poem's extremes of 'sensuality' and 'putrefaction', the artist did numerous studies for all of the figures, coming up with a contrast of plumpness and emaciation that focuses Rossetti's morbid theme.

This visual solution is a powerful dramatisation that closely conforms to the editor's directive that images should be fit for purpose, suggesting the poem's theme even before it is read. As Goldman explains, it overpoweringly 'reflects … the sickly odour of death suggested in the text'.[15] Yet there were limitations to Lucas's influence and, although the illustration is an accurate mirror of the poem, Sandys also made a space in which he could present his own, more idiosyncratic response. This interpretation took the form of emblematic details, the sort of visual tokens which feature in his paintings of femmes fatales, notably *Morgan Le Fay* (Birmingham City Art Gallery, 1864) and *Medea* (Birmingham, 1866), and again in an illustration for *Once a Week*, 'Rosamund, Queen of the Lombards' (fig. 21). Thus, in the bottom right of the design we have a bloated frog (the symbol of vanity and lust), and in the foreground a hissing adder (sexual temptation and deceit). Both

15 *Victorian Illustration*, p. 52.

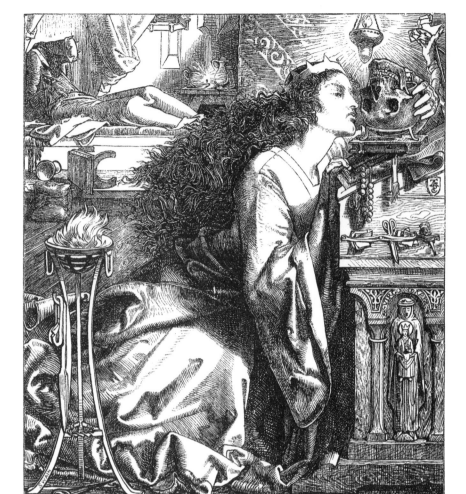

21. Sandys, 'Rosamund, Queen of the Lombards'.
Once a Week, 30 November 1861, p. 631.
Engraved by Swain.

suggest specific meanings while simultaneously pointing to the notion of the lovers' bestiality, their status as creatures of nature driven by lust. The artist's grim definitions are further expanded by his placing of a rat, the Victorian emblem of sensuality and death, gnawing at the body's putrefying wrist.

Commensurate with the tenor of the text, but existing in an extra-textual domain, all of these details enhance the poem's impact, using graphic imagery to extend its distasteful world from the mind's eye to the physical eye. Such details allowed Sandys to work within the editor's directives and he was fortunate in not having to negotiate with the author, who had wanted her brother Dante to illustrate her work, but accepted Sandys purely on Lucas's advice. But Sandys was constrained by the influence of the

engraver. Criticism of the image has stressed the quality of its draughtsman-ship; however, comparison of the artist's finished drawings and the engraving, which was cut by Hooper under the auspices of Swain, shows how much the engraver contributed. In Sandys's final design, which was photographed onto the wood, and now exists in several copies (fig. 20: National Gallery of Canada, Ottawa), the faces of the lovers are loosely modelled with little definition; in the published engraving (fig. 19), on the other hand, the portraits have been significantly changed. The woman's jaw line is clearly defined, making her more refined than in the original drawing, and a simi-lar re-definition is applied to the man's throat. Other alterations are just as radical. The woman's hair, originally an amorphous billowing form with minimal hatching, has been converted into rope-like tresses, while the pro-portions of the figures have been subtly modified to stretch them out and make slightly less voluptuous than they were when they left the artist's hand. The man's legs and the woman's dress are more carefully modelled than they are in the finished design, and the supporting detail, which creates the ef-fect of a sort of Pre-Raphaelite nightmare in which everything is seen with equal intensity, is greatly enhanced, converting it into a dense field of marks. Aiming to convert the design into the strictly linear terms required to make it into an image on wood, the engraver has made distinct technical changes, but he has also done *far more* than cut the photograph as he saw it on the block. Alan Staley describes Sixties engraving as a straightforward event, in which the technician 'was simply asked to respect the lines the artist had put [on the block].'[16] However, Hooper's version shows that engraving was differ-ent from transcribing, and was often a matter of imaginative interpretation, of improving, changing and enhancing aspects of the original work to max-imise its effect on the printed page. In the words of Gilbert Dalziel, whose writings in the twenties had the benefit of historical perspective, illustrations on wood were not only produced by the designer but were 'the joint work of two brains – the artist's and the engraver's'.[17] Dalziel's comment points to the collaborative nature of magazine design, and we can extend his formula-tion to include all of the interested parties. As noted above, 'Amor Mundi' seems to stand on its own, the work of one of the greatest draughtsman of the period. Yet it enshrines a very specific arrangement, and reads effectively when it is re-contextualised, placed at the centre of a series of partnerships and viewed as a collaborative text. That approach re-figures a single image and it can just as easily be applied to magazine illustration as a whole.

In this book I aim to re-contextualize the Sixties periodical by tracing and exploring the various partnerships that led to the production of its

16 Alan Staley, *The Post Pre-Raphaelite Print*. New York: Columbia University Press, 1995, p. 4.
17 Gilbert Dalziel, 'Wood-Engravings in the "Sixties" and Some Criticisms of Today'. *Print Collector's Quarterly*, 15: 1, 1928, p. 84.

images. Playing down the status of the artist, while at the same time recognising his capacity to respond to a wide range of professional pressures, I stress the notion of collaborative production. The following pages explore the various factors at work, evaluating in each case the role of editor, artist, author and engraver, as well as considering the importance of the publishers. As already noted, this arrangement varied from direction to negotiation, and, as Sybille Pantazzi has pointed out,[18] it typically included personal and professional antagonism, anger, resistance, evasion, ambivalence and sarcastic subversion, as well as compliance and creative acknowledgement of the need to change. What we always see is the dynamism of the process, the directing and sharing of creativity, which is built on complex and changing relationships and is only concerned with producing the best possible result. Critics such as Lyn Pykett have lamented the absence of a critical model to provide an inclusive approach to the analysis of Victorian periodicals. My aim in this book is to explain some of the 'determinants' of the illustrated periodical by charting its mode of production.[19] Where appropriate, I consider the wider context as well, placing these working partnerships within a series of economic and cultural frameworks.

18 Sybille Pantazzi, 'Author and Illustrator: Images in Confrontation'. *Victorian Periodicals Review*, 9:2, June 1976, p. 46.
19 Lyn Pykett, 'Reading the Periodical Press: Text and Context'. *Victorian Periodicals Review*, 22:3, Fall 1989, p. 104.

CHAPTER TWO

Artist and Publisher

The relationship between the publisher and the artist was one of the foundations stones on which the Sixties periodical was based, and, like all relationships which operate within a money-exchange, it was asymmetrical. The power was firmly vested in the hands of the proprietor. The publishers created the magazines, employing artists to provide them with appropriate designs, and in a practical sense all artwork of the period originates in the illustrator's need to supply his employer with a marketable product. The publisher-capitalist controlled the means of production, and his influence over the artist's designs was necessarily considerable. Mindful of the need to depress costs and maintain standards, the proprietor could decide how much to pay; what to include and reject; what to commission; what changes should be made; and even, in some cases, how the artist should represent his subject. These pressures were always brought to bear, although the illustrator was free to refuse, resist, accommodate, deflect, re-figure or simply refuse to abide by his employer's directives.

Most illustrations were the result of this sort of creative negotiation, this sharing of views in which the publisher imposed certain demands and the artist, with varying degrees of defiance, interpreted his directives. Sometimes the publishers accepted the artists' attempts to control their material – printing work they may not have liked – and sometimes the artist had to accept his employer's authority. That dynamic process of give and take can be traced throughout the period, and was itself the product of the cultural context in which it operated.

The Economic and Cultural Context

As noted above, the illustrated magazine was brought into existence by its proprietor. The publishers' aim was simple: operating as entrepreneurs, the very embodiment of the Victorian capitalist, they developed their product as another means of making money. The Sixties periodical would never have existed if it had not been profitable, and we should not forget that it was created (like the railway in the forties) as a piece of speculation. This strategy was practised by all of the mainstream publishers, but at the heart of the venture was a group of remarkable individuals. Most important among them were Charles Dickens's publishers, Bradbury and Evans; George Smith of Smith

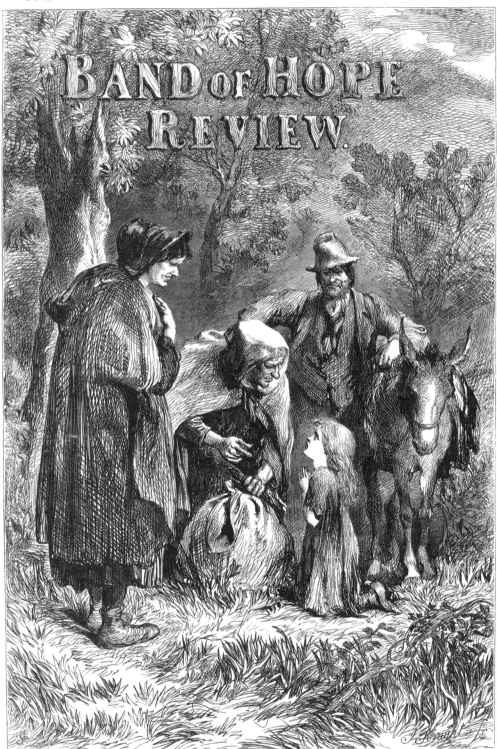

CURIOUS JANE WITH THE GIPSIES.

22 Illustration to *The Band of Hope Review* by an unidentified artist,
1 December, 1861, p. 49 in collected edition, 1861–65.
Engraved by Knight. (Reduced to 63%.)

THE
British Juvenile,
AT HOME, AT WORK, AND AT PLAY.

POOR PUSS—THE SPORTSMAN'S VICTIM.

No. 55. Registered for transmission abroad.

23. Illustration to *The British Juvenile*, number 55, October 1870, p. 1.
Engraved by Kroner. (Reduced to 62%.)

Elder;[1] the Scottish publisher, Alexander Strahan;[2] and the Hogg brothers, James and John. Working in competition with each other, these capitalists created the 'illustrated magazine' as a versatile form that would reach large audiences and generate impressive revenues. The opportunities offered by the periodical were considerable, and it is important to stress that the publishers developed their concept in response to a series of favourable conditions. Some of these were economic, but Smith and his rivals were also encouraged by changes in printing technology and public taste.

The economic situation was extremely positive, allowing the businessmen to produce their magazines more cheaply than ever before. The abolition of the paper tax in 1860 had a significant affect on production costs, and so did the wide-scale adoption of the steam platen press, which could print designs (which had already been produced through the labour-intensive process of engraving on wood) from electrotypes. Carried forward by cheap paper, cheap engraving and cheap printing, the illustrated magazine was an appealing proposition, an industrial artefact that had low costs, was run on established technology and was easy to produce in large numbers. Mass produced and infinitely reproducible, the application of 'modern' techniques converted the magazine into a veritable money-spinner.

Its economic viability was assisted, moreover, by the rise of distribution networks, particularly those offered by booksellers such as W. H. Smith and Menzies. These entrepreneurial traders bought the magazines at a low unit cost, allowing the publishers to generate higher profits than were available through conventional agencies, while simultaneously providing a link between the product and the new markets that were offered by the urban readers of the great cities. Setting up stall on street corners and on the platforms of railway stations, booksellers reached out to pedestrians walking to work and commuters travelling on the line. The magazines were sold as a pleasing entertainment, an object to scan when one arrived at work or during the commute, placed over the knee while sitting in one of the more comfortable carriages. Cheap and easy to carry, *Once a Week* and its competitors were a huge success, and publishers could garner large sums from the distribution of what most purchasers regarded as ephemera, something to read and leave behind at the end of the journey.

The magazines' economic currency was more generally built on their appeal to an audience that was obsessed with visual material. Indeed, the publishers' genius, as astute businessmen, was to recognise and exploit what Kate Flint[3] has described as the mid-Victorian fascination with the 'act of

1 See Jennifer Glynn, *Prince of Publishers: A Biography of the Great Victorian Publisher George Smith*. London: Allison & Busby, 1986.
2 See Patricia Thomas Srebrnik, *Alexander Strahan, Victorian Publisher*. Ann Arbor: University of Michigan Press, 1986.
3 *The Victorians and The Visual Imagination*. Cambridge: CUP, 2000, p. 1.

seeing'. A 'viewing market' had already been created in the forties and fifties by Dickens's illustrated fiction and by magazines such as *Punch* (established 1841) and *The Illustrated London News* (1842), and publishers were quick to realise that most readers *expected* their texts to be accompanied with pictures. Put simply, capitalists such as Smith and Hogg were able to generate money by giving their viewers what they wanted. At the same time, their exploitation of this 'cultural market' was far from unsophisticated, and was never a matter of creating wealth by selling to an undifferentiated audience. On the contrary, they worked their market by targeting specific social groups, each of whom had distinct expectations of visual material.

The 'lower orders' and 'worthy poor' were offered improving images in the form of *The Band of Hope Review* (fig. 22), *The Servants' Magazine*, *The Cottager in Town and Country* and *The British Workman*; working and middle-class children were presented neat visualisations of animals, heroes and saints in *The British Juvenile* (fig. 23), *The Children's Prize*, *Aunt Judy's Magazine* and *The Boys' Own Magazine*; the pious could look to *Good Words* and the downright devout could find much to please them in *The Sunday Magazine*, *Sunday at Home*, *The Quiver* and *The Churchman's Family Magazine*. All of these were profitable markets, yet the prime audience was the professional (and predominantly urban) middle-class. The bourgeois readership had the greatest income, and, more importantly, it possessed an extended knowledge of art that was based on the viewing of exhibitions, the collecting of prints and the reading of periodicals such as *The Art Journal* and *The Examiner*. This was the most profitable target, and the publishers' aim was to exploit the 'cultivated' taste of a large bourgeois audience by offering it artwork of the highest quality. This middle-class orientation informs all of the primary periodicals and, in the early years especially, the publishers were locked in an intense rivalry, each trying to attract the largest share of the market by presenting the best possible line-up. An enviable situation was enjoyed by George Smith, who, in the early years of *The Cornhil*, 1860–62, managed to employ both Leighton and Millais, famous painters with a reputation that was certain to impress the genteel. Strahan came a close second, and

And illustrated by

J E. MILLAIS, HOLMAN HUNT, JOHN TENNIEL, CHARLES KEENE,
FREDERICK WALKER, J. D. WATSON, AND OTHERS.

24. Detail of artists' 'billing' from the title-page of *Good Words*, 1862.

was overjoyed when he was able to list the names of 'J. E. Millais, Holman Hunt, John Tenniel, Charles Keene, Frederick Walker (and) J. D. Watson' on the title-page of the collected *Good Words* for 1862 (fig. 24). James Hogg was even more competitive, listing only 'his' artists in the contents page of

London Society and placing the 'Engravings' before the literature. In every case, the artist's names were clearly intended as the primary selling point: engaged in a competitive struggle to flatter its readers, the magazines quickly became periodicals in which impressive designs in black and white, rather than literature, were the prime attraction.

Artists were thus positioned as part of a business-venture, a strategy to make money in which the publishers sought them out and employed them as contributors to a developing product, a commodity aimed at a specific domain of interest. Put in bald economic terms, the audience wanted high-quality illustrations, and the publishers could make the most income by exploiting artists who had the widest appeal.

The Business Relationship of Publisher and Artist

The publishers' recognition of the need for quality illustrations meant that most of them engaged in a close relationship with the artists who could give them what they were looking for, at prices they could afford, and on terms they could turn into profit. This arrangement was sometimes conducted through the intermediary of the editor or engraver, so that, for instance, Strahan appointed the Dalziels as commissioning agents at work on *Good Words*, and Bradbury and Evans employed Samuel Lucas as the editor of *Once a Week*. But the relationship between the artist and his employer was more typically a matter of personal control in which the publisher dealt directly with his employee. In the words of John Sutherland, whose comments on the treatment of authors is exactly paralleled by the dealings with artists, the illustrators could 'expect personal attention from a publisher, even the greatest'.[4]

John Cassell was a prime exponent of this approach, and so was James Hogg. Both publishers dispensed with their editors and did all the work themselves; applying what we today would call 'micro-management', they controlled all aspects of production and costs, negotiated directly with their artists and supervised the prosaic details of their daily work. But the most powerful of these *animateurs* was Smith. Gifted with a good eye as well as sound business-sense, Smith believed there was a direct relationship between profit and talent. He greatly enjoyed the setting up of the 'Cornhill Artists', and was adept at identifying new talent. He responded positively to Frederick Walker and George du Maurier, who came to him in search of work, and he took an active part in all aspects of recruitment and promotion. He was also a skilled manipulator of networks, making use of every profitable contact, every friendship that could provide him with an appropriate

4 *Victorian Novelists and Publishers*. London: Athlone Press, 1976, p. 85.

recommendation. He was astute in his relationship with the Dalziel brothers. Established in the early fifties, the Dalziels had worked with every outstanding illustrator. Smith's association with the firm allowed him to gain a series of introductions, contacts which ultimately led to the acquisition of such key artists as Millais, Doyle, Leighton, Barnes and Sandys. These designers were taken into *The Cornhill* fold, and surviving letters demonstrate that Smith exerted a considerable influence over their professional lives. Rarely dealing with Thackeray, the nominal editor, artists such as Walker and Millais looked to *The Cornhill Magazine's* proprietor as an employer and (more importantly) as a director of their work. Known as a charismatic personality, he could ask or demand practically anything of his contributors. The Sensationalist Charles Reade was in awe of him; Trollope declared he could make him do anything;[5] Walker regarded him as a mentor and friend; Leighton at least accorded him the status of an equal; and du Maurier viewed him as a demi-god. Dubbed 'The Prince of Publishers', Smith had the status, one might say, of a Renaissance patron, a commercial Medici for the capitalist age.

Other publishers exerted the same sort of influence over their employees. Gifted with a large pool of artists who were struggling to survive in the small world of illustration, and many others who turned to illustration while they tried to make their way as painters, the proprietors of the magazines could pick or discard whomever they pleased. Their main emphasis, of course, was on attracting, retaining and (most of all) *exploiting* the outstanding names, and to that end they devised a series of business strategies. These tactics were both economic and social, a combination of coercion and reward, bullying and the gentle persuasion of involving the artist, who so often strove for professional recognition and status, in the inner world of his employer's social circle.

A primary means of asserting the publishers' will was to involve the illustrators in *soirées* and parties. These social events were nominally intended as light relief; the purpose, however, was almost always to provide a professional forum in which work-related matters were to the fore and the employer could manipulate his guests at the very moment when they were supposed to be off-duty. George Smith was particularly skilled at playing the disinterested host, offering lavish 'Cornhill Dinners' at his home in Hyde Park Square. The conversation was charming, but serious work, such as the discussions of Trollope and Millais, was still the central concern. Hard-nosed negotiations took place at the same time as the consumption of wine, American cheese-cake and the smoking of cheroots. The same approach was adopted by Bradbury and Evans. The publishers offered a weekly provision of dinners at the *Punch* Table and it was here that their editor, Samuel Lucas, brokered most of the deals related

5 Trollope's relationship with Smith is charted in *An Autobiography*, 2 vols. London: Blackwood, 1883, 1, p. 197.

to the illustration of *Once a Week*. As M. H. Spielmann explains, working 'arrangements [were] made more quickly and effectively [at] a single meeting, than [at any] number of special interviews'.[6] Fed and watered by their apparently generous employers – men who gave nothing for nothing – artists were subject to a particularly subtle and invidious influence.

But a more direct form of control, necessarily, was related to pay. Publishers could only make profits by controlling their outgoings, and illustrators, as suppliers of a particular sort of commodity, were kept on a tight rein. Typically, proprietors supervised the wages: there were no contracts in the modern, formal sense of the term, salaries were not given, and the only money to change hands was paid piece-meal, as a fee for each design accepted for publication. Of course, this meant that employers could manipulate financial rewards to achieve the most fitting result, with no commitment to paying the artist for what they considered to be unsatisfactory (or simply unsuitable) work. Judgements were constantly changing (and sometimes) subjective; the illustrators had no power to argue their case; and work that failed to please was simply unrewarded. Indeed, the transaction was hugely weighted in the proprietor's favour, ensuring many employees led a hand-to-mouth existence with no regular income, no guarantees of acceptance of their submissions and no commitment to pay them for their efforts. Some artists gained ground when their work generated profits by attracting a large readership, while others went in and out of fashion. Surviving correspondence shows how even well-established names such as Walker and Lawless were reduced to asking for work because they were pressed financially, and it was not unusual for an artist to have to ask for work because he was 'horribly poor'[7] and 'in need of a little cash'.[8] Even Leech, the mainstay of *Punch* and the productive illustrator of many books, was sporadically in search of pay, writing pitifully in a letter to Samuel Lucas (6 August 1859) that he would do '*anything*' (my emphasis) that might be 'advisable'.[9]

Empowered to hire and fire, publishers could manipulate their offers of employment as they chose. They also controlled the labour market by imposing variable payments, a situation charted in the Hogg correspondence in the British Library, and in the Smith Elder Archive in the National Library of Scotland.[10] New names were encouraged to compete by small fees, which were offered with the implicit promise of a higher rate if the work were

6 *The History of 'Punch'*. London: Cassell & Co, 1895, p. 85.

7 ALS from Walker to Smith, 3 March 1867. Trustees of the National Library of Scotland.

8 ALS from Lawless to Lucas, no date (1859). MA4500, Pierpont Morgan Library, New York.

9 ALS from Leech to Lucas, 6 August 1859. MA4500, Pierpont Morgan Library, New York.

10 Bentley Papers, Add. 46664 vol. CV (ff.239), British Library; business ledgers, *Once a Week*, 1859–64, PUN/A/Brad.BR, British Library; *The Cornhill Magazine* Ledgers and associated mss., The National Library of Scotland.

25. Barnes, 'Put Yourself in His Place'.
The Cornhill Magazine, February 1870, facing p. 129.
Engraved by W. Thomas.

satisfactory. At the bottom of the scale were payments of £10 per illustration, a sum which equates to £600 in modern sterling, but only has value if the income is regular. Moderate rewards were in the region of £12–£15. For example, Robert Barnes was paid £15 for each of his illustrations for Reade's 'Put Yourself in His Place' (*The Cornhill*, 1869–70, fig. 25), and this appears to be the rate for most of *The Cornhill's* regular designers. The highest scale, of £20 per illustration, was reserved for the special deals, the work that demanded the best names and had to be rewarded in the form of a special incentive. To persuade Leighton to illustrate George Eliot's 'Romola' (*Cornhill Magazine*, 1862–3, fig 18), Smith had to offer him £20 per cut, so paying him £480 for the entire series. Charles Keene was similarly paid £20 by Bradbury and Evans for each illustration to Reade's 'A Good Fight' (*Once a Week*, 1859, fig. 26), and others – notably George du Maurier – were eventually rewarded with the top fee.

Treating the artists as jobbing professionals who could be motivated by the promise of money, publishers ensured that they always had a ready

26. Keene, 'A Good Fight'. *Once a Week*, 23 July 1861, p. 71.
Engraved by Swain.

27. Proof of Barnes's 'At the Stile', from 'Margaret Denzil's History',
The Cornhill Magazine, February 1864, facing p. 138.
Engraved by Swain.
From the collection of George Smith; exhibited at the V & A in 1901.

supply of talent and potential talent; if one artist disliked or quibbled about the fee, they simply passed the commission to someone else. Yet control was not only a matter of fees and payment, rejection or acceptance. In order to maintain standards and attract the largest audiences, publishers also insisted on the maintenance of the highest possible standards. This 'quality control' sometimes resulted in designs being turned down; a more typical approach involved re-working and revision. Even established names were asked to re-draw passages in their designs, and it was not uncommon for payment to be withheld until the publisher considered the artist's changes. Only the best would continue to ensure the sales of the magazines, and some publishers were obsessed with offering a 'perfect product'. Bradbury and Evans regularly met with Lucas to assess the standard of the contributions, and the same regime was imposed in Smith's briefing room at 65, Cornhill. Undoubtedly a connoisseur, Smith personally inspected *every* illustration in the form of a drawing, and then re-assessed it when it appeared in the form of a proof. At both stages he demanded changes, and would not print *anything* that did not meet with his requirements; ultimately building a large collection of proofs and drawings[11] which had met with his approval (fig. 27), he would always intervene if he thought an aspect of the work could be improved. The talent had to be displayed to greatest effect, he believed, or the readers of *The Cornhill* would simply look elsewhere.

Publishers thus imposed a wide range of controlling strategies in which the artists were cleverly exploited. Their wages could be manipulated, and so could the work itself; caught in a working pattern of instant acceptance or rejection, piece-meal commission and irregular pay, the magazine designer of the Sixties was placed in the most insecure of positions. The sheer fickleness of his situation, as a casual worker, is demonstrated by a letter from Samuel Lucas to G. R. Hayden (3 April 1862). Hayden's work was approved by Lucas, but rejected by Bradbury and Evans. The artist had been offered a commission, but the editor summarily informed him that the (unknown) author had made changes which ruled out the possibility of having the work illustrated. 'Something else' will be offered, Lucas writes; it never was (fig. 28).

Such behaviour is unscrupulous but unexceptional. Indeed, the publishers' power over their artists can be traced in much of the surviving correspondence. It is tellingly revealed in the letters of the young George du Maurier. Aiming to establish his career, du Maurier was the very embodiment of the naïve professional. Looking for work, and (he insists) literally going hungry, his earliest missives ironically reveal the various ways in which employers, mindful of the best deal, could exploit the illustrator's economic and professional needs. The process of manipulation is exemplified by his

11 The Smith Archive has been dispersed, and is now mainly in private hands. I have a number of items from it.

"Once a Week" Office.
Nᵒ 11. Bouverie St. Fleet Street.
London. E.C.
April 3 1862

Dear Sir

The author of the Tale I had in view proposes to make some changes in it which will prevent my having it illustrated at all — _____

F. H. Hayden

28. MS. Letter, 3 April 1862, from Lucas to Hayden.

treatment at the hands of Bradbury and Evans. 'B and E' recognised du Maurier's potential as a possible contributor to *Once a Week*, and reeled him in by inviting him to an informal meeting, to be held in January 1861, at their offices in Bouverie Street. Sitting by fireside, the publishers politely explained their interest, offering encouragement and advice while gently implying that the interview could have a long-term significance. Flattered and excited, du Maurier reported the interview to his mother, especially his encounter with Lucas, to whom he had taken an immediate liking. Lucas's manner, having expected a drawing that the artist had failed to produce, is telling:

Editor (Lucas): Ah! Du Maurier, it's you is it at last
Du Maurier: Yes! I've been very ill ...
Ed: Stuff – you're a lazy dog; now come and sit near the fire and tell us what good you've done ...[12]

Du Maurier's reporting of the event suggests a creative informality, but what he fails to see is the real purpose. Speaking through Lucas, the publishers appeared accommodating, but their kindness, I suggest, was only a strategy; it did not imply any commitment to offer work. The editor, he writes, says he could 'do just as [he] liked',[13] but in practice the artist was given very little until he achieved a breakthrough with 'The Notting Hill Mystery', which appeared in *Once a Week* in 1862–63. In the preceding couple of years he was simply kept on a string. Work was submitted and regularly rejected, often with no feedback and no explanation as to why they had taken a 'dislike'[14] to a particular drawing, and no indication as to how he could improve his chances. Taken as a whole, the publishers' 'caprice'[15] was infuriating; however, du Maurier met with the same treatment from *Once a Week's* rivals. Rejections were issued by Hogg, the proprietor of *London Society*, and by Smith, who initially declined one of his finest designs, 'The Cilician Pirates' (1863), only accepting it when it had been re-drawn in the manner of Leighton (fig. 29). Such instability necessarily resulted in financial hardship, and du Maurier was engaged in a constant struggle to be paid at a reasonable rate, paid at a level comparable to his rivals or even paid at all. This situation soured his relationships, spoiled his enjoyment of hard-earned cash and undermined his sense of achievement when Smith paid him £20 for the 'Pirates'.

Depressed by these prosaic considerations, du Maurier's status as an outstanding artist was achieved, one might argue, *despite* his publishers' efforts.

12 Daphne du Maurier, ed. *The Young George du Maurier: A Selection of His Letters*. London: Peter Davies, 1951, p. 29.
13 ibid.
14 ibid, p. 95.
15 ibid, p. 38.

Opposite: 29 Proof of du Maurier, 'The Cilician Pirates'.
The Cornhill Magazine, April 1863, facing p. 530. Engraved by Swain.
Formerly in the Collections of George Smith and Gilbert Dalziel.

30. du Maurier, 'Wives and Daughters'.
The Cornhill Magazine, October 1864, facing p. 385.
Engraved by the Dalziels.

Far from being nurtured, or allowed to develop, his career was obstructed at every turn; compelled to negotiate with 'shabby beasts'[16] such as Bradbury and Evans, he was ruthlessly exploited by entrepreneurs who recognised his talent, but only wanted to publish his illustrations on their own terms. Indeed, du Maurier's early career epitomises the conditions experienced by many Sixties artists at the hands of their employers. Of course, he ultimately broke free of the insecurities of his apprentice years, producing distinguished illustrations, among others, for Gaskell's 'Wives and Daughters' (*The Cornhill Magazine*, 1864, fig. 30), as well as small masterpieces such as the serial designs for Prosser's 'The Awdries' in *The Leisure Hour* (1865). But many artists never achieved this level of success and remained at the level of the wage-slave, the producer of commodities in an open market dominated by taste, demand, and their publishers' requirements. Employed as 'units of production' within a highly organised system, the illustrators were middle-class professionals who worked in order to live. In the words of the Marxist critic N. N. Feltes, they were bound by the demands of the market driven 'commodity-text', and were subject to 'new structures of control over the labour process'.[17]

The Publishers' Impact on Imagery

The publishers' economic leverage was primarily used, as we have seen, to control the standard of their contributors' work. Only designs of the highest quality were likely to appear: the proprietors wanted to attract the widest possible audience by offering the best designs and, for the most part, they were successful. The economics were often brutal, but the end result, taking the very best of the periodicals, was a show case of mid-Victorian talent. Credit for the illustrations' quality is rightly given to the genius of the artists, yet we should not forget that their employers' influence, their cajoling, bullying, flattering, criticising, approving, discarding, appealing, withholding or giving of fees, were important too.

 This imposition of economic control was a part of the equation, a necessity of life, which most artists accepted as a primary characteristic of their professional relationships. What is more, the publishers' influence was aesthetic as well as practical. They dictated the standards of illustration, and they had a parallel influence on the choice of subjects, the visual emphasis, the tone and sometimes the drawing itself. They only paid for good drawings, and they only paid for drawings that were appropriate to their economic needs. Their primary consideration, as businessmen making money by cater-

16 ibid, p. 42.
17 *Modes of Production of Victorian Novels*. Chicago: University of Chicago Press, 1986, p. 8.

ing for a certain demand, was the degree to which a particular illustration corresponded with the taste, interests and values of the audience. Regarded as producers of wealth, artists were employed to provide specific types of image, which would appeal to the readership, and ensure the magazine's continuing economic success.

Constrained by this requirement, illustrators responded in a variety of ways. At one extreme was compliance, and at the other downright refusal. A more characteristic response was a sort of subtle disobedience, a mode of subversion in which the artist inscribed secret texts within the fabric of an 'approved' image. The development of the Sixties periodical closely reflects this struggle, with most of its images responding to the specific demands of its context, and others quietly breaking the mould of the publisher's professional instructions.

Viewed as a whole, the employers' control over the illustrations' character was persuasive and far-reaching. Motivated by the need to depress costs and pressurised by the endless demands of deadlines, publishers expected the illustrator to provide an efficient visual response. Copy was needed, and proprietors did not encourage inventiveness or experimentation; wherever they could, they ensured that the artist's task was rigorously prescribed, compelling him to produce exactly what was required. This tactic was partly realized by attributing artists with specialisms that they could endlessly repeat, sometimes to the extent of degenerating into a formula. It is noticeable that Houghton was repeatedly commissioned with 'oriental scenes' which recreated his illustrations for the *Dalziels' Arabian Nights* (1863–65), and others were constrained in a similar way. Pinwell was invariably given melancholy subjects of rural life; Barnes was largely engaged on images of pious poverty, children and good deeds; North always ends up with landscapes; and Keene, the satirist of *Punch*, anything involving humour. None of these registers the full range of their (very considerable) interests, but publishers relied on the artists' capacity to deliver a distinct form of image, a clear visual sign of 'orientalism', 'rusticity', or whatever pictorial mode was needed for a specific setting. Employers also controlled their designers by commissioning designs for texts that only required the most pedestrian of responses. They limited the range of expression by engaging some of their most able illustrators to interpret the anodyne verse that routinely appeared in *Once a Week, Good Words* and *London Society*. For each of these, all that was required was a fey representation of the main situation. For instance, du Maurier closely conforms to the need to offer an uncomplicated image of yearning and loss in his illustration for the anonymous 'Oh, Sing Again That Simple Song' (*London Society*, 1862, fig. 31). Though well drawn, and carefully prepared in a series of studies (now held in Special Collections, University of Exeter), the illustration is a purely literal response, which shows a young woman yearning for

31. du Maurier, 'O Sing Again That Simple Song'.
London Society, November 1862, facing p. 433.
Engraved by Harral.

63

TWO:
ARTIST
AND
PUBLISHER

32. Watson, 'A Summer's Eve'.
London Society, August 1861, facing p. 97.
Engraved by the Dalziels.

Drawn by R. Barnes.] [Engraved by J. Swain.

" If thou would'st truly, nobly live,
 Give,—ever give. "

33. Barnes, 'Blessed to Give'.
Good Words, 1864, facing p. 641.
Engraved by Swain.

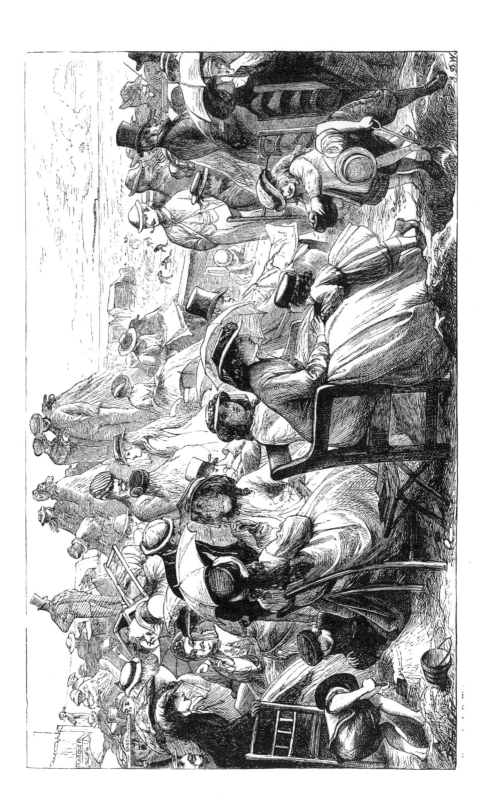

lost love. Hogg wanted a straightforward piece of sentimental visualisation, and that is exactly what the artist gives him. Hogg was similarly fortunate in being able to draw on J. D. Watson, an expert on romantic imagery whose work is exemplified by 'A Summer's Eve in a Country Lane' (1863, fig. 32). This, again, is efficient, sentimental image-making: it evokes the atmosphere of the 'Sweet Summer Eve' by showing a rural setting, and it focuses the poem's emphasis on true love by depicting a handsome couple exchanging flowers. However, it adds nothing to the understanding of the poem and, despite its extremely fine draughtsmanship, is a prime example of an artist's compliance with the demands of a fixed and unchallenging commission.

In each case, the artist was constrained by the need to provide whatever the audience desired. The middle-class readership enjoyed a mixture of humour, orientalism, mild rusticity and sentimental poems, and publishers ensured that these interests were richly satisfied. They required their artists to provide what, in effect, is a highly programmed response, a visual showing of set iconographies which articulated the magazines' underlying messages and allowed no ambiguities in its relationship with its viewers. In the case of Strahan's *Good Words*, the appeal to the evangelical audience is devoutly upheld, with every image providing a visual reinforcement of the readers' unquestioning faith. Figured as combination of scenes from the Bible, exemplified by Millais's 'Parables' (fig. 14), and scenes of charity, such as Barnes's 'Blessed to Give' (1864, fig. 33), *Good Words* is the visual embodiment of Strahan's belief in the power of illustration as a means of expressing or spreading the Word. The focus never slips and even the most commonplace scenes are infused, as Goldman explains, with a 'moral and religious feeling'.[18] Intended as an organ of devotion, a means, in Strahan's own terms, to facilitate the 'mental and moral improvement of the people',[19] *Good Words* is a piece of didacticism, a visual display in which imagery is cleverly used to complement its dour articles and sombre poems. Illustrators could also be used in the service of more trivial needs. In complete contrast to Strahan's religiosity is Hogg's *London Society*, a magazine predominantly aimed at the leisured bourgeoisie, rather than at professionals or business people. This time the artists were required to visualise 'The Hours of Relaxation', a programme which was vividly realised in the form of hedonistic and trivial scenes of the wealthy at play, disporting themselves at art-shows, the races, boating on the river, attending the latest opera, promenading on Rotton Row, attending a picnic or enjoying a day at the seaside (fig. 34). The emotional range is narrow, and the proprietor imposed a remarkable degree of uniformity. Limiting his illustrators to only the most glamorous of designs, his influence is most

18 Goldman, *Victorian Illustration*, p. 116.
19 'Charles Knight, Publisher'. *Good Words*, 1867, p. 617.

Opposite: 34. Watson, 'Holiday Life at Ramsgate'.
London Society, October 1862, facing p. 338. Engraved by the Dalziels.

apparent in the obsessive treatment of the emblems of wealth. *London Society* is crowded with representations of the jewellery and the latest fashions, and some of its most telling designs are images of shimmering crinolines, bustles and veils, a mode exemplified by Morten's 'After the Opera' (fig. 35). Hogg wanted his magazine to appeal to wealthy young women, and to that end his artists produced a luxurious visual montage which often veers perilously close to the iconographies of the fashion-book.

London Society and *Good Words* are, of course, at two ends of a continuum. Publishers such as Hogg and Strahan imposed their own programmatic requirements, but the illustrators' more general task was to represent the values of the average bourgeois. In the words of Thackeray's address to his readers and potential contributors, the magazines were aimed at 'well-educated gentlemen and women';[20] 'politeness' was required, and publishers directed the artists to create a series of visual tropes in celebration of their readers' lifestyles. This emphasis on 'good manners'[21] is clearly 'inscribed' in *The Cornhill*. Smith imposed strict rules of propriety, figuring his magazine as a genteel combination of social etiquette, good physiognomies, gentle romance, country pursuits, comfortable interiors and domestic bliss. Well-bred faces and measured gestures are the dominant concern in *The Cornhill*'s illustrations, a situation exemplified by Millais's designs for Trollope and Walker's illustration for Thackeray's writing of 'Philip in Church' (figs. 5, 11, 13). A parallel emphasis is found in *Once a Week*. Bradbury and Evans aimed the magazine at a broad base of middle-class viewers, from the 'lawyer' and 'doctor' to the 'young wife',[22] and they rigorously maintained this focus. As in *The Cornhill*, the bourgeois emphasis is carried forward in images of well-bred people at work and play, and it is Millais, once again, who acts as the exponent of the key messages.

In 'The Grandmother's Apology' (fig. 36), we have an emblematic sign of the publishers' celebration of middle-class culture. Nominally an illustration to Tennyson, the image reads more convincingly as a symbol of polite living, a merging of tradition (as represented by the generational range between grand-daughter and grandmother); respectability and wealth (their dress, the setting); educational attainment (the girl's opened book); and domesticity (the cat, an emblem of Home). Tennyson provides the passionate message; but it is the artist, chosen for his capacity to interpret the ordinary lives of the bourgeoisie, who symbolises the domestic milieu, reassuringly reaching out to the publishers' target audience and providing them with a visual space in which their own experience is celebrated and given a poetic resonance.

20 'To a Friend and Contributor'. *The Letters and Private Papers of W. M. Thackeray*, ed. Gordon Ray, 4 vols. London: OUP, 1946, 4, p. 161.
21 ibid.
22 Shirley Brooks, Introductory poem to *Once a Week*, 2 July 1859, p. 2.

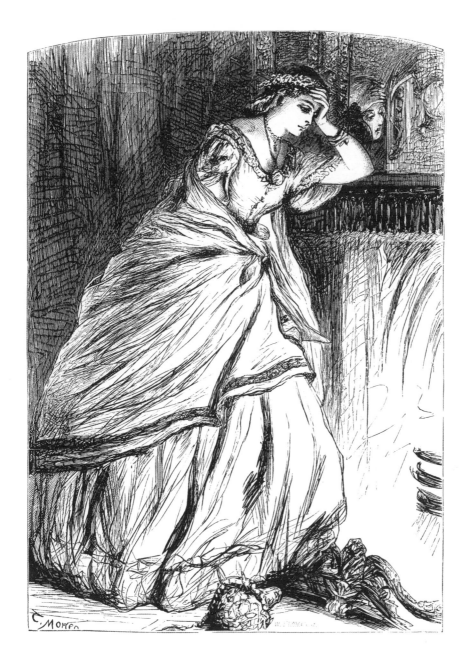

35. Morten, 'After the Opera'.
London Society, January 1863, facing p. 39.
Engraved by Thomas.

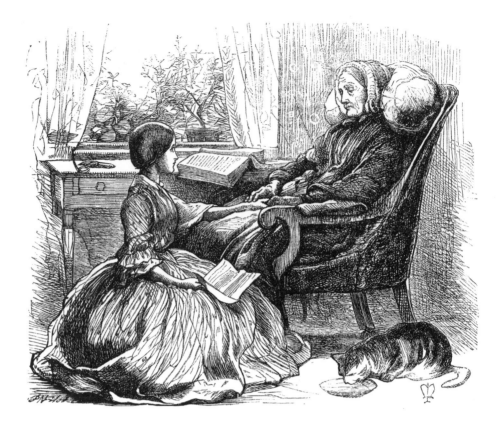

36. Millais, 'The Grandmother's Apology'.
Once a Week, 16 July 1859, p. 41.
Engraved by the Dalziels.

What none of the proprietors wanted, on the other hand, was an affront to this unified method. The publishers were conservative, and so were the artists; for the most part complying with their instructions, they made the 'pleasant ordinary', rather than the confrontational or argumentative, their ideal. As Thackeray explains, there should at no cost be a challenge to 'moral sensibilities'. There may be 'points on which agreement is impossible', but on these, he says, 'we need not touch'.[23] There were nevertheless many instances in which the publishers essentially lost control of their artists, allowing them to produce illustrations which challenged, skewed or subverted the views of the magazine, and of its viewer. These iconoclastic affronts to politeness can be traced in the twin domains of sexuality and social observation.

The bourgeois orientation was gently ridiculed by Leech. Well-known as a *Punch* satirist, Leech was employed at *Once a Week* because it was assumed he would modify his style to match the more sombre tone. What

23 *Letters and Private Papers of Thackeray*, 4, p. 161.

37. Leech, illustration to Brooks's dedicatory poem.
Once a Week, 2 July 1859, p. 2.
Unnamed engraver, probably Swain.

he presents, however, is a series of mocking designs which satirise the audi-
ence's social rituals. His approach is exemplified in his opening illustration
for Brooks's dedicatory poem. The verse is barely serious, but Leech changes
its focus by presenting an image of middle-class papa as a semi-rustic buf-
foon, sitting awkwardly in his garden with nothing much to do, attended by
his daughters (fig. 37). This is not subversive, as such, yet it is hardly the sort
of message that Bradbury and Evans wanted to convey; it shows little 'deli-
cacy', the very quality the publishers wanted Leech to apply in a new setting,
and it orientates the magazine in a slightly confrontational manner, setting it
up as another version of *Punch*. But some artists, notably Charles Keene,
who was another colleague at *Punch*, were far more outspoken. Working
from George Meredith's satirical text, Keene's designs for 'Evan Harrington'
(*Once a Week,* February-October, 1860) are faithful to the writer's intention
while also providing a series of sharp representations of the claustrophobia
of middle-class life. Emphasising its enclosure, its small rituals, its obsession
with dress – strikingly registered in the cloying excess of the women's crino-

38. Sandys, 'The Hardest Time of All'.
The Churchman's Family Magazine, July 1863, facing p. 91.
Engraved by Thomas.

lines and the ridiculous proliferation of top hats – Keene provides a droll gloss on the lifestyle of the typical reader of *Once a Week* (fig. 8). Extending Leech's satire by taking it out of the realms of caricature, he offers a telling commentary, one designed to catch the bourgeois reader unawares. Indeed, both artists evade or reconfigure what might be viewed as the limiting or censorious demands of their employers. Constrained by these requirements, they still manage to negotiate a space in which to articulate a limited but interesting critique. Their work is a small assertion of power in a situation which is otherwise characterised by disempowerment.

Far more challenging, in terms of working constraints, was the exploration of wider social issues. The *Punch* artists inject a certain levity into the pages of *Once a Week*, subverting its bourgeois focus, but there were few opportunities to represent the social conditions of the working classes. To do so would be to court controversy, to engage with the very issues that no publisher, at the cost of alienating his audience, could risk exploring. This is the territory Thackeray describes as dangerous, the place where 'agreement is impossible'.[24] Where representations of the workers do appear, they are usually idealisations, celebrations of the peasants' worthiness framed within the moral context of evangelicalism. There were, nevertheless, a number of occasions when artists in pursuit of a greater social realism outspokenly managed to find a space in which they could evade the publishers' directives and expose the more unpalatable sufferings of the poor. Their special emphasis was the degradation of the industrial proletariat. Offering illustrations to sentimental poems that lament the workers' plight, they subversively explored the very material the middle-class reader could read, but was not supposed to *see*.

The special trick was to create an image that satisfied the publisher while at the same time extending a more general critique, a piece of polemic reaching well beyond the limits of faithful representation. Sandys uses this tactic in his startling design for Sarah Doudney's poem, 'The Hardest Time of All', an account of the famine caused by the slump in the Lancashire weaving trade. Commissioned by John Hogg for *The Churchman's Family Magazine* (1863, fig. 38), the illustration was intended as an anodyne accompaniment to the verse; the poem does not enter into social debate, recasting the worker's suffering in terms of an appeal to God, and the image *could* have been the same sort of pious generalisation. What Sandys presents, however, is a monumental female figure, wrapped in grief as much as she is wrapped in her clothing, surrounded by details of her redundant trade in the form of a carefully detailed loom, scissors and other implements. This is the very reverse of Doudney's platitudes about 'wild despairing moments'; in the poem the 'waiting time' is waiting for God's intervention, but in the illustration the

24 *Letters and Private Papers of Thackeray*, 4, p. 161.

39. Walker, 'Love in Death'.
Good Words, 1862, p. 185.
Engraved by the Dalziels.

40. Whistler, 'The Relief Fund in Lancashire'.
Once a Week, 26 July 1862, p. 140. Private Collection.
Engraved by Swain.

'waiting' is unambiguously a matter of waiting for work or until the weaver starves.[25] Dressed in contemporary costume, this worker is absolutely of the present; figured as a raw, journalistic sign, the image unambiguously criticises the heartlessness of economic *laissez-faire* and points to the culpability of those in charge of the means of production.

Controversial and challenging, 'The Hardest Time of All' is an unpalatable design, presenting the middle-class viewer with precisely the sort of 'coarseness' that would not normally be tolerated by any of the publishers. But how did it escape the proprietor's censure? Hogg's involvement in the process of approval is not recorded; however, he may have published the design because he wanted to exploit the artist's reputation as a leader in black and white. His tactic was in all likelihood a matter of calculated risk, of striking a balance between offending his ultra-conservative readership, and establishing his periodical on an equal footing with the best of the illustrated journals. The picture might be offensive, yet no-one could question the quality of its draughtsmanship. Hogg took the risk of publishing it, and Sandys took the risk of alienating his employer and losing his fee.

Other designers were willing to gamble the same odds. Walker survived the strictures of Strahan and Macleod, producing a sharp re-visualisation of Dora Greenwell's sentimental poem, 'Love in Death' (1862). Later re-worked as a painting, Walker's design is a striking piece of social realism: pared down to its graphic essentials, it shows a young woman, essentially an emblematic figure of poverty, sheltering her child as she struggles through the bitter cold (fig. 39). Whistler also produced a brace of controversial images, dealing once again with the plight of the Lancashire weavers. In 'The Relief Fund in Lancashire'(fig. 40), he expresses the idea of death by starvation, illustrating a wispy figure who is literally fading away. Shorn of its poem by Tennyson – who seems to have developed a strategic 'illness' and withdrew his lines – it is still a powerful sign, an emblem of the sort of 'political' imagery most publishers would not tolerate. Significantly, it only appears in *Once a Week* as the result of Whistler's belligerence, the sort of pressure not even Lucas could resist. At the same time, many other designs of a similar directness were *not* accepted, and the small scope of the remaining work is a clear indication of the publishers' censorious influence. Proprietors would not readily accept affronts to the social proprieties of their readership; nor would they knowingly accept *any* hint of sexual impropriety.

If anything, the magazines were more squeamish of sexuality than they were of social commentary. In all of the journals there is barely a kiss, hardly a loving embrace, and, within the confines of their representations of middle-class people dressed in elaborate costumes, only the slightest hint of the body

25 *The Churchman's Family Magazine*, 2, 1863, p. 91.

Opposite: 41. Title-page, *The Leisure Hour*, 1867.

Leisure Hour, Dec. 1, 1867]

THE LEISURE HOUR.

1867

LONDON:
PATERNOSTER ROW,
AND
164, PICCADILLY.

within. There are no representations of naked torsos; no low-cut dresses of the sort favoured by the wealthier bourgeoisie (and openly celebrated in Victorian paintings); no female legs; no images of arousal; and no suggestion of the exposure of arms or throats. Even an ankle – the one, say, daringly displayed by Millais in his illustration of Lucy Robarts (fig. 13) – could be the subject of prudish disapproval. Proscribed by their publishers, artists who might otherwise paint nudes on a regular basis, such as Leighton, were roundly denied the opportunity to represent the nakedness of their contemporaries. Such material was simply not acceptable when it was read in a family context: the middle-class readers featured on the title-page of *The Leisure Hour* would not accept the intrusion of lewd images into the domestic space of the fireside (fig. 41), and women and children had to be 'protected' from any hint of impropriety.

Yet artists did find a way of incorporating risqué images into their work. Laurie Garrison has written provocatively of du Maurier's negotiation of the 'discourses of vision and sexuality'[26] in his illustrations for 'Eleanor's Victory' (*Once a Week*, 1863), and others engaged in the same cryptic game, playfully undermining the starchiness of their commission by including gnomic signs, unfamiliar settings and visual innuendo. The most obvious means of evading the publishers' censorship was to explore eroticism by inscribing it in pictures of an imagined past. This was an acceptable practice, widely used in painting; typified by the art of Poynter and Alma-Tadema, it provided a distinct means of presenting the nude by projecting it into a classical, or sometimes a medieval, milieu. Displaced in time, or offered in service of mythology, these subjects could be justified on the basis of their aesthetics as celebrations of the human form, and *never, so the argument ran,* of human desire. Critics of Victorian morality have read this double-standard as a prime example of sexual hypocrisy, but as far as the illustrators were concerned the capacity to project their subjects onto fantasy figures provided a ready-made code, a distinct method of visualising their suggestive designs, which allowed them to reclaim the sorts of freedoms they believed were rightfully theirs.

Du Maurier celebrates male physicality in illustrations such as 'The Cilician Pirates' (fig. 29). The most challenging artist, however, is Fred Sandys. Known as an abrasive character who was difficult to control, Sandys cleverly exploited the aesthetic loop-hole which allowed the nude to appear in a stylised setting. He is most successful in illustrations such as 'Once More on the Organ Play' (*Once a Week*, 1861, fig. 42), which shows a suggestive image of a male body raised ecstatically on the bed, animated – in a characteristically mid-Victorian fusion of opposites – by the throes of death and sexual

26 'The Seduction of Seeing' in M. E. Braddon's *Eleanor's Victory*', in *Victorian Literature and Culture*, 36, 2008, p. 112.

42. Sandys, 'Yet Once More Upon the Organ Play'.
Once a Week , 23 March 1861, p. 350.
Engraved by Swain.
Image taken from *Reproductions of Woodcuts by F. Sandys*.

arousal. He is equally outspoken in his depiction of female sexuality. This is mildly suggested by his draped nudes for 'Cleopatra' (*The Cornhill Magazine*, 1861, fig. 43) and 'Cassandra and Helen' (*Once a Week*, 1866), and taken to a daring extreme in 'Rosamund, Queen of the Lombards' (fig. 21). Nominally a faithful illustration, a literal representation of its poem, this image is a subtle mediation of sexual signs. The figure is kept fully dressed, but the artist endows her with an elongated throat and swirling hair, both conventional signifiers of arousal that feature throughout Victorian art, and notably in Rossetti's famous design for 'The Palace of Art' in the 'Moxon' Tennyson (fig. 44). Presenting nothing to offend in the explicit sense of the term, he provocatively encodes the figure's meaning in visual forms, which at the time of publication had a high degree of currency. There were nevertheless distinct limits to what could be shown, even in a literary or mythological setting. Sandys stretched expectations in his image of 'Danaë in the Brazen Chamber'. Commissioned by Bradbury and Evans to accompany a mildly erotic poem by Swinburne, 'Danaë' (1866, fig. 45) was a calculated challenge which confused the publishers. The representation of the aroused female figure was perfectly acceptable, even though its iconography was remarkably

42

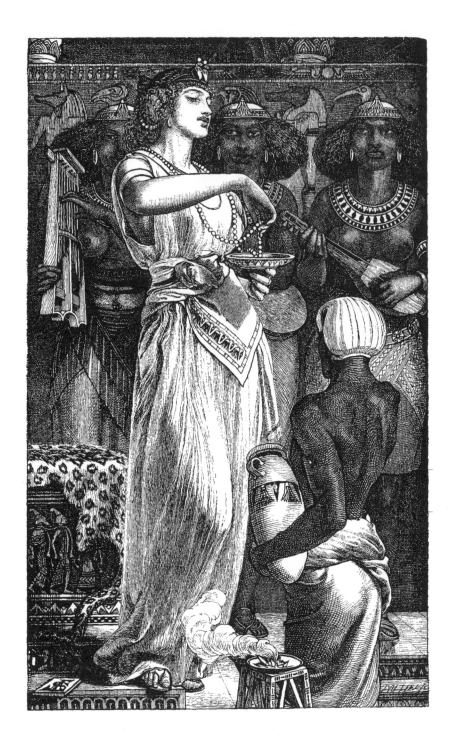

43. Sandys, 'Cleopatra'.
The Cornhill Magazine, September 1866, facing p. 331.
Engraved by the Dalziels.

44. Rossetti, first illustration to 'The Palace of Art',
Tennyson, *Poems*. London: Moxon, 1857, p. 113.
Engraved by the Dalziels.

candid. Danaë's languorous pose, with closed eyes, ecstatic expression and
upturned head, was scrutinised without comment, and so were her stream-
ing hair, her naked arms and upper leg, glimpsed through a tousled gown.
Unambiguously erotic, the image recalls Rossetti's painting of *Beata Beatrix*
(1862–64, Tate Britain). Such imagery was acceptable when it appeared in
this sort of encoding as a type of Desirable Woman, a *femme fatale* safely
banished to a more distant time. Yet the 'prudish' William Bradbury would
not accept the tiny detail which shows her lover's genitals, simplified in the
manner of antique art, in the half-concealed embroidery at the left of the
composition. On viewing the proof, which Sandys regarded as an example
of Swain at his most accomplished, Bradbury 'playfully stamped his foot',
declaring, in a slang expression which at the time of speaking was regarded as
shockingly obscene, 'I will have no poultry on display in *Once a Week*.'[27] Will-
ing to accept the highly eroticised representation of the female figure, the
publishers could not risk the explicit showing of male genitalia, no matter

27 Quoted in Betty Elzea, Frederick Sandys: *A Catlaogue Raisonné*. Woodbridge: Antique Collectors'
Club, 2001, p. 226.

45. Sandys, 'Danaë in the Brazen Chamber'.
The Century Guild Hobby Horse, 3 (1888), facing p. 147.
Engraved by Swain.
Image taken from *Reproductions of Woodcuts by F. Sandys*.

how innocuous its form, and despite the fact that they retained Swinburne's risqué poem. No compromise was made, and the illustration remained unpublished for more than twenty years, only appearing towards the end of the century in the more liberal pages of *The Century Guild Hobby Horse* (1888). 'Danaë' was a fine print, though all that mattered was its 'moral' content.

The inconsistency of this judgement typifies the publishers' anomalous approach to the process of censorship, an unevenness which is similarly evident in their treatment of social commentaries. But the very fact that proprietors could simply reject Sandys's design is a clear indication of their authority. Set up as paymasters and arbiters of taste, they allowed their artists certain freedoms, while keeping them under tight control. The relationship between the illustrator and the proprietor was a genuine collaboration, although the creative power, confined and exploited by the person who controlled the process of publication, always remained in the hands of the employer.

CHAPTER THREE

Editor and Artist

In the previous chapter we explored the ways in which publishers shaped their journals to fit the market, compelling their artists to provide a suitable product. This emphasis on personal involvement endowed the magazines with a distinct taste, making them into a curious combination of crowd-pleaser and personal utterance, but it also meant that their editors were reduced to a secondary role. In most cases, the editor was never more than an executive, a middle-manager whose principal task was to realise his employer's directives. All of the more interesting work – the conversations with artists, the commissioning, the negotiations, the scrutiny of proofs and the jollies – was reserved for the attention of the publisher. This situation is exemplified by the working relationship of Smith and Thackeray, the editor of *The Cornhill Magazine*. Smith employed the novelist for his literary cachet, using his name as an attraction to pull in the readers. Yet he denied him any tangible power – Thackeray being in any case comically incompetent – and did all of the artistic transactions on his own terms. Others followed a parallel course, and were just as instrumental. William Macintosh engaged William Meynell as editor of *Golden Hours*, although he only expected him to supervise the mundane business of assembling the monthly contributions once he (the publisher) had made his selection of illustrations, approved the engraving and spoken to the artists. The publishers of *The Leisure Hour*, the Society for the Promotion of Christian Knowledge, went even further. Suspicious of one individual having overall control, they placed the magazine at the disposal of a working panel. These unnamed professionals were given specific tasks, all of the more interesting work being conducted, in line with the usual routine, by the proprietors. Regarded as literary journeymen, editors of Sixties magazines were generally engaged at a much lower level of professional activity than one might expect. Once again, we see how the mid-Victorian 'commodity text' was produced within a framework of what were sometimes extremely limiting procedures. There were nevertheless several distinguished examples of editors who managed to accommodate their employers' directives and, at the same time, impose their own varieties of control. This inventive approach was adopted by three outstanding men: Donald Macleod, Thomas Guthrie, and Samuel Lucas.

Employed by Strahan as the editors of *Good Words* and *The Sunday Magazine*, the Reverends Macleod and Guthrie delivered an efficient package that clearly expressed the publisher's moral emphasis. As ministers in the

Free Church of Scotland they were ideally placed to manipulate the magazines' scriptural texts. But they also developed a more individual approach to the treatment of visual art. They liaised with the Dalziels, who did the commissioning, and they co-selected the work they thought to be the most appropriate. Strahan reserved final judgment, but his servants still managed to clear a space in which they could exercise control and help to shape the magazines' visual textures; personal contacts were rigorously pursued, and artists regularly responded to direct instruction from Guthrie and especially from Macleod. Editorial influence was similarly appropriated, through a process of guile, by Lucas. On the face of it, Lucas was simply a servant of Bradbury and Evans. He acted as their agent, hired and fired on their whim and, as we have seen in the case of controversial material such as the 'Danaë' by Sandys, always deferred to their moral judgements. Yet Lucas was a powerful figure who exerted a formative influence on *Once a Week's* pictorial style; he gave Bradbury and Evans the images they wanted, and he made sure they were the images he wanted as well.

Indeed, all three of these editors had distinct ideas as to what illustration should do, how it should convey the periodicals' prime messages, and how it should be related to the written text. Placed between the publisher, who decided on standards, and the artist, who provided the image, Macleod, Guthrie and Lucas had a considerable effect on the designer's approach. Transcending the usual limitations, they made a distinct contribution to the magazines' visual appeal.

Macleod, Guthrie and the Evangelical Magazine

Macleod and Guthrie shared Strahan's belief in the didactic nature of art, and insisted that *The Sunday Magazine* and *Good Words* were exclusively used as organs of Christian belief. In the words of John Cassell, whose programme for *The Quiver* was equally applicable to Strahan's magazines, their aim was the 'Promotion of Biblical Truth' and the 'Advancement of Religion in the Homes of the People'.[1] This credo was realized by offering an extensive series of scriptural scenes, moralizing narratives and illustrations of good works.

Both editors stressed the traditional iconographies of Christianity, especially the Old Testament. These images are brought to the fore, placed in the readers' hands as part of a visual continuum which allowed the devout to glance at illustrations of the holy stories, and relate them, during the quiet reflection of a Sunday's evening by the fireside, to the sermons heard earlier in the day. What is more, the illustrations are formulated in a specific way.

1 The first prospectus for *The Quiver*; reproduced in Simon Nowell-Smith, *The House of Cassell*. London: Cassell, 1958, p.59.

46. Millais, 'The Sower'.
Good Words, 1863, facing p. 677.
Engraved by the Dalziels.

47. Millais, 'The Prodigal Son'.
Good Words, 1863, facing p. 161,
Engraved by the Dalziels.

48. J. E. B., 'Soul Gardening'.
Good Words, 1863, facing p. 304.
Engraved by the Dalziels.

Believing that religious messages were best communicated in a concrete form, Macleod and Guthrie encouraged their designers to represent their messages in terms of a striking materiality. This belief in the power of a pragmatic 'reality' was one of the mainstays of The Church of Scotland's evangelicalism, and the same sense of the here-and-now, the showing of God's hand in the fabric of the everyday, can be traced throughout the pages of the magazines. Macleod's influence was significant. Always stressing the need for 'graphic' intensity and 'apposite'[2] design, he directed his illustrators to provide visual representations that made a clear link with the everyday world of his readers.

He found an exemplar in the work of Millais, whose 'Parables of Our Lord' had been commissioned by the Dalziels in 1857 and was a natural fit, one might say, in the pages of *Good Words* (1863). Millais's designs were published by Macleod because they offered exactly the sort of pragmatic approach the editor wanted to encourage. Macleod emphasized the value of pictorial evangelizing, of preaching through the medium of the 'real', and Millais does the same. Presenting his work as if it were part of a sermon in which the preacher illustrates the stories with material examples, he represents events in a pared-down style. This typically takes the form of simplified, monumental figures, telling gestures and imposing compositions. In 'The Hidden Treasure' (fig. 14), the dramatic situation is vividly conveyed by moving the 'finder' to the front of a tilted plane, contrasting his hurried handling with the huge backs of the static oxen, which are placed, blocking the space, and suggesting his secrecy, in the background. The story is told with parallel directness in 'The Sower' (fig. 46). Focusing on the idea of the difficulty of spreading the Word, Millais diminishes the sower, and foregrounds the 'gravel' and 'rocky knolls'. Moreover, the same practicality infuses 'The Prodigal Son' (fig. 47). This moving design expresses the father's 'gush of love' in the form of monumental figures locked together, creating an unambiguous image of unanimity and oneness.

Such physicality, 'told for instruction' but 'clothed with flesh and instinct with life',[3] is an apt representation of the editor's approach to the key messages. More effective than any abstraction, 'The Parables' are figured as a series of unambiguous signs. Their intensity sets the tone for *Good Words*, and it is instructive to compare their robust directness with the cloying conventionality of J. E. B.'s 'Soul Gardening' (1863, fig. 48). Here we have precisely the fragile, abstracted image Macleod generally disliked, a compound of wispy ethereality and shallow piety. The editor must have approved this image, but it forms a marked contrast with his usual emphasis on the tangible world of

2 William Garden Blaikie's comments on Guthrie's preaching style, *Leaders in Modern Philanthropy*. London:RTS [1884].
3 Thomas Guthrie, 'The Parables'. *Good Words*, 1863, p. 1.

49. Houghton, 'My Treasure'.
Good Words, 1862, p. 504.
Engraved by the Dalziels.

50. Houghton, 'True or False'.
Good Words, 1862, p. 721.
Engraved by the Dalziels.

51. Lawless, 'Rung into Heaven'.
Good Words, 1862, p. 153.
Engraved by the Dalziels.

52. Watson, 'The Early Lark'.
Good Words, 1861, p. 299.
Engraved by the Dalziels.

53. Small, 'Lilies',
frontispiece to annual issue of *Good Words*, 1866.
Engraved by the Dalziels.

bodies, clothes, places, heavy landscapes, flesh and blood. That orientation can be traced more generally in the work of the magazine's signature artists, all of whom came under the editor's (surprisingly flamboyant) spell.

His impact is pronounced in images which represent the practical application of morality. In Barnes's 'Blessed to Give' (1864, fig. 33), the illustrator finds another graphic solution, stressing the currency of giving by representing the poor not as a stereotype but in the form of a convincing man of the street, a badly dressed labourer who, despite his own poverty, is 'blessed' when he contributes to the upkeep of a hospice. The material existence of goodness is further embodied in numerous representations of Home and domestic relationships. Watson figures the simple pleasures of the fireside in 'Rhoda', and there are parallel images of the God-like hearth by Pinwell, Lawless and Barnes. A more telling view, however, is Houghton's. In 'My Treasure' (1862, fig. 49) and 'True or False' (fig. 50), he shows the domestic idyll not as a place of still reflection or peace, but as a restless domain of over-worked parents and mischievous children. Some critics, notably Goldman, have found this vision of childhood 'disturbing',[4] especially when it appeared in a more extended form as a book, *Home Thoughts and Home Scenes* (1865). But Houghton's illustrations were designed as a celebration of vitality. Their lines are infused with movement because they embody the notion of high spirits, having fun and tirelessness. In the moralistic terms of Macleod, they act as a visceral incarnation of the pleasures of being young, the God-given blessing, so the editor would have it, of being alive.

Macleod's inclusion of this material provides a topical balance to the biblical illustrations, and it is noticeable that God, faith and the spiritual are practically invisible, except in the texture of the 'real'. However, there is an emphasis on significant 'Moments in Life' (1862). These are usually reveries suspended in time, when individuals suddenly become aware of ageing, mortality and the presence of God. A good example is Lawless's 'Rung into Heaven' (1862, fig. 51), in which the artist represents a poetic scene of children who are literally placed beneath some bells, their eyes cast heavenward in anticipation of the angelic peal. The same reflective note informs Watson's 'The Early Lark' (1861, fig. 52); Small's 'Lilies' (the frontispiece to the volume for 1866, fig. 53); and many designs by Pinwell, Walker and Pettie. Such images closely reflect the editor's emphasis on illustration as a didactic tool, a means of expressing Christian virtues and discovering the realities of faith.

So Macleod's programme for *Good Words* is a matter of visible preaching, of showing rather than telling. Designed for maximum impact, the illustrations produced under his direction are intended to function as tangi-

4 Goldman, *Victorian Illustration*, p. 126.

54. Birket Foster, 'Autumn'.
The Sunday Magazine, 2 October 1865, facing p. 1.
Engraved by the Dalziels.

55. Barnes, 'The Pitman to His Wife'.
The Sunday Magazine, 2 October 1865, facing p. 17.
Engraved by Swain.

ble emblems, the signs, as one writer notes in an article on the effectiveness of prayer, of the work 'of God's fingers … the visible expression of his sovereign will'.[5] In the words of an *Art Journal* reviewer of Millais's 'Parables', which can be applied to the illustrations as a whole, these are 'not pictures to be heedlessly looked at', but to slowly reveal their 'true meaning' and 'real value' as 'examples of Christian art in the comparatively humble form of [the] woodcut'.[6]

A similar programme is registered in *The Sunday Magazine*. However, Guthrie's approach to the engravings is more systematic than Macleod's. Macleod emphasises the power of the mute speaker, the eloquence of the concrete design, but Guthrie is more interested in conveying his messages through a calculated balance of image and word. In *The Sunday Magazine* the text and illustrations are linked in a sort of expressive rhythm, an oscillation of meaning in which the moral lessons are stated and reinforced, mirrored, expanded and exemplified in a visual form. This approach is epitomised by the numbers for 1865–66. In the opening editorial, Guthrie writes of 'Autumn', a piece which characteristically starts as a literal description of the 'meadow's cool sward',[7] and immediately reinforces its effect by juxtaposing the letterpress with an idyllic scene by Birket Foster (fig. 54). As the article proceeds, however, the significance of Autumn – as a metaphor for a stage in human life – is slowly revealed, and we turn back to the engraving with an enhanced sense of its meaning. The illustration is placed, in other words, in an emblematic relationship with the text, exemplifying the literal and allegorical dimensions of the article, and enhancing its dramatic impact. The same balanced pairing recurs throughout the magazine, in each case compelling the reader to glance between the written and visual texts in a process of checking and comprehension, which underscores the editor's robust Christianity. The 'Annals of a Quiet Neighbourhood' (1865–66) typify this parallel movement, combining a vicar's observations on the physical and spiritual condition of his parishioners with Barnes's pragmatic representations of the rural poor. The text is unusually honest in its treatment of humble life – particularly in its representation of hostility towards the churchman – and Barnes's illustrations are used, always at key moments, to stress the text's emphasis on the need for practicality and good deeds. The same unsentimental approach informs Barnes's treatment of 'The Pitman to His Wife' (fig. 55) and Pinwell's 'Days of Grace' (fig. 56). The second image underscores the text's juxtaposition of middle-class charity and proletarian suffering. At the same time, it subtly shifts the emphasis, relocating it from a contrast between faith and faithlessness to a striking dissonance of wealth and well-being, poverty and disaffection. The text adopts a relatively mild

5 J. J. Stewart Perowne, 'The Order of Nature and the Efficacy of Prayer'. *Good Words*, 1866, p. 141.
6 'Illustrations of The Parables'. *The Art Journal*, 1864, p. 107.
7 'Autumn'. *The Sunday Magazine*, 2 October 1865, p. 1.

Opposite: 56. Pinwell, 'Days of Grace'.
The Sunday Magazine, 1 March 1866, facing p. 385. Engraved by Swain.

approach which reinforces stereotypes, but Pinwell 'ventilates' his theme, evading the censure of his publisher and grafting a social challenge on top of the conservative text.

Pinwell's approach is nevertheless a key example of Guthrie's partnering of text and illustration. His preaching style was characterised by the 'faculty of illustration', and he knew how to intensify the impact of his moral messages by uniting high rhetoric and images which, as in *The Sunday Magazine*, are sometimes disconcertingly 'pathetic'.[8] Like Macleod, he realised the value of the concrete sign and its capacity to communicate physically, rather than intellectually. This assumption informs the editors' treatment of Strahan's moral project, while also allowing them to impose themselves, their values and their personalities, into the content of the two magazines.

Samuel Lucas and *Once a Week*

Macleod and Guthrie were appointed to their posts on the basis of their expertise as preachers. Bradbury and Evans were equally careful in employing Samuel Lucas as the first editor of *Once a Week* (1859–65). Well known as a critic and reviewer on the pages of *The Times*, Lucas was generally regarded as a 'man of sound judgement and sure taste',[9] a 'plain'[10] speaker and one-time circuit judge who was highly cultured and 'thoroughly middle-class'.[11] This was exactly the sort of educated person the publishers needed to guide *Once a Week*, which was intended to rival the high quality of Dickens's literary journal, *All the Year Round*. Having invested in a pictorial magazine to outdo the 'blindness' of Dickens's paper, they wanted someone who could manipulate the illustrations as well as the text, establishing the magazine as a market-leader in the provision of quality designs. Respected as a critic of art and literature, Lucas was an effective choice.

Only constrained by the publishers, he persuasively took control of *Once a Week's* visual style. This process was partly achieved by acting as Bradbury and Evans's agent, and partly by commissioning new talent. He redeployed the best known artists at *Punch*, and quickly built a fresh portfolio, which included some of the most interesting designers of the time, principally Sandys, Lawless, du Maurier and Millais. Supported by his employers and always making a point of *seeing* to work on their behalf, Lucas assembled a team which was unequalled in the history of illustration. Smith

8 Blaikie, p. 1.
9 Royal A. Gettman, 'Serialization and *Evan Harrington*', *PMLA* (1949), p. 967.
10 Spielmann, p. 85.
11 Stephen Elwell, 'Editors and Social Change', *Innovators and Preachers: the Role of the Editor in Victorian England*, ed. Joel H. Wiener. Westport, Conn: Greenwood Press, 1985, p. 29.

and Hogg may have thought that they had the finest crop, but Lucas's initial set-up is widely regarded as a peerless collection of names.

With this new company in place, he set about shaping their contributions to match his requirements. Looking for the best possible quality, he engaged in a series of tough negotiations. Sometimes regarded as a man of 'genial manners'[12] and admired by many for his 'transparent frankness',[13] his treatment of artists was nevertheless a curious combination of rudeness and guile. He ruthlessly exploited du Maurier, using him to his own advantage, and he was equally dishonest in his dealings with Holman Hunt. Writing to a friend in November of 1861, Hunt puzzles over Lucas's capacity to enthuse over his illustrations for 'Witches and Witchcraft' (1860), but then show no interest whatever when the work was complete. As the artist explains

I did the two or three which appeared at the special solicitation of Lucas, but when they were ready it seemed to me that he was rather disappointed with them and seemed not very anxious to insert them – so I was rather glad to come to an end with the task which I had accepted.[14]

This tactic was part of Lucas's management style. On the face of it, his approach seems disastrous, and yet he was remarkably successful in all that he did, somehow managing to enlist and maintain a stable of designers who should have deserted the magazine as soon as they were paid. By turns emollient and tyrannical, supportive and downright insulting, he still managed to improve the quality of his artists' work, extracting illustrations which worthily reflected their talent. More importantly, he exerted a heavy influence on the magazine's aesthetics. He regulated the publishers' insistence on maintaining a 'genteel standard',[15] and he laid equal stress on the twin issues of 'realism' and the correspondence of image and text.

Lucas was centrally concerned with verisimilitude and 'copying from nature'. In his literary reviews he reviles the 'obscure' and 'artificial', placing the highest value on 'facts' and 'nature',[16] and the same emphasis can be traced in his criticism of art. What Lucas most admired was a Pre-Raphaelite exactitude and 'truthfulness', and the illustrations of *Once a Week* closely reflect this orientation. The editor pressurised his artists into replicating Pre-Raphaelite 'realism', and it is noticeable that 'his' illustrations are far more detailed than those appearing in *Good Words* or *The Cornhill*. Indeed, some

12 'Samuel Lucas', *DNB*, 12, Oxford: OUP, 1936, p. 242.
13 *The Life and Letters of Charles Samuel Keene*, ed. G. S. Layard. London: Sampson Low, 1892, p. 443.
14 Reproduced in Judith Bronkhurst, *William Holman Hunt: a Catalogue Raisonné*. 2 vols. New Haven: Yale University Press, 2006, 1, p. 275.
15 Elwell, p. 29.
16 '*Scenes of Clerical Life*', *The Times*, 2 January 1858, p. 9.

57. Sandys, 'The Old Chartist'. *Once a Week*, 8 February 1862, p. 183.
Engraved by the Dalziels. Image taken from *Reproductions of Woodcuts by F. Sandys*.

of them are an exact embodiment of his belief in the precise registration of
visual phenomena. Sandys's 'The Old Chartist' (fig. 57) is a prime example
of Pre-Raphaelite clutter, with every object seen with equal clarity, and so is
'Rosamund' (fig. 21), a material image which stresses the 'thingness' of
objects, and clearly recalls the visual detail of paintings so typical of Holman
Hunt and Millais. Other illustrations reflect Lucas's belief in a realism which
is both 'domestic and homely', combining scenes of everyday life with close
observation of 'facts'. In Lawless's design for 'My Angel's Visit' (fig. 58), for
example, the artist adheres to the editor's pursuit of the 'truth' of 'nature' by
showing an everyday scene in sharp detail. The figures in the foreground are
described accurately and the background is seen in equal focus as a scratchy
combination of grass, crows, cattle and far-off buildings. In du Maurier's
'Eleanor's Victory' (fig. 59), the artist similarly stresses the here and now, no-
tably in the form of a plaid shawl, and the same direct observation informs
the closely realised interiors of Keene's 'Evan Harrington' (1860).

Working to the editor's agenda, the artists of *Once a Week* convert the
magazine into a Pre-Raphaelite journal, essentially a much more effective

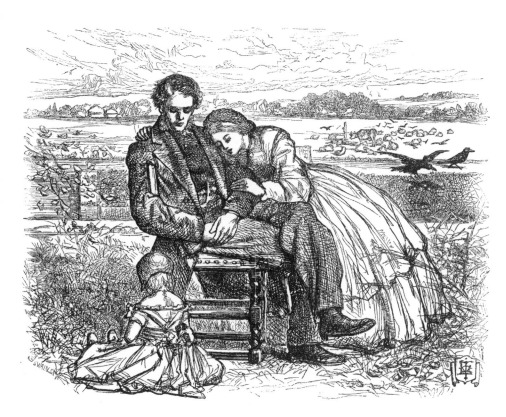

58. Lawless, 'My Angel's Visit'.
Once a Week, 8 December 1860, p. 658.
Engraved by Swain.

realisation of the Pre-Raphaelites' ideals than their own periodical, *The Germ*
(1850). They gave the editor what he wanted, and there was no room for
negotiation. When du Maurier presented work which Lucas considered
insufficiently 'real', he simply turned it down, rejecting his illustration for
Whymper's 'From my Window' because he regarded the artist's represen-
tation of the girl's muslim dress to be insufficiently detailed.[17] The drawing
was eventually done by Sandys (fig. 60), and this time Lucas approved its
meticulous representation of material 'truth'. Insisting on mimesis and the
avoidance of poor drawing, Lucas made specific demands and was often a
hard taskmaster.

 He was equally forthright in his emphasis on the correspondence be-
tween a written text and its illustration. As far as he was concerned, illustra-
tion should be a faithful mirror, a graphic representation which re-affirmed
the content of the words. This notion reflects a broader aesthetic, but
Lucas was inspired by the critical belief that the pairing of image and word,

17 Leonée Ormond, *George du Maurier*. London: Routledge, 1969, p. 126.

59. du Maurier, 'Eleanor's Victory'.
Once a Week, 25 June 1863, p. 127.
Engraved by Swain.

60. Sandys, 'From my Window'.
Once a Week, 24 August 1861, p. 238.
Engraved by Swain.

so commonplace in mid-Victorian culture, was in need of improvement. The general situation, he believed, was quite poor, and the main culprits were the artists. As he explains in a *Times* review of 24 December, 1858,

The artists in a very large number of instances give the least possible thought and attention to the text. It is really extraordinary to what an extent they can mistake or contradict the meaning of the author confided to them …[18]

The mismatch of text and illustration was more common, Lucas insists, than readers would suspect. He found incompatibility in even the most celebrated of illustrated texts, the 'Moxon Tennyson'. 'In this volume', he says, the artists are especially 'reprobate', and frequently fail to observe the 'conception of the author'.[19] Clearly, Lucas had little patience with Rossettian self-expression, and artistic independence was precisely the approach he *absolutely did not* want to encourage in *Once a Week*. On the contrary, he insisted that his artists should work hard to create visual equivalents of the texts entrusted to them; in contrast to Smith, who aimed to facilitate effective illustration through a process of pairing in which there was a general compatibility of vision, Lucas believed it was the artist's responsibility, as a servant of the author and his text, to create whatever visual effects were required. What is more, he expected the artist to be able to respond to the text *as* a text, and without any contact with the writer. As far as he was concerned, such relationships were irrelevant: he did not forbid them, but he did his best to keep the illustrator under his control, rather than an author's. Indeed, working for Lucas meant exactly that: all the artist had to do was illustrate according to his editor's belief in the role of illustration.

This approach emphasised the designers' status as secondary creators, discouraging any assertion of material at odds with the text, or any creative *frisson* that might be generated by working with the writer. In Lucas's view, illustrators were craftspeople, interpreters whose individuality should be suppressed in favour of their role as a type of medium, discovering each text anew and offering a 'telling representation' or 'translation' of the author's 'spirit'.[20] In the words of Lucas's most insightful critic, William E. Buckler, he

suggested that the drawing should follow the text so closely that if the letterpress were entirely withdrawn, the reader would be able to guess the intended subject of the illustration …[21]

The formulation seems straightforward, but is more difficult to pin down than one might think. On a fundamental level, it meant repeating the

18 'Illustrated Books', *The Times*, 24 December 1858, p. 10.
19 ibid.
20 'More Gift Books', *The Times*, 2 January 1865, p. 12.
21 '*Once a Week* under Samuel Lucas', *PMLA*, 67 (1952), p. 929.

61. Tenniel, 'The Silver Cord'.
Once a Week, 8 December 1860, p. 645.
Engraved by Swain.

author's descriptive information in a visual medium. That project encompasses details of setting, situation, narrative, objects and portraits: if the writer mentions an item, place, person or event, the illustrator has to show it. This instruction was conveyed by Lucas to all of his collaborators, and there is no doubt that *Once a Week* shows a remarkable accord between the texts' physical *mise-en-scène* and their visual representation. Tenniel's designs for Shirley Brooks's 'The Silver Cord' (1861) are good examples, replicating the author's intense field of details with a literal exactitude. His mirroring is exemplified by the illustration of the sea-crossing (fig. 61). This comic image recreates the crowded deck, the peering travellers, the shawls, the campbed and, most tellingly of all, Mrs. Lygon, snootily sitting in second-class but as far away as possible from other passengers. Predicated on the need to tell a story in a visual form, Tenniel faithfully responds to the author's details, achieving exactly the sort of correspondence the editor was looking for. Lucas reviled Maclise for misrepresenting the 'Excalibur scene' in the 'Moxon Tennyson', but Tenniel, among others, was a true servant of his text.

However, this approach was only part of the equation. At a much deeper level, Lucas expected his artists to represent the author's 'spirit' in the sense

62. Millais, 'On the Water'.
Once a Week, 23 July 1859, p. 70.
Engraved by the Dalziels.

of somehow visualising the writing's tone, aura or ambience, which he describes as its 'characteristic effects'.[22] Unfortunately, his credo gives no clue as to how this should be done, and, faced with an undeniably complicated task, most illustrators took the opportunity to construct their own artistic space, interpreting the editor's directives in a creative way. Constrained by the need to replicate details of character and narrative, Lucas's illustrators offer a series of idiosyncratic responses which preserve the editor's demands for 'accord',[23] but are highly imaginative as well; working within the framework of his instructions, many of his artists managed to negotiate precisely the sort of independence Lucas discouraged, but which was necessary to make sense of the commission. It is one thing to insist on the faithful representation of a hat or a face, yet the editor's emphasis on tone necessarily implies (and demands) a higher level of artistic endeavour. Sandys, du Maurier, Lawless, Keene and many of the *Once a Week* artists moved up to this new position, and Millais, especially, offered a paradigm of the 'negotiated image' in his illustrations for a series of poems. In his design for the anonymous 'On the Water' (fig. 62), Millais complies with his employer's insistence on copying by recreating the 'drooping branches' of ivy and lilies, but also manages to recreate a sense of the poem's dreamy yearning. The subtle movements of light, ripples,

22 'Modern English Caricature', *The Times*, 2 January 1863, p. 8.
23 'More Gift Books', p. 12.

63. du Maurier, 'The Notting Hill Mystery',
Once a Week, 29 November 1862, p. 617.
Engraved by Swain.

'drooping hair' and 'softest accents'[24] are visualised in the form of languorous rhythms which link the parts of the composition, and the emphasis of the illustration, as in the poem, is on a still reverie, a weighted moment of accord. The repetition of the sibilants in the fourth stanza is elegantly re-visualised by the recurring lines of the enclosing bower, and that enclosure is itself a lyrical representation of the lovers' sense of ecstatic yearning, 'on the water'. The illustration is, in this sense, precisely the sort of tonal responsiveness the editor required. According to Allan Life, who writes convincingly of Millais's 'literary interpretation', the image preserves an exact 'stylistic appropriateness',[25] allowing the artist to create a poetic image, a visual echo rather than a simple re-telling of the poem's catalogue of things. Faithful to the text in the external as well as the internal sense of the term, Millais's design is a measured artistic response to Lucas's insistence on creating an apt 'translation'. Such calculated fidelity is developed throughout the illustrations of *Once a Week*,

24 'On the Water', *Once a Week*, 23 July 1859, p. 70.
25 'The Periodical Illustrations of John Everett Millais and Their Literary Interpretation', *Victorian Periodicals Newsletter*, 9:2, June 1976, p. 52.

many of which are highly imaginative readings of the poems they re-visualise.

The editor's approach to the showing of text is also tellingly exemplified in the form of illustrated serials. He was fortunate in being able to draw on the talents of two outstandingly versatile artists: du Maurier, who interpreted Braddon's 'Eleanor's Victory' (1863) and Felix's 'The Notting Hill Mystery'(1862); and Keene, the illustrator of Reade's 'A Good Fight' (1859), Meredith's 'Evan Harrington' (1860) and Wood's 'Verner's Pride' (1862–63). Both provide faithful visual texts which mirror the external details of their narratives as well as their 'spirit'. Pressed in by the need to picture the author's 'meanings' – though never being allowed to discuss those meanings by consulting the writer who made them – they resist conventional responses and visit each novel anew. In practice, they epitomise Lucas's demand that illustration should be driven forward by the subject and idiom of the letterpress, in each case adopting distinctive styles which register the texts' uniqueness.

Du Maurier complies with Lucas's insistence on visual 'accord' by focusing on the 'characteristic effects' of Felix's detective fiction, 'The Notting Hill Mystery'. Sometimes (inaccurately) described as the first of the genre, but still obsessively collected as one of the earliest examples of its type, Felix's text is re-visualised by du Maurier as a staccato montage of dramatic events. The narrative is episodic, violent, moving between climactic events, and the illustrations underscore the nature of the text by offering a series of melodramatic tableaux. The story's rapid movement is similarly registered in the composition of individual designs, with many images employing a series of harsh diagonals to stress movement and uncertainty (fig. 63). 'The Notting Hill Mystery' is a restless, visceral, breathless event, a head-long rush into improbability and surprise events, and each of these qualities is materialised in du Maurier's harsh jumble of designs.

He takes a more measured approach in his response to 'Eleanor's Victory' (1863). Aiming to find a new 'translation', he focuses on the novel's physical texture, its emphasis on melodramatic extremes, and its characterisation. In keeping with Lucas's general requirement that illustration should stress the 'real', du Maurier highlights Braddon's representation of the contemporary world. He emphasises the physical details of place and dress, so registering the text's journalistic immediacy. Its presence as a 'true' account of what 'actually' happened is notably embodied in his angled compositions, which 'open' one side of the design to the picture-plane, inviting the reader/viewer to enter the scene as if it were an extension of a real space. Thus, when Richard inspects Lancelot's portfolio, the design admits the reader into the informal setting of the studio (fig. 7). This dynamic treatment constantly reaffirms the story's immediacy, fusing its weirdness with the prosaic world of the middle-class reader, who is shown exactly the sort of scene he or she could see every day. The illustrations are equally effective in preserving the text's emphasis

III

64. du Maurier, 'Eleanor's Victory'.
Once a Week, 8 August 1863, p. 183.
Engraved by Swain.

on the melodramatic, literally recreating the many occasions when the characters register their emotions by adopting a theatrical pose. Braddon makes a link between the sensational novel and the stage, moving her characters into elaborate tableaux as if they were actors strutting the boards, and the illustrations do the same. The artist's emphasis on these tableaux helps to clarify the text's convulsive narrative, converting its turgid excess, its heavy overloading with supplementary details, into a clear montage. Du Maurier would certainly have been aware of Lucas's dislike of 'doubt and perplexity',[26] and his illustrations preserve the text's mysterious tone while minimizing its sense of narrative superfluity. But the artist is most sensitive as an interpreter of character. Braddon creates distinctive personae in the form of striking visual types, and so does du Maurier. More importantly, he grasps the heart of the author's 'message' by representing the characters' psychological complexities. Eleanor's emotional condition is starkly portrayed, echoing and expanding her progress from naïve immaturity to vengefulness, and finally to mature acceptance and willingness to forgive. This is partly represented by her changing face, and it is also shown by changing her stature. In Braddon's novel, Eleanor is at first powerless and has to learn how to dominate. In the illustrations, likewise, she progresses from physical compliance to restless movement, a process exemplified by the difference between the scene in the studio (fig. 7) and the dynamic figure who strides out in the nocturnal garden (fig. 64).

2

Sensitive to this sort of nuance, du Maurier registers the essentials of 'Eleanor's Victory', while pointing to its paradoxical fusion of extremes. The novel is a combination of realism and theatricality, psychological analysis and quick-flowing narrative, and the same mix informs the designs. Lucas disliked sensationalism, with its emphasis on artificiality and exaggeration, but du Maurier's designs refigure the novel in a form that the editor must have endorsed. Of course, 'Eleanor's Victory' was produced at a time when the artist was trying to establish himself at *Once a Week*, and his faithful interpretation of Lucas's guidance reflects a genuine desire, driven forward by economic necessity, to work, as he puts it, in 'harness'.[27] Such willingness earned further commissions, and made him into one of the editor's favourites.

Another 'signature' artist, and the name most associated with *Once a Week's* serial illustration, was Charles Keene. Reassigned from the existing pool of talent at *Punch*, Keene believed that 'a man who draws anything could draw everything'.[28] If du Maurier was versatile, then Keene, a cheerful bohemian with no fixed ideas on how to approach his commissions, had an even greater

26 'The Newcomes', *The Times*, 20 August 1855, p. 5.
27 'The Illustrating of Books from the Serious Artist's Point of View', *The Magazine of Art*, 1890, p. 374.
28 Joseph Pennell, *The Work of Charles Keene*. London: Fisher Unwin, 1897.

65, 66. Keene, 'A Good Fight'.
Once a Week, 3 & 17 September 1859, p. 191 & 231.
Engraved by Swain.

range. His capacity to change modes, adapting his style and technique to fit the text, made him an ideal artist to respond to Lucas's requirements, and his two primary commissions, for Reade and Meredith, show how much he was guided by his editor's insistence on a faithful reading of narrative, tone and *mise-en-scène*.

His response to Reade's 'A Good Fight', the original version of *The Cloister and the Hearth* (July-October 1859), is an ingenious visualisation which neatly matches with the novel's content and ambience. A main focus is narrative. He depicts the key episodes and stresses the rapid pace by emphasising movement. Gerard, Catherine, Margaret and the other characters are constantly on the move, and he underscores the text's breathlessness by showing them in a constant state of flux, peering from windows, embracing and turning, leaving and entering. Keene is equally effective in representing the characters' febrile range of emotions. Reade places them in dangerous situations, compelling them to respond with anxiety and fear, and the artist recreates and interprets the author's emphasis on psychological extremes. Thus, in the illustration of Gerard and Margaret fleeing through the wood, he effectively visualises Reade's terse style in a sketchy composition, produced, it seems, on the run. Pressed by 'unforeseen danger' as they run to 'gain the wood',[29] the characters are depicted in a fluid rhythm of moving figures, complete with a starkly telling representation of Margaret's nervous face as she looks back (fig. 65). Such images underscore the author's emphasis on adventure, surprise and rapid transitions, yet the visual interpretation goes well beyond the process of underlining. Its particular strength lies in its evocation of an imagined medieval past, a mirror of the text's historicism. Reade describes costumes and settings, and Keene catches the aura of times past by giving them a vivid pictorial form (which was based, it was reputed, on studies in the British Museum). He goes even further in his offering of a visual equivalent to match Reade's florid prose. The author invokes the archaic diction and lexis of medieval Flanders, and Keene recreates the effect by casting his illustrations in the form of neo-medieval woodcuts (fig. 66). His use of this idiom was regarded at the time as a bold response, and later Victorian critics such as Walter Crane were impressed by his invoking of the 'decorative effect of the old German woodcut'.[30] Responding to a piece of antiquarianism, Keene was 'careful', as Joseph Pennell remarks, to give his response a 'medieval character'.[31] What we can say is that Keene approached the commission in a spirit of flexibility, subordinating his approach, in the manner specified by Lucas, to the particular demands of the tale.

29 'A Good Fight', *Once a Week*, 3 September 1859, p. 191.
30 *The Work of Charles Keene*, p. 20.
31 ibid, p. 21.

67. Keene, 'Evan Harrington'.
Once a Week, 1 September 1860, p. 253.
Engraved by Swain.

Aiming always to comply with Lucas's demands for a 'powerful translation', he adopts a completely different slant in his work for 'Evan Harrington' (1860). The style this time is brusquely modern; Meredith's tale is one of contemporary ambition and class, with a strong emphasis on the life of the everyday, and Keene stresses its topicality by recreating the everyday details of top hats and crinolines, young swells and eligible spinsters (figs. 67, 68), comic grotesques and other details of the mid-Victorian setting. Meredith satirically charts the manners and customs of the middle-classes as he explores Evan's struggle to escape his humble origins, and Keene shows numerous moments in which the trappings of class etiquette are humorously depicted, usually through the medium of facial expressions and telling gestures. His treatment is typified by the moment when Jack, Laxley, Evan and Rose are brought together in an embarrassing *contretemps*. Jack and Laxley fight in the street, while Rose and Evan delicately spoon, glancing into each other's eyes as they gently hold hands (fig. 67). At once a showing of the middle-class in love, the illustration symbolises Meredith's focus on the limits of respectability and the relationship between manners and desire. By turns journalistic and tender, Keene's designs are an apt visual equivalent to Meredith's sometimes confusing tale of frustrated love and the limitations of class.

As so often in the development of Sixties illustration, they make the novel seem far more engaging than it really is. Forrest Reid, for one, was wildly enthusiastic, describing the designs as 'equal to any that were made for a novel'.[32] His judgement is hyperbole, although there is no doubt of Keene's capacity to approach his commissions in a novel way, producing work which was 'always fresh'.[33] There is a marked contrast between interpretations of Reade and Meredith, and a further contrast between each of these series and his response to 'Verner's Pride'. Like du Maurier, Keene preserves a strong sense of the individuality of the source material, and it is interesting to consider how each of the authors responded to their interpretations. Although she was not supposed to liaise with the artist, Braddon wrote to du Maurier expressing her approval; Meredith indicated his pleasure; and only Reade, the most exacting of critics, who hated any form of collaboration, was dissatisfied and insulted the publishers.

Lucas's view can only be surmised, although he must have recognised how well the artists had tried to find equivalents to their texts, offering designs which are always in 'accord'. Controlled by Lucas's aesthetics, du Maurier and Keene are faithful to their texts, satisfying their editor by making sure that they never betray the 'meaning of the author' as 'confided in them'.

32 *Illustrators of the Eighteen Sixties*, p. 123.
33 Derek Hudson, *Charles Keene*. London: Pleiades Books, 1947, p. 32.

68. Keene, 'Evan Harrington'.
Once a Week, 28 July 1860, p. 113.
Engraved by Swain.

The same can be said of almost all of the illustrative material in *Once a Week*. To a remarkable degree, the images serve their texts, giving an overall sense of harmony that is unrivalled in the Sixties magazine. Indeed, Lucas was a significant influence on the development of Sixties illustration *as* illustration, and a prime influence on the development of the illustrated journal. Terse, inventive and single-minded, he pioneered the *idea* of the Sixties magazine as an 'illustrated miscellany' of pictures and words, so providing an exemplar for *Good Words*, *The Cornhill* and all subsequent journals. He also promoted a model of working, of compelling the artist to respond in specific ways. Presenting *Once a week* as a magazine in which the illustrators were expected to comply with his aesthetic ideas, he imposed his will while at the same time allowing – or not understanding – the ways in which artists refocused his demands, accommodating his requirements yet simultaneously suiting their own stylistic, thematic and tonal concerns. The artists were constrained by the publishers' demands and, at *Once a Week*, *Good Words*, *The Sunday Magazine* and perhaps elsewhere, they were forced to work to their editors' requirements as well. Dominated by strong personalities, they still found the space in which to breathe.

CHAPTER FOUR

Publisher, Author and Artist

Lucas emphasised the solitariness of the artist's task, compelling the designer to engage directly with the text while remaining aloof from the writer's influence. He genuinely believed that his approach created a sort of purity and several authors were persuaded, albeit reluctantly, to agree. The essayist Harriet Martineau was sceptical of Lucas's strategy, and wanted to get in touch with Millais, who illustrated several of her pieces; when she saw the work, however, she was delighted with the freshness of his insightful approach. Speaking of his vibrant designs for the 'Historiettes' (*Once a Week*, 1863), she writes of the power of viewing her text from a fresh perspective, essentially the 'new sensation', the 'seeing of my own personages and incidents presented through his mind'.[1] Otherwise suspicious of *Once a Week's* editor and his interfering 'hints',[2] she had to concede the effectiveness of putting Millais on the spot (fig. 69).

But Lucas's strategy was unique. Smith's approach, in complete contrast, was to *encourage* the partnership of writer and artist. In his opinion, the collaboration of illustrator and author was the central event, the prime effort on which effective illustration, most notably for the serial novel, was based. There was, of course, strong evidence for the value of this sort of partnership. Ainsworth had worked with Cruikshank; Dickens had formed strong working relationships with Cruikshank and Phiz; and Thackeray had collaborated, in stormy liaison, with Doyle. These writers and artists created a dynamic fusion of image and word, and Smith's project was to recapture some of the excellence of the thirties and forties by allowing *his* writers and artists to work in similar circumstances. His specific aim was to rekindle the intensity of the illustrated text as it appeared in parts or in the columns of the magazines. Dickens and Thackeray had published their novels as free-standing instalments, with letterpress and a couple of illustrations, and Smith wanted his journal to reproduce exactly the same sort of 'dual text'. In *The Cornhill Magazine*, as in the work of Dickens and Thackeray, the writer and the artist were to be drawn together, creating a symbiotic blend of writing and design. Smith's strategy, to create this effect, was bold but simple. Looking always for compatible talent, the publisher united a number of writers and artists whose vision and stylistic concerns were roughly equivalent

1 Vera Wheatley, *The Life and Work of Harriet Martineau*. London: Secker & Warburg, 1957, p. 371.
2 *The Collected Letters of Harriet Martineau*, ed. Deborah Anna Logan. 5 vols. London: Pickering & Chatto, 2007, vol. 4, p. 236.

120

FOUR:

PUBLISHER,

AUTHOR

AND

ARTIST

69. Millais, 'Son Christopher'.
Once a Week, 14 November 1863, p. 575.
Engraved by Swain.

to each other, and whose approach to the work made it possible for them to enter into a close working partnership. Goldman has remarked that the 'collaboration' of writer and artist was 'hardly a common occurrence at the time',[3] but consideration of *The Cornhill* serials shows that most of them were produced as the result of some form of consultation, few being created – as they were at *Once a Week* – with no liaison at all.

What is more interesting, of course, is the nature of these working relationships. Created anew, *The Cornhill's* partnerships were still traditional, and can be understood as versions of the earlier model. In previous decades, the arrangement was part of a continuum: at one end were power relationships in which the writer dominated the artist, and at the other a greater equality and sharing. The same can be said of the Sixties, and there are marked similarities between these later collaborations and those in earlier periods. In some cases the artist had minimal influence, and in others he was treated as an equal; however, all of these pairings were subject to some sort of struggle. Borne down by the presence of the author, the creator of the source-

3 *Victorian Illustration*, p. 210.

material, the illustrator was forced to compete for ownership, control, or sometimes nothing more than a reasonable share in the process of creating the dual text. Smith may have envisaged his magazine as a sort of Parnassus in which writers and artists produced their work in creative harmony, but the reality was always a complex mix of agreement, accord, coercion, disagreement, criticism and disappointment. *The Cornhill* designers had to battle to assert themselves, and their illustrations were always produced under the creative pressure of working with a series of demanding authors. As in their relationships with publishers and editors, they were compelled to negotiate the spaces in which to operate, arriving at their designs through a process of rivalry and accommodation.

Surprisingly, this process rarely resulted in artistic failure. On the contrary, the creative *frisson* led to the production of a series of rich and complicated texts, fusions and interactions of image and word, literal illustration and interpretive design. This dynamic competition can be traced throughout *The Cornhill's* serials. Millais's dealings with Trollope, and Walker's with Anne Thackeray Ritchie are interesting examples. But the illustrator's struggle to create his response is exemplified by three sets of collaborations: Reade and Barnes, who worked on 'Put Yourself in His Place' (*The Cornhill Magazine*, 1869–70); Thackeray and Walker, the artist and illustrator of 'Philip' (1861–62); and Eliot and Leighton, partners at work on 'Romola' (1862–63). These productions encompass some of the extremes of the author – artist relationship, and epitomise the latter's strategies for imposing some form of interpretive control.

121

FOUR:
PUBLISHER,
AUTHOR
AND
ARTIST

The Illustrator and the Domineering Writer:
 Reade, Barnes and 'Put Yourself in His Place'

The inequality of designer and writer was underpinned by the Victorians' belief in the supremacy of the author. Contemporary criticism bracketed art and literature as equivalent forms, but in practice the illustrator was usually placed in a subservient role. Lucas's approach stressed the designer's secondary place, and other theorists made similar claims. The illustrator's task, so Dickens argued in a famous *All the Year Round* essay of 1867, was only ever a matter of confirming whatever had already been created. In Boz's blunt terms, the artist should do no more than 'put the more remarkable scenes' as 'described by the author, before the reader's eyes'.[4] More significantly, Dickens believed that the only way to achieve that accord was by a process in which the artist took direct instruction from the author. In his own work,

4 [Charles Dickens], 'Book Illustration'. *All the Year Round*, 10 August 1867, p. 151.

70. Small, 'Griffith Gaunt'.
The Argosy, 3, 1866, facing p. 194.
Engraved by Swain.

Dickens always enjoyed the dominant role, directing, specifying, choosing scenes, modifying some and rejecting others; and his opinions, as the foremost practitioner of the visualised novel, were influential. Several writers of the Sixties emulated his tyrannical stance, and one of them, the Sensationalist Charles Reade, set out to dominate his collaborators by recreating a mirror-image of Dickens's dictatorial approach.

Well known for his belligerent outspokenness, Reade's views on illustration were, if anything, even more extreme than the older novelist's. He did not regard his partners as his creative equals, but saw them as functionaries whose art should promote the author's intentions and provide whatever he specified. This position was forcefully expressed in Reade's loud pronouncements, and his views, articulated at some length in his letters and notebooks, and sometimes at the dinner table, hardened into a credo. What he always wanted was someone who would 'draw in the same key' and never miss the 'point' of the author's intention'; as he explains in a letter to the American publishers, Ticknor and Fields, the illustrator should take 'up the tale' and

re-tell it, re-present it in strict visual equivalence.[5] Such results could only be achieved, so Reade argued, by imposing the strictest forms of authorial control. Yet finding an artist who would comply with such an authoritarian approach was always problematic. Reade quickly developed a reputation for unreasonable behaviour, and he was well known for criticising and in some cases terrorising those whom he accused of disobedience. He bullied Matt Stretch, the American designer at work on *Good Stories*, and he derided Edward Hughes for what he saw as an inaccurate response to 'A Terrible Temptation' (*Cassell's Magazine*, 1871).[6] He was on more equitable terms with William Small, who provided striking illustrations for 'Griffith Gaunt' in *The Argosy* (1865, fig. 70), although there is evidence to suggest a serious falling out with the compliant du Maurier, the interpreter of 'Foul Play' (*Once a Week*, 1868). He even managed to insult Charles Keene, the interpreter of 'A Good Fight', condemning his illustrations as 'paltry',[7] blaming him for the lack of face-to-face consultation, and ignoring the fact that it was Lucas, not Keene, who had made the arrangement.

123

FOUR:

PUBLISHER,

AUTHOR

AND

ARTIST

This antagonistic attitude made the author into a liability, posing a problem which had to be faced by any editor or publisher who wanted his work to be embellished. Lucas had already dealt with Reade, but only at the cost of a lengthy argument, and Smith must have realised the risks. The issue of illustration immediately arose when Smith agreed to publish Reade's rabid novel of romance, working-class life and trades-unionism, 'Put Yourself in His Place' (March 1869–July 1870). This fiction, with all its faults, was a natural choice for extensive visualisation, and the publisher approached the task of finding the 'right artist' with characteristic directness and courage.[8]

Smith's ideal choice was an artist who could represent Reade's cast of working-class characters. The political neutrality of most contemporary illustration meant that he had few candidates, although he probably considered Pinwell and Small, both of whom had recently published examples of social observation, most notably in *The Quiver* (1866–69). Pinwell's image was the usual 'idyllic' blend of poetic stillness and dry commentary (fig. 71); but Small's was much more appropriate. Representing a meeting of industrial workers who are told there is no work for them, this was exactly the sort of hard-hitting approach the publisher was willing to risk (fig. 72). However, his final choice was Robert Barnes. Barnes was selected because he had had

5 Letter to Ticknor & Fields, 2 November 1855. Reproduced in Wayne Burns, *Charles Reade: A Study in Victorian Authorship*. New York: Bookman, 1961, p. 151.
6 Nowell-Smith, p. 94.
7 Pantazzi, p. 44.
8 Information in this section is based on my essay, 'A Forgotten Collaboration of the 1860s: Charles Reade, Robert Barnes and the Illustrations for "Put Yourself in His Place"'. *Dickens Studies Annual*, 30, 2001: 321–342.

THE QUIVER

Saturday, November 10, 1866.

(*Drawn by* G. J. PINWELL.)

"I met her by the yard gate, in her simple working dress."—p. 119.

JUDAS THE TYPE OF SELF-DECEPTION.

BY THE REV. J. B. OWEN, M.A.

THE two apostles of the name of Jude or Judas —for the names are identical—present another instance of duplicates among the Twelve, like the two Simons and the two Jameses. The final act of ingrate perfidy by which the career of Judas was foreclosed, almost shades out of view the uniform baseness by which it seems to have been always preceded. We have no record of

125

FOUR:
PUBLISHER,
AUTHOR
AND
ARTIST

72. Small, ' We Can't Find Work for You'. *The Quiver*, August 1868, p. 697.
Unidentified engraver.

Opposite: 71. Pinwell, 'I Met Her by the Yard Gate'. *The Quiver*, November 1866, p. 113.
Unidentified engraver.

experience of representing the poor – so equipping him, it seemed, with the sort of knowledge that could be applied to Reade's story of class and trades-unionism – and because he had consistently demonstrated both versatility and a willingness to discover each text anew. Most importantly of all, Smith realised that Barnes was malleable. To a large extent, Barnes was an artist-journeyman, a professional willing to adapt his style to the specific requirements of the text and its author. This attitude seemed to make him precisely the sort of talent to provide the writer with the 'right' response, and when Barnes and Reade met for the first time in the early part of 1869 there was a general agreement as to which of them would be the dominant partner.

Reade accepted Barnes's placement on Smith's terms, but immediately asserted his authority.[9] There were several factors in his favour. He had the advantage, first, of being the senior partner, while Barnes, who had thus far only contributed to minor novels such as Wood's 'Oswald Cray' (*Good Words*, 1865), and Greenwood's 'Margaret Denzil's History' (*The Cornhill*, 1864), was relatively unknown (fig. 27). This inequality of status gave Reade a considerable leverage. Unabashed by the prospect of dominating his partner, he undoubtedly stressed their lack of equivalence while at the same time implying that considerable rewards might be available. Reade understood that the underachieving Barnes needed a break, needed to move his career forward. The prospect of being the sole illustrator on a major serial, written by a major novelist, and earning £15 per cut was a considerable coup, and Reade must have pressurised Barnes into realising how a 'successful' collaboration could materially enhance his otherwise limited reputation.[10]

All Barnes had to do was provide the author with whatever he was looking for, and it is not surprising to find that he was extremely co-operative. He collaborated with Reade in a series of face-to-face meetings, and he responded in detail to the author's directions. As in the case of Dickens's instructions for Phiz, these 'notes' involved general guidance as to which elements to emphasise and how some of the characters should be inflected. But Reade's attention was focused on two primary elements at the heart of Barnes's style, both of which could be turned to the service of his text. One was Barnes's capacity to compose his scenes as if they were theatrical tableaux; and the other was his emphasis on 'realism'. These elements are also a central characteristic of Reade's writing, and the author quickly realised he could use Barnes's oxymoronic mixture of 'melodramatic realism'[11] as a means to elucidate his own. Alternating between theatre and simplified 'fact', Barnes's

126

FOUR:

PUBLISHER,

AUTHOR

AND

ARTIST

9 Information contained in a letter from Reade to Smith, 16 January 1869. Smith Elder Archive, NLS.

10 Information contained in George Smith's private notebook, Smith Elder Archive, NLS.

11 Wayne Burns, '*The Cloister and The Hearth*: a Victorian Classic Reconsidered'. *Nineteenth Century Fiction*, 2, 1947–8, p. 76.

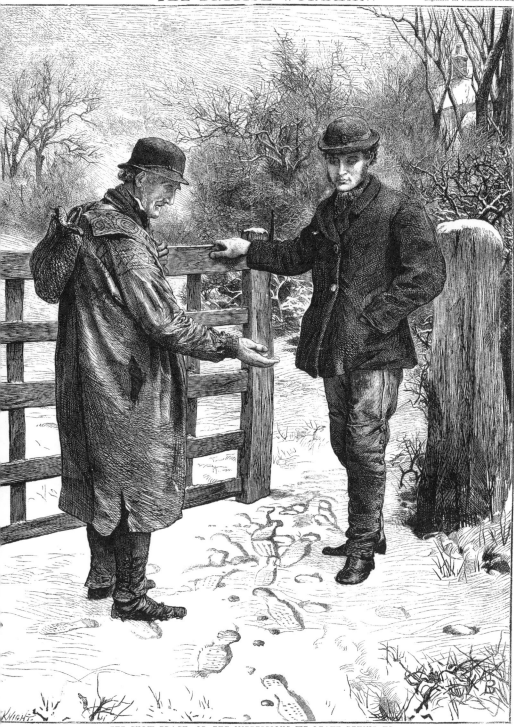

THE SNOW TRACK; OR, THE IMPRESSIONS WE LEAVE BEHIND US.

73. Barnes, 'The Snow Track'.
The British Workman, 1 February 1869, p. 1.
Engraved by Knight. (Reduced to 50%.)

art seems in close equivalence to Reade's. Nevertheless. the match was far from seamless, and Reade insisted on changes in approach which, he reasoned, would help to fit the pictures to his textual requirements.

Barnes had produced several designs in which he explored the notations of theatre, and Reade wanted that aspect of his work to be foregrounded. No correspondence survives, but in his meetings with the artist he must have insisted on Barnes's approaching the text as a dramatist, whose aim was to emphasise its rhetorical business. In Reade's terms, the illustrations should 'present a stage situation', forming a striking 'tableau' which could easily be 'transplanted to the theatre'.[12] Barnes's 'Dreaming Love and Waking Duty' (*London Society*, 1862), is a good example of this sort of theatrical *mise-en-scène*, and Reade wanted the artist to take the process one stage further by showing the characters as if they were *literally* actors, revealing their emotions through the static attitudinizing of melodramatic gesture. This emphasis on 'dramatic power'[13] was crucial to the success of the illustrations, and Reade was careful to highlight the need for theatrical poses in Barnes's response to 'Put Yourself in His Place'. Equally important was the need to illustrate the 'facts' of the humble classes. Barnes's work for *The British Workman* (1869, fig. 73) provided a loose fit with Reade's exploration of trades-unionism, but the main emphasis of his work was rural, not urban, peasant rather than proletariat, pleasing details rather than hard-bitten workplace. Reade's task in this domain was thus a matter of exploiting Barnes's interest and directing it towards a tougher, more journalistic approach, which highlighted a notion of the workers as political activists and troublemakers. To that end he issued Barnes with documents pertaining to the industrial conflict in Sheffield, newspaper cuttings, and his own notes, which were based on seven years' research. A stickler for verisimilitude based on 'diligence and investigation',[14] he wanted the designs to reflect a close observation of the 'facts' of the story, its setting and its milieu. He also took the illustrator on a reconnaissance trip where, on 19 and 20 January 1869, they conducted research by looking at factories and workshops. Of course, this activity was bound to be superficial, although it provided the artist with a visual resource, an opportunity to observe the social milieu and working conditions of the urban poor. Directed to 'cull' the 'Truth',[15] Barnes filled his mind with images of industry, conflict and suffering. This visual frame set him up as the artist of 'Put Yourself in His Place' (figs.74–78).

12 Burns, *Charles Reade*, p. 347.

13 Comments made by Reade, reproduced in M. L. Parrish, *Wilkie Collins and Charles Reade: First Editions Described with Notes*. New York: Burt Franklin, 1968, p. 269.

14 Letter to Ticknor & Fields, 21 July 1855, Huntington Library, San Marino.

15 Letter to Smith, 19 January 1869, Morris L. Parrish Collection, Manuscript Division, Dept. of Rare Books and Special Collections, Princeton University.

128

FOUR:
PUBLISHER,
AUTHOR
AND
ARTIST

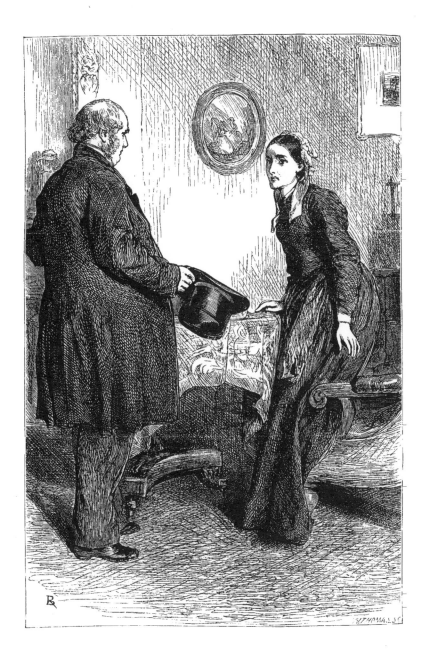

129

FOUR:
PUBLISHER,
AUTHOR
AND
ARTIST

74. Barnes, 'Put Yourself in His Place'.
The Cornhill Magazine, May 1869, facing p. 513.
Engraved by Thomas.

130

FOUR:

PUBLISHER,

AUTHOR

AND

ARTIST

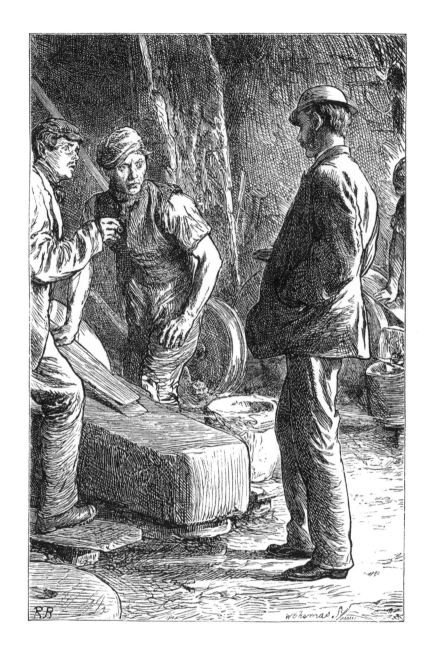

75. Barnes, 'Put Yourself in His Place'.
The Cornhill Magazine, September 1869, facing p. 258.
Engraved by Thomas.

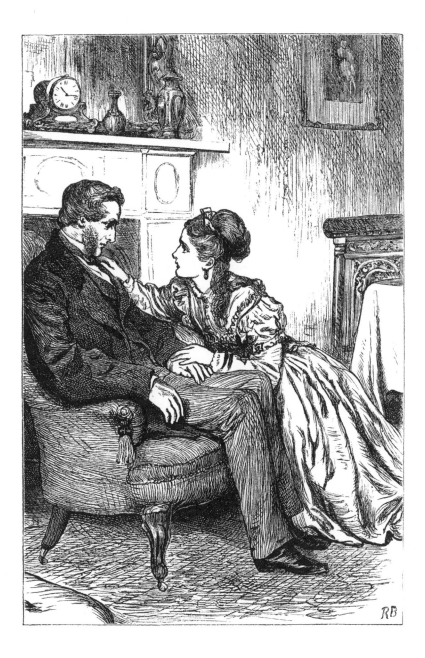

131

FOUR:
PUBLISHER,
AUTHOR
AND
ARTIST

76. Barnes, 'Put Yourself in His Place'.
The Cornhill Magazine, December 1869, facing p. 642.
Engraved by Thomas.

132

FOUR:
PUBLISHER,
AUTHOR
AND
ARTIST

77. Barnes, 'Put Yourself in His Place'.
The Cornhill Magazine, April 1870, facing p. 385.
Engraved by Thomas.

Prepared in detail by the author's briefings, Barnes's approach to the commission was rigorously professional. He was required to unite melodrama and social realism, and this is precisely what he managed to do. He foregrounds the writer's interest in melodramatic gesture by showing the characters as thespians who move in a series of stage-like spaces and, at moments of great emotional intensity, freeze into gestural tableaux. He particularly stresses moments of conflict and recoil, when Little, Grace, the Doctor and others are forced to respond to a moment of surprise or an unexpected meeting. This visualisation crystallises the directions in the texts, materialising the characters' emotions by showing their poses with absolute precision. Thus, when Mrs Little and Dr Amboyne meet anew, the artist highlights their feelings of surprise by visualising a classic 'start', a moment of melodramatic recoil in which the characters stare at each others' faces while the doctor raises his hands and Mrs. Little begins to raise hers. Representing a climax of 'astonishment',[16] the illustration underscores the text's focus on melodramatic excess (fig. 74). Equally distinctive is the emotionalised conflict between Henry and his tormentors. In the confrontation between Henry, Tucker and Simmonds, the artist shows the two workmen in frozen attitudes of surprise and hostility, with glaring faces (fig. 75). The sufferings of Grace are likewise a matter of theatrical display. These images respond to numerous textual directions, visualising the character-actor's turmoil in a series of veritable show-stoppers. When she thinks she has lost her father's approval, for example, she is shown kneeling in front of Carden in a gesture of pleading (fig. 76), an exact match to the author's description of her 'imploring'[17] eyes. Grace's despair on losing Henry (or thinking she had lost him) is also conveyed, in a series of visual equivalents to the gestures in the novel, through the attitudes of drooping (fig. 77), hiding her face with her forearm, and couch-bound prostration. Attitudinising wherever she can, Barnes's Grace is the material embodiment of the actor inscribed in Reade's text, a visual sign of her theatricality.

Yet, at the same time, and in close compliance with his instructions, Barnes frames his theatre in a rigorous observation of Readian 'facts'. Remembering what he saw in Sheffield, where he did studies and sketches, he is careful to reproduce the novel's urban milieu. This is partly visualised in the form of tangible exteriors – a good example being the crowded yard outside Cheetham's workshop when the bomb goes off – but it is clinched by the replication of the workshops' interiors. Developing the author's spare descriptions, Barnes treats these rooms as catalogues of things, dense Pre-Raphaelite spaces containing all sorts of industrial gear, from grindstone and gearing to treadles and tools. His strategy is focused in the scene showing Grace collapsing in Henry's workshop. The illustration registers the melodramatic gestures, yet

16 'Put Yourself in His Place'. *The Cornhill Magazine*, May 1869, p. 520.
17 ibid, December 1869, p. 658.

133

FOUR:

PUBLISHER,

AUTHOR

AND

ARTIST

134

FOUR:

PUBLISHER,

AUTHOR

AND

ARTIST

78. Barnes, 'Put Yourself in His Place'.
The Cornhill Magazine, August 1869, facing p. 129.
Engraved by Thomas.

gives equal emphasis to the 'white heat'[18] of the forge, the tools placed on its rim, the smoke, the anvil in the background and the bellows (fig. 78).

This working-class imagery intensifies the reader's experience of the text, focusing the mind's eye on passionate events taking place in material settings. At once theatrical and journalistic, they reaffirm the novel's combination, in the words of contemporary reviewers, of 'dramatic positions' and 'naturalness',[19] 'startling incidents' and 'forcible description'.[20] Never less than 'bold', they stress the idea of the text as propaganda, helping to make Reade's novel into a 'great sensation' which, if John Coleman is to be believed, ultimately led to the author being the subject of a series of death-threats, which were allegedly sent by infuriated trades-unionists.[21] This inflammatory effect was what Reade the firebrand was looking for, and he realised that Barnes had helped him to create a genuinely 'sensational' effect. In contrast to his dissatisfaction with almost all of his other sets of illustrations, the author proclaimed himself 'satisfied' with the artist and with the 'spirit' of his designs.

In Reade's own terms, his domination of the illustrator had worked: aiming to control, he had specified the visual emphases and made sure, through the process of checking the proofs, that Barnes complied. What is surprising, perhaps, is the fact that Barnes never entered into *any explicit* disagreement with his senior partner. He wanted to please and he wanted to co-operate; meekly compliant, his approach shows none of the tensions that normally characterise such unbalanced relationships. Most remarkable is the fact that Barnes never opposed Reade's stereotypical writing of the working classes. Given his own humble background – as the son of a shoe-maker and an illiterate mother – we might have expected some sort of negotiation of this aspect of the tale. His other work, notably *Pictures of English Life*, is highly sympathetic to the poor (fig. 79), and yet he is willingly drawn into Reade's lurid territory of melodramatic excess, caricature and class insults. That said, he is not entirely reduced to the level of an efficient translator. Offered only limited space for manoeuvre, he still managed to find ways in which to impose a more personal interpretation.

At several points Reade only required him to produce a visual representation of interiors and conversations, but it is here, in the familiar ground of genre, that Barnes makes his mark. Focusing on Henry's middle-class lifestyle, Barnes infuses a note of still reflection and psychological depth into what is otherwise a driven narrative, with little characterisation. Perhaps the best example of this contribution is his treatment of 'Honest Work' (fig. 80). The scene represents Grace's attempts to carve a head in profile, under Henry's

135

FOUR:
PUBLISHER,
AUTHOR
AND
ARTIST

18 ibid, August 1869, p. 150.
19 'Put Yourself in His Place'. *The Examiner*, 11 June 1870, p. 373.
20 'Put Yourself in His Place'. *The Saturday Review*, 11 June 1870, p. 778.
21 *Charles Reade*. London: Treherne, 1903, p. 321.

136

FOUR:

PUBLISHER,

AUTHOR

AND

ARTIST

79. Barnes, 'Fireside Joy'.
Pictures of English Life. London: Sampson Low, 1865. (Reduced to 45%.)

tender supervision. Unusually, it does not correspond exactly with any single
passage in the text, but conflates two episodes. What it does do, however, is
inject a sensitive awareness of human feeling; presenting the characters in a
telling interchange of looks that includes Henry's concerned gaze and Grace's
shy attentiveness, it takes the reader far beyond the scope of Reade's writing,
and convinces us of the validity of their romance. Dickens hated what he saw
as the Sixties tendency to illustrate 'pictures about nothing', but it is precisely
this reflectiveness that enhances the source-material, allowing the illustrator
to find a small space in which to take control of his material. Even Reade had
to admit that 'Honest Work' added another dimension to his work. Initially
annoyed at what was obviously disobedience, he concedes to Smith (though
not, tellingly, to Barnes), that his artist has done well, introducing a new
emphasis and adding to the novel's emotional effect. 'Mr B', Reade says, has
'very happily' made changes.[22] Such liberalism would not have been accepted,
one expects, if the illustrator had not otherwise worked in the most unequal
of partnerships, giving Reade exactly what he required.

22 Letter to Smith, 16 February 1869. Smith Elder Archive. Trustees of the National Library of
Scotland.

137

FOUR:
PUBLISHER,
AUTHOR
AND
ARTIST

80. Barnes, 'Honest Work', 'Put Yourself in His Place'.
The Cornhill Magazine, March 1869, facing p. 257.
Engraved by Thomas.

138

FOUR:

PUBLISHER,

AUTHOR

AND

ARTIST

The Struggle for Control: Trollope, Millais, Thackeray and Walker

The illustrations for 'Put Yourself in His Place' are quite unlike anything else in Barnes's *oeuvre*, a fact that strongly suggests the author's overpowering influence. Described by Goldman as 'important' and 'sustained',[23] they reflect the dynamics of an asymmetrical relationship in which the artist's creative personality is kept in check by the impact of the author's instructions. Such compliance characterises many collaborations of the period, though others were harsh and turbulent, only existing, in the words of Sybille Pantazzi, as a convulsive combination of 'rivalry', competition, and 'uneasy marriage'.[24]

A combative model is provided by Trollope's relationship with Millais. Usually regarded as a harmonious sharing of image and word, this partnership was more unsettled than one might expect, particularly in the formative period of the early Sixties. The protagonist was Trollope, who, despite his later praise for Millais, was initially dissatisfied with his artist's response; disliked the freedom Smith had given to his collaborator; and wanted to impose a more direct control. The most problematic of the dual texts was their first collaboration, 'Framley Parsonage' (*The Cornhill*, April 1860–March 1861). Millais worked on his own, and Trollope was horrified when he witnessed what he believed to be an absolute contradiction of the nature of his text. He took a marked exception to Millais's famous design of 'Was it not a Lie?' (fig. 13), which shows Lucy lying on the bed, her face and figure overwhelmed by the curious abstract patterns of a vast crinoline dress. The scene, so Trollope wrote angrily to Smith, is 'simply ludicrous … a burlesque … as might do for *Punch*'. He goes on to criticise the 'execution' and completes his comments by remarking on the poorness of the design as illustration: 'Even the face does not at all tell the story, for she seems to be sleeping'.[25] Millais's response was silence, and he was probably never told of the author's contempt. The episode is emblematic, nevertheless, of the on-going struggle to impose control, with the author having one notion of how his text should look, and the illustrator having another.

Of course, Millais's status gave him a power few artists possessed. When 'Framley Parsonage' was published, the main attraction was the illustrator's designs, rather than Trollope's writing, and the author realised he could only proceed so far. Far bloodier battles were fought between authors and artists who, unlike Barnes, were completely unwilling to accept an inferior status. These collaborations were personal struggles, charged and sometimes acrimonious affairs in which the illustrators took instruction from the author, but still exerted their own influence on how the material should look.

23 *Victorian Illustration*, p. 138.
24 Pantazzi, p. 39.
25 Reproduced in N. John Hall, *Trollope and His Illustrators*. London: Macmillan, 1980, p. 15.

Perhaps the best example of this struggle for control is the collaboration of Thackeray and Walker, the joint producers of 'The Adventures of Philip' (*The Cornhill Magazine*, May 1861 – August 1862). The partnership of these two figures provides an interesting case-study of the process of change: each attempts to determine the shape, content and form of the illustrations; responsibility is passed from one to the other; disagreements arise; threats are made and retracted. The end result is nevertheless a sort of dynamic sharing, in which the artistic beneficiary is both the author (who gets far more than he envisaged) and the text (which is serviced by a series of highly imaginative and insightful designs).

In the first instance, however, the relationship of writer and artist was entirely asymmetrical. Thackeray was tired of drawing on wood, and needed someone who could improve his designs by re-composing them on the block. A good technician was required, and Smith came up with one in the form of the inexperienced Walker, who was looking for work and, at this point in his career, would accept even the smallest opportunity. In the words of Smith:

On one occasion I saw a young gentleman, quitting the outer office, whose appearance attracted by attention; I enquired who he was, and was told by the clerk ... that he was a young artist of the name of Walker, who wished to draw for *The Cornhill* ... When Mr. Walker paid another visit, and I saw his drawings, it occurred to me that here was the artist who would redraw Mr. Thackeray's designs satisfactorily ...[26]

The intention, in other words, was to employ Walker as a sort of amanuensis, a functionary whose task was to legitimise Thackeray's amateurish designs, but to take no part in the creative process of interpretation. This menial status was the central characteristic of the job and Walker was absolutely required to remain within its narrow bounds. He had no creative input, and was treated by the author with a sort of genteel contempt. Used to illustrating for himself – a process exemplified by his designs for *Vanity Fair* (1847) and *Pendennis* (1849–50) – Thackeray was bored with the notion of collaboration, and offered only the barest instructions as to what he wanted to be done. In his directions for his first 'improvement', he simply required an enhancement of his original drawing of 'The Old Fogies' (January 1861):

Can you copy the face on this block as accurately as may be to another block, improve the drawing of the figures, furniture and make me a presentable design for wood engraving?[27]

Clearly, there is no room for manoeuvre in these instructions. Walker was not supposed to re-model or rearrange the composition, only to make it 'presentable'. And this is exactly what he did: working from Thackeray's

139

FOUR:
PUBLISHER,
AUTHOR
AND
ARTIST

26 Leonard Huxley, *The House of Smith Elder*. London: 1923, pp. 141–2.
27 *The Letters and Private Papers of W. M. Thackeray*, 4, pp. 219–20.

140

FOUR:
PUBLISHER,
AUTHOR
AND
ARTIST

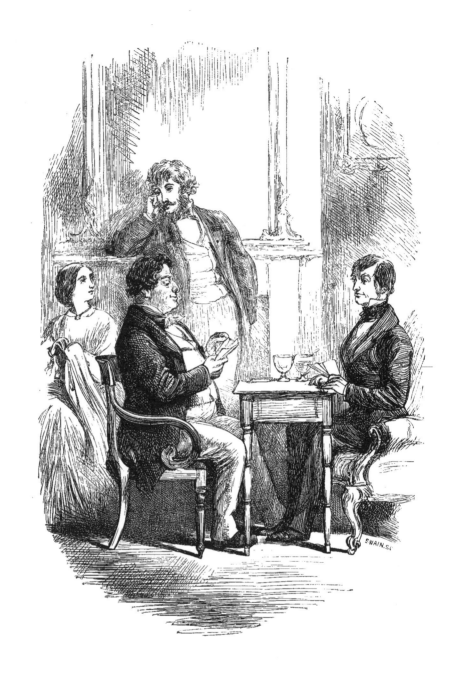

81. Walker after Thackeray, 'The Old Fogies',
'Philip', *The Cornhill Magazine*, March 1861, facing p. 270.
Engraved by Swain.

amusing but stilted design, he recasts the image, making it far more fluent than its original (fig. 81). The result is still strangely synthetic, a sort of sophisticated reworking of Thackeray's caricature, which seems neither of the forties – when the author's visual style was formed – nor of the Sixties. It improves on the author's original, but is informed with a strong sense of aesthetic strain; it pleased Thackeray, who wrote in February 1861 of his 'satisfaction',[28] but it was far from pleasing to the ambitious Walker.

Troubled by his status and dissatisfied by what has to be viewed as a botch-job, Walker demanded a better arrangement, 'dug in his heels', demanded he was treated as a 'proper' illustrator, and insisted on being the images' sole originator. Thackeray's response was an interesting one. Without demur, he accepted the need for Walker to produce his illustrations for himself; bearing in mind his incapacity to draw on wood, he was probably relieved at the prospect of not being required to draw at all. But he was not willing to cede any further artistic control, insisting that Walker should still respond to his suggestions. This may have seemed a reasonable accommodation, one granted by a senior figure to a newcomer; however, Walker did not understand the *extent* to which Thackeray would try to control his contributions. In practice, Thackeray had no intention of allowing him to originate his designs by making his own interpretation, or even to choose his own scenes. The work was still to be supervised, just as the writer had directed Doyle's illustrations to *The Newcomes* (1854–55), by issuing written instructions and, occasionally, by offering his own rough sketches. Freed to make his own drawings, Walker's status as an illustrator remained ambiguous, constrained by the author's hand: he could illustrate in his own style, though he was never trusted with the subject, the focus of the design or its composition. Thackeray wanted to separate Walker the draughtsman from Walker the illustrator, and surviving letters demonstrate how the artist's bold demands did not secure the freedom he craved.

Nevertheless, Walker found ways of satisfying Thackeray while developing his own interpretive approach. Essentially this was a matter of complying with his instructions while asserting his own individuality, usually by slightly changing or expanding the emphasis. Such calculated misreading allowed him to accommodate the author's requirements, and, at the same time, find his own focus of interest. A good example of this duality is provided by the illustration of 'The Good Samaritans' (fig. 82). The image was carefully specified as showing 'three or four children … Mr. P. round face, no moustache; Mrs. Pendennis making breakfast … Pendennis reading newspaper. Philip just come into breakfast room'.[29] This is what Walker represents. Yet he adds other dimensions too: Philip's uneasiness is powerfully conveyed by his

28 ibid, p. 222.
29 ibid, p. 239.

141

FOUR:

PUBLISHER,

AUTHOR

AND

ARTIST

142

FOUR:
PUBLISHER,
AUTHOR
AND
ARTIST

82. Walker, 'Good Samaritans', 'Philip'.
The Cornhill Magazine, July 1861, facing p. 2.
Engraved by Swain.

143

FOUR:
PUBLISHER,
AUTHOR
AND
ARTIST

83. Walker, 'A Quarrel', 'Philip'.
The Cornhill Magazine, October 1861, facing p. 385.
Engraved by Swain.

144

FOUR:

PUBLISHER,

AUTHOR

AND

ARTIST

84. Thackeray, 'A Quarrel'.
Pen and ink image taken from
The Letters and Private Papers of W. M. Thackeray, 4, p. 245.

awkward position, knees together; Mrs. Pendennis looks away, as if embarrassed; and Pendennis glances up from a tousled paper, his facial expression one of concern for his friend's misfortunate as a 'ruined man'. Thackeray wanted him to illustrate the scene in the author's style as a melodramatic tableau, but the artist explores its mental and emotional interest, focusing on its role as a terrible moment of uncertainty. Indeed, Walker's approach to 'Philip' is generally one in which he preserves its many set scenes, as specified by the author, but foregrounds its sometimes submerged emphasis on suffering and psychological complexity. This process is typified by his design for 'A Quarrel' (fig. 83). Thackeray insisted on the melodramatic nature of this scene, and issued the artist with a rough sketch of the characters' confrontation (fig. 84). In Walker's image, however, the focus is psychological rather than theatrical: Philip does not put on his hat, or make a bow; instead, he backs into the door, holding his topper defensively in front of him as he looks anxiously at his accuser. The scene is certainly dynamic – particularly Ringwood's aggressive movement out of the chair, with one fist clenched – but the illustration stresses Philip's 'meek' and embarrassed response. Thackeray wanted it to be a piece of stage-business; Walker, by contrast, re-figures it as a key stage in Philip's mental and emotional development.

This interest in harsh experience is territory the artist claims for himself. Paradoxically, he subverts or accommodates the story-teller's instructions with the sole aim of obeying the larger demands of his story; Thackeray tells Walker what to show, yet the illustrator offers an interpretation which stresses the novel's interiority and underplays its drama. 'Philip' is the story of a mental journey, and Walker provides an interesting and provocative visualisation that extends its central messages. This approach has serious implications, in other words, for the ways in which the novel can be read. At the time of production, the illustrations had the effect of modernising Thackeray's old-fashioned writing, taking it out of the domain of the social humour of the forties and fifties and referencing it to the psychological concerns of the mid-nineteenth century. Bold, original and full of the life of the times, Walker's designs function as ideal representations of a 'modern novel', the very modernity admired by Burne-Jones and the Pre-Raphaelites. Marcus Stone updated Dickens's *Our Mutual Friend* (1865) by stripping away the anachronistic designs of Phiz, and Walker does the same for Thackeray by replacing his cartoons with images of depth and feeling.

This situation also had serious implications for the sharing of control. 'Philip' was produced, as we have seen, as the work of an asymmetrical relationship, with the artist very much in the role of the inferior. However, no-one reads Thackeray's tale any more, except as a means of inspecting its still, resonant, melancholy images. Power may have been Thackeray's, though it was ultimately passed to the artist.

145

FOUR:
PUBLISHER,
AUTHOR
AND
ARTIST

85. Walker, 'The Village on the Cliff'.
The Cornhill Magazine, July 1866, facing p. 1.
Engraved by Swain.

A More Equal Relationship: Walker, Thackeray Ritchie, Leighton and Eliot

Walker's tough stance demonstrated the value of resistance, of insisting on the artist's right to illustrate as he saw fit. In no subsequent commission would he be placed at such a disadvantage, and his later work was characterised by a more equal sharing between himself and his author. This new arrangement was exemplified by his collaboration with Thackeray's daughter, Anne Thackeray Ritchie.

Walker illustrated two of her novels: 'The Story of Elizabeth', which appeared in *The Cornhill* from September 1862 to January 1863, and 'The Village on the Cliff' (July 1866–January 1867). Both were produced on the basis of sharing. The artist and writer met regularly, discussed ideas, decided on the choice of subjects and how the figures should be arranged, considered possibilities, and negotiated the final designs. Sometimes the illustrator responded to the text, or to the wishes of the author; and sometimes he made the decisions himself. This process is enshrined in their surviving

correspondence, now in the National Library of Scotland, which details a complex interaction of idea and counter-idea, creative disagreement, checking, compliance and negotiation. The end result, however, is always productive, an intricate fusion of image and word, written text and visualisation.

Walker excels in representing Thackeray Ritchie's small world of domestic incidents. In the opening illustration of 'The Village on the Cliff', for instance, he sets the author's tone by showing the main figures in a middle-class setting, surrounded by busy children (fig. 85). Designed to establish the place and its emotional tenor, the image acts as a sort of portal, a gateway to the novelistic world that lies within. He shows the same sensitivity in his depiction of character. Having negotiated with the author and established her expectations, he creates a series of convincing types, visual embodiments of Thackeray Ritchie's ordinary cast, which can be read interchangeably with her descriptions. The fusion of image and word is so complete that it is sometimes impossible to differentiate between the two. Thackeray Ritchie was certainly pleased, claiming that the figures in the illustrations were perfect, 'so completely everything that I hoped and imagined' that 'I have always thought that *he* wrote the book and not I'.[30]

This process of mirroring and embodiment is perhaps the ultimate test of the quality of the working partnership, giving rise to a dual text that somehow creates the characters in two minds, rather than one. Trollope notes precisely this effect when he writes in his *Autobiography* of the way in which his characters were 'impressed indelibly on my memory by the excellence [of Millais's] delineations',[31] and the same can be said of du Maurier, whose visualisations of Braddon and Reade are far more effective and memorable than the writing in which the ideas originate. What is always needed, of course, is a creative sharing, a collaboration of equals. Walker and Thackeray Ritchie are good examples, and there are several other partnerships in which the author and artist are genuinely united.

The outstanding collaboration of the Sixties was undoubtedly that of George Eliot and Frederic Leighton. Brought together by Smith, who employed them, in the manner of superstars, to boost sales, Eliot and Leighton produced a distinguished dual text in the form of their historical novel of the Italian Renaissance, 'Romola' (*Cornhill Magazine*, July 1862 – August 1863). This text was the result of a willingness to share. The artist and writer were both intensely competitive, but their partnership was figured, as Richard Ormond explains, as a 'polite battle of wills'[32] in which each struggled for dominance, and finally arrived at a sort of equilibrium. The illustrations were the product, in short, of creative pressures that were accommodated

147

FOUR:

PUBLISHER,

AUTHOR

AND

ARTIST

30 Henrietta Garrett, *Anny: a Life of Anne Thackeray Ritchie*. London: Pimlico, 2000, p. 81.
31 *Autobiography*, 1, p. 199.
32 *Lord Leighton*. New Haven: Yale University Press, 1975, p. 58.

by the artist, who in turn influenced the author's writing and the author's demands. This sort of collaboration can be explained in detail by exploring the nature of their professional relationship, its tensions, its requirements and its impact on the finished designs.

Unlike the collaborations of Reade and Barnes, and Walker and Thackeray, the partnership of Eliot and Leighton was based on a professional *equivalence*. Their status was roughly at the same level: Leighton was the emerging star of the Royal Academy, a reputation based on *Cimabue's Celebrated Madonna is Carried in Procession Through the Streets of Florence* (1853–55, The National Gallery, London); and Eliot was the author of *Scenes of Clerical Life* (1858) and *The Mill on the Floss* (1860). Both were emerging talents; both were concerned with their careers; and neither wanted to frustrate any further advancement. Handsomely paid by the indulgent Smith, who offered Eliot a staggering £10,000 and Leighton an equally impressive £480, it was in their joint interest to present a unified front.

These conditions set the partnership on an equal footing, but it had the specific effect, it can be argued, of suppressing the author's influence. As noted earlier, Reade bullied Barnes because of a difference in status, and Thackeray treated the upstart Walker as a regrettable necessity. However, Eliot realised that working with Leighton was never going to be the same as working with a technician. On the contrary, it could only be a privilege that would raise the kudos of her novel by associating it and her with one of the outstanding artists of the time. As G. H. Lewes remarks, as if he were speaking for his wife, Leighton was 'by far the *best* man to be had in England'.[33] Matched with a major talent, Eliot respected Leighton's standing, and her approach to the collaboration was far more measured, say, than Reade's coercion of Barnes. From the beginning of their partnership she accepted she would not occupy the dominant role, demanding a passive response to instructions. However, she did try to impose her will, adopting a strategy in which she attempted to direct Leighton's efforts by engaging in a sort of aesthetic debate about the relative virtues of literature and illustration. Never doubting the quality of his work, she still argued for the primacy of the written word, insisting, in the September of 1862,

I am quite convinced that illustrations can only form a sort of overture to the text. The artist who uses the pencil must otherwise be tormented to misery by the deficiencies or requirements of the one who uses the pen, and the writer, on the other hand, must die of impossible expectations.[34]

33 Letter from G. H. Lewes to Charles Lee Lewes, 21 May 1862. *The George Eliot Letters*. London: OUP, 1956, 4, p. 36.
34 Mrs. Russell Barrington. *The Life, Letters and Work of Frederick Leighton*, 2 vols. London: Allen, 1906, 2, p. 99.

148

FOUR:
PUBLISHER,
AUTHOR
AND
ARTIST

149

FOUR:
PUBLISHER,
AUTHOR
AND
ARTIST

86. Leighton, 'The Blind Scholar and His Daughter', 'Romola'.
The Cornhill Magazine, July 1862, facing p. 1.
Engraved by Linton.

This critique undermines the idea that illustration could be an equal to the text, consigning it to the status of decorative 'overture', while at the same time implying its shortcomings as a mode of expression, compelled, despite its failures, to respond to the writer or the writing's requirements. It is probably an 'impossibility', she says, to create a 'perfect correspondence' between her 'intention' and the designs.[35] Such comments appear to have been made to persuade – or goad – Leighton into producing a mirror-image of the text, and there are several occasions when she questioned the accuracy of his representations, trying to get him to picture her writing as if it were no more than a set of unambiguous details. Leighton visualized the first number with no immediate assistance, and Eliot's response was a sharp one. Analysing 'The Blind Scholar and His Daughter' (fig. 86), she focuses on perceived errors of representation, criticising the artist for what she saw as infelicities in pose, portraiture and arrangement:

I should have wished Bardo's head to be raised with the chin thrust forward a little … and turned a little towards Romola, 'as if he were looking at her'. Romola's attitude is perfect … Her face and hair, though deliciously beautiful are not just the thing – how could they be? I meant the hair to fall forward from behind the ears over the neck and the dress to be without ornament..[36]

These comments are offered in the guise of helpful guidance, with the intention, perhaps, of encouraging what she saw as a more focused approach to subsequent designs. Yet her remarks are ultimately no more than polite dissent: unlike Thackeray and Reade, she was not able to direct his choice of scenes (although she attempted to); she did not have the power of veto (a privilege reserved for Smith); and could not instruct him to make any significant changes.

In any case, Leighton was made of sterner material than many of his contemporaries. Eliot may have tried to manipulate his response by issuing instructions, or through the medium (as she euphemistically puts it) of a 'little conversation',[37] but the artist was only willing to collaborate on his own terms. Indeed, Leighton's agenda was markedly different from his author's. Eliot thought of illustration as subsidiary, an 'overture' to the text, while Leighton viewed the equation the other way around. As far as he was concerned, the story offered an opportunity to produce some interpretive designs, just as the narratives of his paintings were merely a starting point. His emphasis, as he explains in a letter to George Smith (20 October 1862), was on providing small compositions which worthily expressed their

150

FOUR:

PUBLISHER,

AUTHOR

AND

ARTIST

35 ibid, p. 96.
36 ibid, p. 97.
37 ibid, p. 96.

subject matter and preserved the 'subtle shades of expression,'[38] missing the complexities normally required from painting in oils. With that idea in mind, he willingly consulted with the author; politely took her views into account; though only responded to ideas that he considered to be worthwhile, and were consistent with the writing itself. Eliot tried to impose her will; Leighton, by contrast, heard what he wanted to hear, and rejected what he saw as an extraneous agenda.

His resistance had the desired effect, and, as the partnership progressed, Eliot came to realise that her collaborator could never be bullied. By the September of 1862 she had accepted that he would do as he wished, a realisation embodied in her comments on the impossibility of drawing Baldassarre.[39] Leighton does not represent him the way she wishes, but her theorising about the problems of visualisation is surely a coded acknowledgement of her inability to force any change. She realised at this point that Leighton would respond to sensible suggestions, would not and could not make changes which were outside the scope of his art, and would never accept what he considered to be irrelevant.

She also accepted that, if Leighton would not respond to her instructions, she might respond to his, or at least to some of his, opinions. Remarkably, Leighton's role changed from that of an interpreter to one of an adviser. Given the writer's proofs a month in advance of their publication, he had time to apply his considerable understanding of literature, Italian history and culture. He almost certainly advised her on aspects of Italian language. Appointed, at least in part, because he had lived in Florence and was familiar with an Italian milieu, his knowledge of the novel's cultural setting was far superior to Eliot's, and she benefited from his first-hand experience of the language as it was currently spoken. It is impossible to say which parts of the novel were revised as the result of his counsel, but it is likely that his 'critical doubts', had some impact on the writing and may have compelled the author to re-write some of her passages of dialogue.

We can be sure that Leighton influenced Eliot, and Eliot influenced Leighton. The production of 'Romola' was in this sense a genuine example of collaborative sharing, of creating a dual text in which the artist and writer were not confined to specific roles. Their contributions fuse into one, and it is not always possible to identify the ownership of each part. On the other hand, Leighton's response to Eliot's text is clearly expressed and unambiguous. Approaching the novel as a major commission, his images can be conceptualised as a dynamic interaction of mirroring and extension, of *illustration* (which reinforces the text), and *interpretation* (which develops it, adds additional material and foregrounds specific elements).

151

FOUR:
PUBLISHER,
AUTHOR
AND
ARTIST

38 Smith Elder Archive, NLS. 39 Barrington, 2, p. 98.

152

FOUR:

PUBLISHER,

AUTHOR

AND

ARTIST

The illustrations are generally faithful to the text, underlining its central messages in the twin domains of setting and characterisation. They are particularly effective as representations of the Florentine setting. Eliot offers intensely worked descriptions of Renaissance décor, and the images materialise and focus her *mise-en-scène*. This effect is partly realised in the form of the initial letters, which map the urban scenes in which most of the action takes place. Placed at the opening of each instalment, the initials provide a vivid representation of the labyrinth of narrow streets, the Piazza della Signoria (fig. 87), the city gate and other parts of the city, at the heart of 'old Florence'. Focusing always on restricted spaces, these cuts reinforce the historical setting, crystallise Eliot's pedantic (and sometimes overworked) descriptions into a tangible form, and insist on the action's claustrophobic smallness. The Renaissance setting is more generally visualized within the two full-page engravings accompanying each part. Several of these are vigorous representations of Florentine streets and interiors, offering what in effect is a carefully realised topography of late medieval Florence. We are presented with a detailed treatment of Tito and Nello's meeting in the marketplace (fig. 88), as well as a vivid scene depicting the plight of 'The Escaped Prisoner' (fig. 89), and an intimate image of 'Tessa at Home' (fig. 90). Each illustration presents a series of historical details which sometimes visualise the descriptions in the text, and sometimes fill in the gaps with detail of their own. Designed to root the story in a specific time, they create an overall impression of authenticity, a journalistic vision of Florentine life at work and play.

Of special importance, as a means of underscoring the text's antiquarianism, is the visualisation of the costumes. Eliot obsessively describes her characters' dress, and Leighton, supporting her text, does the same. The artist follows the cloying descriptions applied to the costumes of the main characters, and further enhances the effect by applying details which he borrowed from Renaissance paintings such as those by Ghirlandaio. Eliot wanted him to offer faithful representations of the *berretta* (a 'close cap', she helpfully tells us), and '*gamurrina*' (a petticoat),[40] and these, and other accessories of a similar kind, are faithfully shown. Following the text wherever he can, Leighton underlines the author's emphasis on historical fact.

He puts an equal emphasis on the writing of character, principally Romola. Eliot disapproved of Leighton's treatment of her heroine, but his visualisation, when one checks the text and ignores the author, is entirely faithful to its source. Working in strict accordance with Eliot's description, he gives a close approximation of her physical presence. The author details her character as:

40 ibid, p. 101.

153

FOUR:
PUBLISHER,
AUTHOR
AND
ARTIST

88. Leighton, 'A Recognition', 'Romola'.
The Cornhill Magazine, August 1862, facing p. 145.
Engraved by Linton.

154

FOUR:

PUBLISHER,

AUTHOR

AND

ARTIST

89. Leighton, 'The Escaped Prisoner', 'Romola'.
The Cornhill Magazine, November 1862, facing p. 577.
Engraved by Linton.

90. Leighton, 'Tessa at Home', 'Romola'.
The Cornhill Magazine, May 1863, facing p. 569.
Engraved by Linton.

A tall maiden of seventeen or eighteen.. The hair was of reddish gold colour, en-
riched by an unbroken small ripple.. It was confined by a black fillet above her small
ears, from which it rippled forward again ...[41]

And the artist offers a parallel sign. Bound by the austere limitations of
black and white, Leighton cannot re-create the effects of colour; neverthe-
less, his illustration manages to suggest a strong sense of luxury and volup-
tuousness (fig. 86). The sentimental portrait of Tessa, a matter of 'baby fea-
tures'[42] and soft looks, is similarly matched in 'Under the Plane Tree' (fig. 91),
and Eliot admired Leighton's Nello as being 'better' (or more completely
realised) than hers.[43] Taken as a whole, Leighton finds apt equivalents to
the written cast of 'Romola' and – as usually happened with the process of
serialisation – the illustrations helped to establish the characters' identities,
allowing the original reader to make connections from one episode in *The
Cornhill Magazine* to the next.

41 'Romola', *The Cornhill Magazine*, July 1862, p. 36.
42 ibid, p. 179.
43 Barrington, 2, p. 97.

156

FOUR:

PUBLISHER,

AUTHOR

AND

ARTIST

91. Leighton, 'Under the Plane Tree', 'Romola'.
The Cornhill Magazine, August 1862, facing p. 184.
Engraved by Linton.

157

FOUR:
PUBLISHER,
AUTHOR
AND
ARTIST

92. Leighton, 'The Visible Madonna', 'Romola'.
The Cornhill Magazine, March 1863, facing p. 281.
Engraved by Linton.

158

FOUR:

PUBLISHER,

AUTHOR

AND

ARTIST

93. Leighton, 'The First Kiss', 'Romola'.
The Cornhill Magazine, September 1862, facing p. 289.
Engraved by Linton.

159

FOUR:
PUBLISHER,
AUTHOR
AND
ARTIST

94. Leighton, 'Coming Home', 'Romola'.
The Cornhill Magazine, December 1862, facing p. 726.
Engraved by Linton.

The illustrator was far more radical, however, in his treatment of narrative and theme, which he re-tells very largely in his own terms. Leighton was centrally concerned with the progression of the story. Working with Eliot's slow narrative, which is weighed down with elaborate tableaux and pages of intricate detail, he transforms Romola's ponderous tale into a fast-moving flow. This effect is achieved by his representation of key moments, and also by stressing the movements of the characters within individual scenes. His approach is typified by 'The Escaped Prisoner' (fig 89), essentially a jumble of movement, and by the tender scene of 'The Visible Madonna' (fig. 92), which shows Romola surrounded by a group of children clutching at her dress. Placing *change* at the forefront of his interpretation, and embodying the idea of movement in the dynamism of his figure-drawing, Leighton privileges the story's interest in transition and flux. He further motivates the narrative by organising his designs into a series of contrasts, compelling the reader to move rapidly through a series of visual juxtapositions. These involve contrasts of interiors and exteriors, public and private spaces, actions and reflections, events and moments of deep feeling. Thus, in the opening sections we move from the private rooms of Romola and her father (fig. 86) to the public setting of the market place (fig. 88); then to the intimacy of Tessa and Tito 'Under the Plane Tree' (fig. 91); and finally to the strained embrace of Tito and Romola, as visualised in 'The First Kiss' (fig. 93). The reader/viewer is directed through a series of visual frames and is compelled, as it were, to scrutinise each link. Presenting the story as a montage of contrasts, Leighton quickens its pace, converts it into a story-board of rapidly unfolding events, which clarifies the narrative, and makes Eliot's over-careful novel seem far racier than it is.

The principle of contrast is similarly used (in a brilliant fusion of story and theme) to visualise what Leighton sees as the fiction's central concern with the dualities of experience. To some extent, this is a matter of emphasising the contrast between sensuality and sexual dysfunction, an issue recently explored in an extended essay by Mark Turner. According to Turner, Leighton creates a sequence of oppositions between Tito's sensual love for Tessa (fig. 91), the painful intensity of the 'First Kiss' (fig. 93), and the cold formality of 'Coming Home' (fig. 94). The contrast, Turner insists, creates an 'unsettling'[44] pattern, a formalised difference between Tito's insensitive treatment of Romola and his passionate love for her rival. This analysis is an insightful discussion of Leighton's visual response and its emphasis on dramatic contrast. But Turner's interpretation, though suggestive, only provides a partial explanation. The artist is more generally concerned, I suggest, with the broad contrasts of unchanging human experience, using his designs to explore a sort of primal juxtaposition between solitariness and the bustle of society,

160

FOUR:

PUBLISHER,

AUTHOR

AND

ARTIST

44 'Drawing Domestic Decline: Leighton's Version of *Romola*'. *Frederic Leighton: Antiquity, Renaissance, Modernity*, eds. Tim Barringer & Elizabeth Prettejohn. New Haven: Yale University Press, 1999, p. 178.

youth and age, vitality and stagnation, vivid life and unchanging death. These polarities are the focus of his interpretation, presenting the novel *not* as a historical fiction, confined to the representation of an imagined past, but as an examination of the fundamentals of life. His approach seems at odds with Eliot's historicism; however, a close reading of the text reveals that he was merely uncovering a submerged element, privileging the author's half-spoken desire to reveal the eternal within the temporal. Looking for some unifying thread, Leighton picks up on a small clue at the end of the first page of Chapter One, where Eliot comments on

The great river courses which have shaped the lives of men … and those other streams, the life-currents that ebb and flow in human hearts, (and which) pulsate to the same great loves and terrors …[45]

That undercurrent recurs throughout the novel, and Leighton makes it the central idea in his montage of contrasts. His notion of changing 'life currents' is exemplified in miniature in the opening design, 'The Blind Scholar and His Daughter' (fig. 86). Disliked by Eliot, the illustration is a true frontispiece, an emblem of the entire sequence in which the artist's reading of the novel's eternal themes is neatly encapsulated. We have an extreme contrast between youth (represented by the vital drawing of Romola), and age (a particularly decrepit looking Bardo). Other signs, not included in the text, point to a parallel alternation between life and death. The inert casts of classical statuary imply both death and timelessness, while a series of accessories exemplifies the contrast between the vital present (symbolised by the tiny flower on the window-sill) and the unchanging, ossified past (the floral decoration on the lectern). Innocence and optimism – suggested by the sun-rays to the rear of Romola's head – are similarly measured against experience (Bardo's scrolls, the open book on the lectern). Adding details of his own, and issuing the engraver with specific instructions designed to preserve the drawing's 'delicacy',[46] Leighton thus creates a dense visual surface, which converts 'Romola' from an over-laden romance into a philosophical treatise, from a representation of a specific period in history into a meditation on history's significance, the power of time and the flow of unchanging events.

The overall effect is one of great sophistication, of pictorial reading that materially expands and enriches the reader/viewer's experience of Eliot's tale. Placed in a collaboration in which the author tried to impose her own, limited views on the role of illustration, Leighton provides a highly imaginative response, one that is true to the spirit of the writing and expresses his own interest (which he later developed on an epic scale) in eternal experience.

45 'Romola', *The Cornhill Magazine*, July 1862, p. 1.
46 Undated letter to Swain. Leighton House, London.

Never entirely appreciated by the author, he offers an 'approximate truth', which transcends the limits of 'perfect correspondence' and creates a dual text, an elegant counterpoint of image and word, of thought and feeling, action and its philosophical implications.

Surprisingly little discussed in modern scholarship, Leighton's illustrations might also be viewed within the broader contexts of Sixties art. Condemned by Reid as 'cold'[47] and lifeless, and by Hugh Witemeyer as 'heedless of the text',[48] his images can be read as some of the most interesting of their time. Produced within a difficult relationship, they exemplify the constraints imposed upon the artist, while simultaneously providing a clear representation of his power to break free. Never one to be taken lightly, Leighton showed how spaces could be made for self-expression. Visually striking and imaginatively linked to their source, his illustrations read as a triumphant assertion of the illustrator's right to interpret, a hard-won status eventually achieved by the down-trodden Walker, and never realised by the subservient Barnes.

162

FOUR:

PUBLISHER,

AUTHOR

AND

ARTIST

47 *Illustrators of the Eighteen Sixties*, p. 207.
48 'Frederic Leighton's Illustrations of *Romola*', Chapter 9 of *George Eliot and the Visual Arts*. Reproduced at www.victorianweb.org see authors/eliot/hw/9.html, p. 12.

CHAPTER FIVE

Artist and Engraver

Previous chapters have examined the impact of the publisher, the editor and the author. Each of these was in a position of power: motivated by a desire to control, they influenced the artists' working patterns and compelled them to respond to a series of exacting requirements. The end result was often one of diversification in which the illustrator demonstrated a striking range of styles and textual responses. This judgement is certainly true of du Maurier, who was highly malleable, and always gave what was demanded of him. His illustrations for *The Cornhill* are different from his work for any other periodical, and there is a marked contrast between the 'fancy' pictures for *London Society* (fig. 31) and his dramatic illustrations of 'Eleanor's Victory' in *Once a Week* (figs. 59, 64). Each reflects a dominant influence: the first embodies Smith's emphasis on draughtsmanship; the second responds to Hogg's demand for an imagery that would dramatise his readership's obsession with wealth; and the third is a version of Lucas's stress on realism. Millais's responses are similarly heterogeneous. His earnest designs for *Good Words* (figs. 46, 47) are quite unlike his illustrations in *The Cornhill*, which reflect the editor's emphasis on good manners (fig. 5), and his images for *The Argosy* seem unconnected to his work for *Once a Week*. Constrained by the instructions of publisher, editor and author, Millais produced the requisite image, and, like du Maurier, would not have remained in work if he had failed to deliver.

That much is true, one might argue, of all Sixties artists. Subject to the influence of flattery, coercion, criticism and financial reward, illustrators were framed by a set of circumstances, which were limiting and, at the same time, liberating, allowing them to develop some of their best work as they struggled to accommodate the varying demands of their partners. The 'look' of Sixties periodicals is the product of these partnerships rather than of the work of artists in isolation, and the end result – as I have demonstrated throughout this study – is a synthesis in which the artist still found room to express his own interpretations. However, the influence of the publisher, editor and author was only a part of the equation.

Equally significant was the contribution of the engravers. These craftsmen were to some extent an extension of the management: they acted as intermediaries for the editor, the publisher and the artist, and were often entrusted with the task of managing production. This position was occasionally taken by Linton, who worked for Thackeray and Smith, and by the

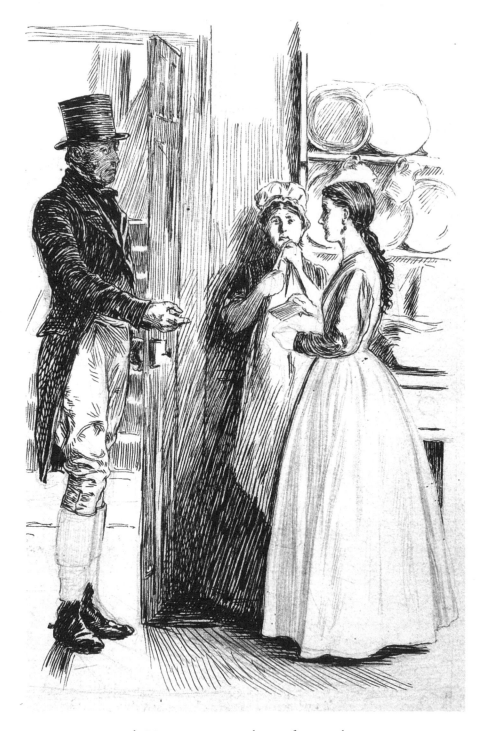

95. du Maurier, preparatory drawing for scene showing
Dr. Gibson and the letter, for Gaskell's 'Wives and Daughters',
The Cornhill Magazine, 1864–65. Pencil on paper. Mounted in an album.
Published September 1864, facing p. 355.
Reproduced with permission of Special Collections, University of Exeter.

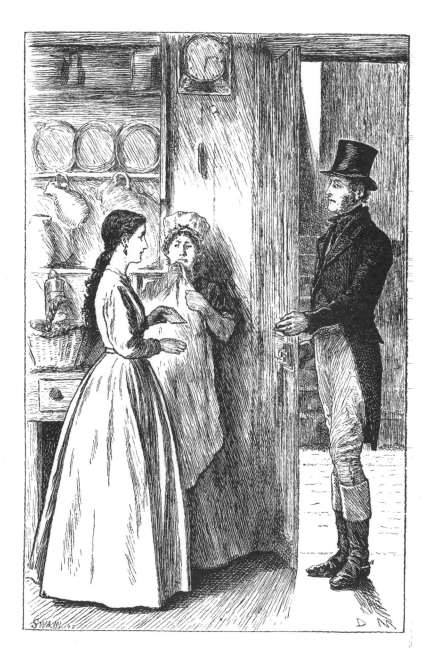

96. du Maurier, 'A Love Letter', 'Wives and Daughters' by Gaskell,
The Cornhill Magazine, September 1864, facing p. 355.
Engraved by Swain.

Dalziels, the executors of Strahan and Macleod. But their primary task was to engrave the artists' designs. Placed in a position of extraordinary power, they were responsible for converting the illustrators' work from its original form (as a drawing on paper) into a graphic representation, which was printed from an engraving cut onto the end-grain of a piece of boxwood.

Several critics have explained this process as a straightforward transfer, a conversion from one medium into another in which the engraver was only a technician, an intermediary with little to do except re-create the original design. In reality, though, the wood-cutter's role was intensely problematic. The prime difficulty was, of course, the relationship between the artist and the engraver. Some artists were collaborative and others, used to working as painters, heartily resented what they saw as the engravers' influence over their work. There was also the problem of the technical process, of converting the drawing into a print that could be mass produced. Taken together, these factors added up to a collaboration that was often fractious, frequently bad-tempered, usually tense, and invariably competitive. Forced to collaborate with the engraver, and resentful of the idea that engravers were interpreters rather than neutral transcribers of an existing work, artists struggled to control their images, and, as they saw it, retain authorship. The outcome, as in all of the artists' relationships, was a matter of negotiation and compromise, of accepting some changes and resisting others. That transaction is extremely complicated, meriting a book in its own right. My focus here is limited to two key issues: the artist's struggle for control as he engages with the process of engraving; and the contribution made by the engraver.

The Technical Process

Several publications have charted the procedures by which a drawing became a print. Geoffrey Wakeman provides a clear outline in his *Victorian Illustration: The Technical Revolution* (1973), and parallel material can be found in Goldman's reading of Millais, and Engen's work on the Pre-Raphaelites. It is useful, nevertheless, to recount the main stages in the scheme of preparation.[1]

Once commissioned, the artist's idea was realised in the form of original drawings, sometimes in a variety of media. Drawn in chalk, pencil or watercolour, these images were often experimental, and there are many survivals which demonstrate the illustrator's application of mind as he struggled to respond to a literary text. Du Maurier was especially conscientious, and

1 John Jackson [and W. A. Chatto], *A Treatise on Wood Engraving*, 1st edn. London: Knight, 1839, pp. 635–738; 2nd edn. London: Bohn, 1861, pp. 561–652. Others include Thomas Gilks's *A Sketch of the Origins and Progress of the Art of Wood Engraving*, London: Myers, 1868.

working scrapbooks at the University of Exeter give a vivid idea of how carefully he approached the work.

Some of the most revealing are preparatory designs for Gaskell's 'Wives and Daughters' (*The Cornhill*, 1864–66). In one of these we see the first version of the opening illustration. Figured as a fine piece of drawing, the study shows that du Maurier experimented with pose and the dynamics of the human form, only arriving at a final solution when he had considered his theme in detail. His emphasis on nuance is further embodied in his image of Dr. Gibson and Molly, illustrating the moment when he demands to see the letter that has been passed to her. The characters are once again vividly realised, but more telling is the way in which the artist has surrounded the central group with studies of heads and hands (fig. 95). Both images are intensely worked and offer a number of visual alternatives. What they unambiguously suggest is high intelligence and careful application, an overwhelming desire to visualise afresh and a desire to produce work that matched the quality of painting. Control was the issue, and du Maurier did his best to create illustrations that accurately embodied his idiosyncratic (and challenging) response to Gaskell's text (fig. 96).

However, as soon as the image was ready to be put on the boxwood, the illustrator began to lose control. The preparatory drawing, so carefully wrought, was invariably coarsened by the process of transfer. This involved making a tracing, or rubbing the lines onto the hard surface of the end-grain, which was prepared using a coat of Chinese White. In both cases, the artist had to correct the design, making it into a facsimile or copy of its original. It also meant that he had to re-draw the detail onto the block: a process which *may* have retained the fine effects of the original, but often lost the subtlety of his first attempt. Constrained by the need to work in hard pencil, with little margin for error and no margin for rubbing out, the artist's transfer was often quite radically different from the finished design as it appeared in his portfolio. Of course, there was a significant diminution of loss when Thomas Bolton invented the photographic transfer (1860), so allowing the original image to be 'caught' on the surface of a sensitised block. We can see this process at work in a photograph of Walker's 'Guy Griffiths' (*The Cornhill*, July 1867), which was printed on the wood before it was engraved (figs. 97, 98), and shows how well the photographic process could preserve the integrity of the original design. But there was no perfect way of converting a drawing into a print. Photography helped, yet artists were compelled to sacrifice aspects of their draughtsmanship that were suited to working on paper or canvas, but *not* to the austere medium of engraving in black and white. The soft modelling and shading associated with drawing had to be replaced with a more linear approach, stressing strong contrasts of light and dark rather than chiaroscuro, and some ambiguities – particularly in the treatment of detail –

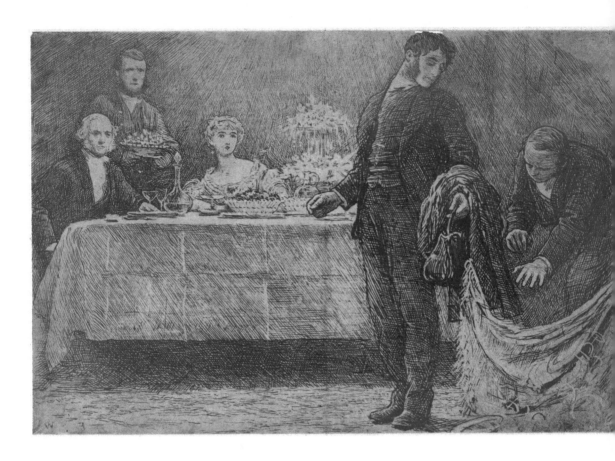

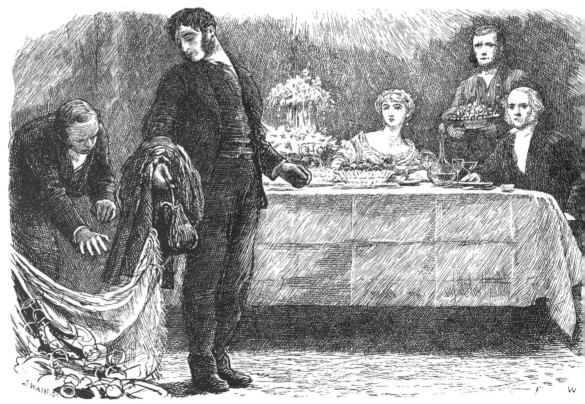

had to be simplified before they could be reduced in scale. Such changes were commonplace and the development of Leighton's 'First Kiss', from 'Romola', is a case in point. Initially conceived as a moody image in white chalk on blue paper, this design (and all of his series) had to be refigured as a bold exercise in linear modelling. Comparison of a photograph of Leighton's original design and the final proof shows how radical the alterations could be (figs. 99, 100),[2] and similar modifications were imposed on the work of every Sixties artist. For instance, Keene's sometimes impressionistic approach was forced to obey the strictures of the wooden block; Sandys reluctantly made a series of compromises; Holman Hunt doggedly complied; and even Millais was compelled to observe the conventions of black and white, eliminating the intense detail of his paintings of the fifties and offering in its stead images of pared-down economy.

These changes had to be made before the block was offered for engraving. Once it was handed over to the engraver, however, the design was subject to many other variables over which the artist had *no control whatever*. It was theoretically straightforward: the engraver (a technician who worked for a master engraver such as Swain) converted the box into a relief by excavating everything except the lines. In practice, however, the artist had to accept the uncertainties of mass production. Described by Walter Crane in his *Artist's Reminiscences* (1907), this process usually meant that the wood was engraved in the glare of gas-light or the dimmer conditions of light reflected through spheres of water.[3] It certainly meant that the image was interpreted by a craftsman paid on piece-work; and it usually involved working to strict deadlines, sometimes until late at night. Pressed in by the need for economy, such practices sometimes led to radical mistakes and always led to some sort of transformation.

Nor could the artist always rely on his design being cut by a single hand, since, after the invention of Charles Wells, in or around 1860, very large designs that were urgently needed might be drawn on jointed blocks, which were then unbolted and engraved separately so as to speed the work, and then rejoined and worked over by a single master engraver. The block shown for Sandys's 'The Sailor's Bride' (1861) was not engraved, but is jointed with the original bolts (figs. 101, 102). Where blocks were split and then engraved in their pieces, they are sometimes marred by the contributions of two or more hands, existing only as the products of a botched collaboration.

So the artist had to accept numerous losses, had to accept the re-interpretation of his image as an industrial artefact, a commodity re-created under the craftsman's hand in a workshop, under pressure of time and with a prime

2 The original chalk drawings for 'Romola' are in the Houghton Library, Harvard University and the Fitzwilliam Museum, Cambridge. The 'transfers' on tracing paper are in the Royal Academy, London.
3 *An Artist's Reminiscences*. London: Methuen, n.d. [1907], p. 48.

Opposite (above): 97. Walker, photograph of the drawing on wood of 'Guy Griffiths'. Sepia print, 1867. Formerly in the collection of George Smith.
Opposite (below): 98. Walker, the same illustration after the process of engraving and electrotyping. *The Cornhill Magazine*, June 1867, facing p. 676. Engraved by Swain.

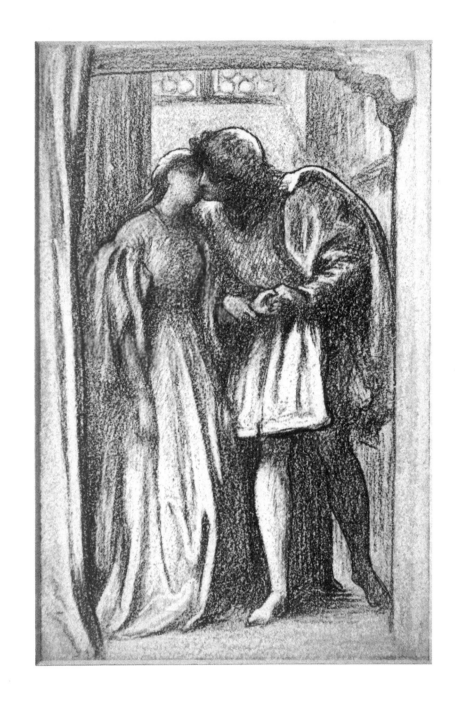

99. Leighton, 'The First Kiss'.
Sepia photography by Jeffery of preparatory drawing in chalk on blue paper.
Formerly in the collection of George Smith.

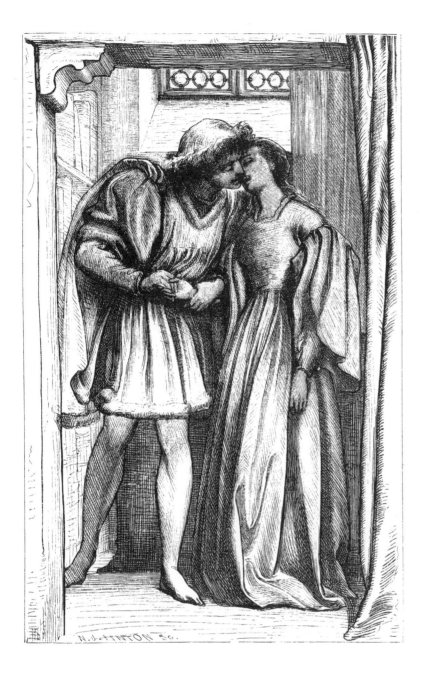

100. Leighton, 'The First Kiss'.
Proof as first printed from the original block in
Eliot, *Romola*, 2 vols. London: Smith Elder, 1880, 1, facing p. 117.
Engraved by Linton.

101. Sandys, 'The Sailor's Bride', 1861. Pencil and ink drawing on two blocks bolted together.
102. View of the rear of the block, showing the bolts holding the two parts together.
The label 'C. Wells/24 Bouverie Street Inventor' is impressed on the side.
A version was finally engraved by Swain, published in *Once a Week*, 13 April 1861, p. 434.
© Birmingham Museums and Art Gallery.

emphasis on achieving a quick turn-around. Some engravers, or 'woodpeckers',[4] as they were known, produced quality work under these circumstances; some were of lesser quality; though most arrived at a mediation of the image, a relief block that could print a reasonable facsimile of its paper original.

Proof impressions were routinely taken, and the artist had the opportunity to suggest corrections and emendations. This might be taken as a final regaining of artistic control, of imposing a degree of manipulation on the image when it reached the end of its transition. However, the artist's approval at this stage was in reality something of an illusion, implying a sort of final quality check when his power, as such, was strictly limited. Practically *none* of the magazine illustrations was printed from the original wood. The artist approved the proof that was made from the block, but the illustrations themselves were printed from metal casts known as electrotypes. The blocks themselves could not withstand the demands of long runs, and might crack under the pressure of the platen power press. The quality of the electrotypes was very close to that of the original wood block, but what the artist could *never* approve was the print taken from the electrotype, when it had been printed in very large numbers on steam power presses, mechanically inked, and imposed heavily enough to allow the type to give as clear an impression as did the electro. This impossibility of any final 'inspection' is startling, especially when one bears in mind that the changes from proof to commercial print are often very marked.

The contrast between the two can be traced in many examples, and the differences are exemplified by juxtaposing the electroype of Leighton's illustration for 'Drifting Away' ('Romola', fig. 103), with the proof, as it was printed in the edition of 1880 (fig. 104). Compared with the fine lines of the proof, the electrotype is a much darker version of the image approved by the artist: more heavily inked, and impressed more deeply, it lacks the delicacy of the proof, the masses of which are lighter and less dense. The artist may have approved the proof, but here, as elsewhere, he was forced to contemplate the intervention of a printing process which almost invariably changed, darkening the qualities of the original.

What we have, in short, is a multi-linked chain, a constant mediation and re-formulation of the image, which takes the studio into the workshop, and converts the artist into an artisan serving others on a factory line. Viewed as an industrial process, the journey from original drawing to print reads as if it were an engineer's report:

Commission for illustration – preparatory drawings and studies – finished design – outlines traced using tracing paper – tracing made onto block – details done directly onto block (or passed to engraver for photographing onto wood) – passed

4 ibid.

to engraver – master engraver delegates work to 'line' and 'tint' men – engravers excavate lines – proof printed – master engraver inspects – handed back to artist (copies given to editor, publisher and author) – comments made by artist (sometimes by other parties) – block revised, or (on extreme examples, entirely re-cut) – final proof passed to artist and sometimes to author and publisher – electrotypes made using voltaic process – post-production checks and cleaning of burr – passed to printer – locked into galleys – printed on steam press … bound into periodical … sent to distributors … sold.

This arrangement was economically viable, the only model by which the magazines' huge demand for illustrations could be satisfied. Mediated through a complicated process, the intimate drawing in the portfolio becomes a mass-media artefact, a piece of industrial design. In the process of transformation, personal utterance becomes public statement.

Working Collaboration of Artists and Engravers: Antagonism and Dissent

These changes could never be neutral, and although the great majority of prints were executed to the highest standards, they were not the same as the unique original. As noted above, some coarsening takes place; some nuance may be lost. Magazine illustrators were well aware of these dangers, although it is interesting to note that none of them comments on the inadequacies of the technique. Having looked at some dozens of manuscript letters, I have failed to find a single comment in which an artist complains about the crudity of the electrotypes, the length of the run – which was bound, ultimately, to produce a darker image – or the limitations of moving from the intimate domain of colour and shade to the tough discipline of the linear 'cut' in black and white. Instead, their criticisms were levelled at the engraver, who, despite being only one element in a complicated process, was always held responsible for the end result. It is human nature to blame a person rather than a machine or a procedure, and the master engravers who supervised the production of Sixties design were frequently the subject of sarcasm and invective.

Artists typically complained that engravers had spoiled their illustrations 'in the cutting'. This notion was practically universal: Leech was frequently dissatisfied with what he regarded as inaccurate reproduction, and so were Leighton, Keene, Holman Hunt, North, Pinwell, Sandys, Selous and Walker. The downright rudeness of some of their comments is surprising, but is best understood not as abuse, as such, but as a genuine sign of frustration and disappointment. The situation is summed up by Rossetti. Rossetti never published in the magazines, yet his comments on the Dalziels' performance, as they interpreted his work for the 'Moxon Tennyson' (1857), is emblematic

Opposite (above): 103. Leighton, 'Drifting Away', 'Romola'. *The Cornhill Magazine*, June 1863, facing p. 682. Engraved by Swain.
Opposite (below): 104. The same image as it appears when printed from the original block in *Romola*, 1880, 2, facing p. 295.

of his contemporaries' stance. As far as he was concerned, the Dalziels had wrecked his designs, reducing them to a level of 'vapid' banality.

I took more pains on one block lately than I had done with anything for a long while. It came back to me on paper the other day, with Dalziel performing his cannibal jig in the corner, and I have really felt like an invalid ever since.[5]

Rossetti's anger and sense of hopelessness were quickly replaced with a counter-measure, a coming to terms with the disappointment by turning the Dalziels' interpretation into a joke, a satire in the form of comic doggerel:

> O woodman spare that block
> O gash not anyhow
> It took ten days by clock,
> I'd fain protect it now.

> Chorus: Wild laughter from Dalziels' Workshop.[6]

Such irony is Rossetti's attempt to re-impose a sense of control, even though the damage had already been done. His strategy is unique, although the need to manage, to exert some form of influence over the engravers and compel them to preserve the essentials of the work, was the nagging concern of all of his fellow-artists. Frequently disappointed with the proofs and the published image, illustrators tried to re-locate the engravers' power, shifting it back into their own domain.

A typical strategy involved the forthright complaint. Publishers were the frequent recipients of disgruntled commentary, and so were the editors. Holman Hunt was especially outspoken, and did his best to influence what he saw as the poor interpretation of his work by *Once a Week's* engraver, Joseph Swain. Writing to Lucas about the cutting of 'At Night' (January 1860), he bitterly remarks on the way in which the engraving has altered the original's effect of 'great tenderness', even changing the 'expression on the face of the woman'. The emotion, or 'aspect', does not 'survive',[7] he believes, and comparison of the print and a photograph of his original design certainly shows some marked differences (figs. 105, 106). In the illustration on paper the wife is far more melancholy than she is in the engraving; her head has been turned more towards the face of the grieving husband, and her lips slightly opened. Working from Hunt's design, the engraver has made his own reading; the printed illustration is little more than a semblance of the original drawing, and the artist, presented with an image which is a *version* of his own, had every right to feel annoyed.

5 Letter to William Allingham, 18 December 1856, *The Correspondence of Dante Gabriel Rossetti*, 4 vols. Ed. William E. Fredeman. Cambridge, Brewer, 2002, 2, p. 146.
6 Letter to William Bell Scott, 7 February 1857. ibid, p. 70.
7 Reproduced in Bronkhurst, 2, p. 103.

105. Holman Hunt, 'At Night'. Photograph of preparatory drawing in *Pre-Raphaelitism
and the Pre-Raphaelite Brotherhood*, 2 vols. London: Macmillan, 1905, 2, p. 147.
106. The published design in *Once a Week*, 21 July 1860, p. 102. Engraved by Swain.

107. Sandys, 'If'.
The Argosy, March 1866, facing p. 336.
Engraved by Swain.

However, nagging the management was of limited effectiveness. A more direct approach was one in which the artist engaged in a dialogue with the engraver. Several illustrators tried this strategy, in each case doing their best to influence the mode of engraving and so retain the highest possible degree of ownership. This approach was adopted by Sandys, notably in his dealings with Swain and the Dalziels. In both cases, the artist adopted an authoritarian stance: frequently belligerent, usually outspoken, and sometimes downright bullying, he made it absolutely clear that the craftsmen were his social inferiors, and that all work must be completed to *his* satisfaction, and not *theirs*. This emphasis characteristically took the form of detailed instructions that left the engravers very little room for manoeuvre. His treatment of his putative collaborators is typified by his dealings with Swain, whose technicians were responsible for several of his designs for *Once a Week* and *The Argosy*. Each of these images was closely supervised by the artist. Speaking of 'If', a design for *The Argosy* (fig. 107), Sandys wrote to the engraver with detailed instructions and the need for 'alterations'. He also specified changes in the cutting of an unidentified design in *Once a Week*, closing the letter by telling the engraver he must 'not do anything till I see you'.[8] Unwilling to allow his partner the right to work unsupervised, he aimed to micromanage every aspect of his interpretation. His treatment of the Dalziels mirrors his dealings with Swain, though he probably accorded them greater respect. Collaborating on the design of 'Until Her Death' (*Good Words*, 1862, fig. 108), his approach is novel. Aiming to flatter the Dalziels by allowing them some participation in the process of artistic creation, he wrote to the brothers with an explanation of his symbolism:

Death holds up a nun's dress, her hood on his head. A bride's dress, wreath and vail [*sic*] is on a chair. She is about to take her choice how she will meet him. But I will write more …[9]

Sandys appears to have believed that explanation of the gravity of the subject would compel the engravers to take it more seriously than a lighter theme, but his initial confidence in their abilities quickly gave way to the usual desire to dominate. A few days after the first letter he wrote again with the aim, one might speculate, of influencing his engravers at the very moment that the cutting was in hand. This time he gave what he believed were specific instructions, with no room for misunderstanding:

I did not write, wishing to hear of the block first … Will you when cutting the sky keep the straight lines in such order as will produce a clear tone of gradated blue heaven, with white clouds on. I was fairly worn out with close working, and

8 Undated letter to Swain in the Pierpont Morgan Library, New York. This is part of a number of letters between Sandys and Swain from the collection of Gordon N. Ray, MA 4500.
9 Quoted in Elzea, p. 216. MS. is in John Rylands Library, Manchester.

108. Sandys, 'Until Her Death'. *Good Words*, 1862, p. 312,
Engraved by the Dalziels.

pressed so much for time . . . Please also keep my lines quite as thick as they are throughout the block . . . The landscape is exact, literal. The view I have is from my house looking from Thorpe across the valley . . . to the village of Trouse. It was drawn on the spot.[10]

The effect is nevertheless confusing. Some of his requirements are straightforward, such as his wish that the thickness of his lines is preserved; others are entirely unreasonable. How could the engravers 'produce a clear tone of gradated blue heaven'? And how could they live up his expectation that the landscape will be 'exact', 'drawn on the spot'? Both judgements are the artist's own, subjective expectation of the effect of his design: the first indicates his thinking in colour, rather than in the black and white demanded by the print, while the second is an entirely poetic, intuitive response to a landscape laden with personal associations. Sandys's requirement seems to be that the engraver should think in colour, as if he were a painter in oils, and re-create the landscape as if it were freighted with the same Romantic associations as his own. Such demands were a tall order and when the proof was delivered

10 ibid.

he was thoroughly disappointed. His response was two-fold: he condemns what he sees, remarking how

It seems to me to have been cut by another hand and spoilt and you afterwards have done your best to make it tolerable. The tower of the church is smoking, nave and chancel lost. Poplars well well!

And then insists on improvements, and a detailed series of alterations:

There is a fold by the black neck band. Either make this very light or cut away. Lighten the hair a little in front, it will relieve the head, also lighten the hollow in the cheek. Show a light also as marked on the belt. It gives shape to the body. A shadow is brought onto the shoulder from the hair. Cut it quite away as marked. I have made some touches on the top of the arm. Near the book at her feet is a small fold which is too dark. Please do all you can to make the landscape a mass. It is now spotty. I put some cattle and sheep in. Where are they now?...[11]

The written corrections were accompanied by sketches, and the proof (now in the Hartley Collection) was 'improved' with touches of gouache. He expected the engravers to come up with 'Dürer's work',[12] and only approved the image once the changes had been made. What is remarkable, however, is the fact that comparison of his drawings, surviving proofs and the finished illustration reveal barely any differences. Even at proof stage, the Dalziels were much nearer the mark than Sandys would allow, and the printed version of 'Until Her Death' is one of their finest engravings, a graphic transfer which closely adheres to the artist's 'intention'.

Artist and Engraver: a Collaborative Model

The difficulties experienced by Sandys and his engravers strongly suggest that the best results were not achieved by adopting an authoritarian approach. One might argue that the Dalziels achieved high standards in the production of 'Until Her Death' *despite* rather than *because* of the artist's interference. The whole process was needlessly marred by confrontation and dissent and the end result was a marked cooling of professional relationships. However, not every artist followed the same path, and many realised that the finest work would be produced by adopting a more reasonable approach. Always looking for ways of imposing control, some illustrators were willing to reward their 'woodpeckers' with professional respect.

Du Maurier usually enjoyed productive relationships with his engravers, and did his best to achieve the desired result by valuing their contributions. In contrast to Sandys, who approached the collaboration as an onerous

11 ibid.
12 ibid.

109. Millais, 'The Parable of the Unmerciful Servant',
illustration to *Parables of Our Lord,* 1863. Wood engraving.
India proof touched with opaque white watercolour, with notes in the margin in graphite
pencil from artist to engraver. Block: 5½ x 4½ inches.
Museum of Fine Arts, Boston. John and Ernestine A. Payne Fund, 55.1450.
Photograph © 2010, Museum of Fine Arts, Boston.

110. The same image as printed in *Good Words*, 1863, facing p. 749.
Engraved by the Dalziels.

dealing with an inferior, du Maurier treated his engravers as equals. He was close to Swain, particularly during the production of 'Eleanor's Victory' (*Once a Week*, 1863). The serial publication of Braddon's novel allowed the artist and engraver to consult at length; freed of the demands of a rapid turnaround – which usually made it impossible for collaborators to engage in detailed discussions – they had time to compare notes, inspect and correct the proofs, and make a wide-ranging series of adjustments. This process was conducted in genial and agreeable terms, with shared jokes and urbane banter, as, for example, when du Maurier returned a proof which had misrepresented his drawing of a cat. Featuring only as a realistic touch in one of the street scenes, the offending feline was not up the artist's standards.

'I am sorry . . . that the animal you mention should have turned into a dog when it got to Bouverie Street. I can assure you it was a Persian cat when it left New Grove House and you must try to engrave it back again . . .'[13]

The fault, as it turned out, was the artist's, the result of his lack of expertise in drawing on wood, and he remedied the situation by providing the engraver with a number of sketches that enabled him to correct the fault. Such an acknowledgement would never have been made by the arrogant Rossetti or the overbearing Sandys, but the pragmatic du Maurier understood that effective collaborations were usually built on constructive dialogue and the sharing of expertise.

A parallel approach was adopted by Millais. Driven by the need for perfection, Millais realised that the only way to gain the desired effect was through a process of checking and correction which respected the skills of the engravers. Like du Maurier, he treated his collaborators as fellow-professionals rather than servants or rivals, always praising their work before he offered some revisions of his own. His approach is exemplified by his relationship with the Dalziels, who commissioned 'The Parables of Our Lord' (*Good Words*, 1863), and is clearly revealed in his response to 'The Parable of the Unmerciful Servant'. Presented with an uncorrected proof (Hartley Collection, Museum of Fine Arts, Boston), Millais helpfully provided a series of annotations which identified the passages in need of improvement (fig. 109). The figure to the far right is labelled with a pointer saying 'lighten'; the figure to the near right is in need of improvements to the eye and cloak; and the whole effect is to be heightened by accentuating the moustache and mouth of the figure standing between them. Should these messages be misunderstood, the artist assisted the engraver by lightening key passages, a process achieved by over-painting the black ink, which is sometimes far too dark, in opaque body colour.

13 From the Hartley Letter File, Museum of Fine Arts, Boston. Reproduced in Sarah Hamilton Phelps, 'The Hartley Collection of Victorian Illustration'. *Boston Museum Bulletin*, 71:360, 1973, p. 64.

Millais's strategy was thus a matter of constructive change, of trusting the engravers to inflect his design with a higher degree of expressiveness while never asking them to re-cut or engage in detailed revisions. Treated with the respect they always craved, the Dalziels responded in detail: the final print is much lighter than the over-dense proof, and Millais was rewarded with an appropriate result (fig. 110). Intelligent enough to see that absolute control over the image was not possible under the circumstances, he engaged the best possible approach. Lacking in the sort of class-arrogance routinely practised by some of his contemporaries, the illustrator did not regard himself as *separate* from the engravers, but more as an individual participating in a lengthy procedure which he could still influence.

A less sophisticated approach was adopted by Leighton. Leighton wanted his illustrations with 'Romola' to be models of fine engraving, although his relationship with Linton started badly. When he received the proof for the first illustration, 'The Blind Scholar and His Daughter' (fig. 86), his response was a hostile one: instead of liaising with his engraver, he complained to George Smith, insisting that his work had been spoiled by gross incompetence. In Smith's urbane words,

he came to me in great agitation. The engraver, he declared, had entirely spoilt his drawing, leaving out certain essential lines, and putting in other irrelevant ones of his own. [14]

As far as Leighton was concerned, Linton was merely a technician whose task was one of neutral copying from drawing to block, and he regarded any changes as an impertinence. However, Smith's enquiries revealed a number of inconsistencies, which made it all but impossible for Linton to give the artist what he was looking for. The main problem, as Smith puts it, was his complete inexperience of drawing on wood. Indeed, his illustration for 'The Blind Scholar' seems to have been an impressionistic composition, an exact replica of his earliest design. Leighton drew all of his illustrations in chalk on blue paper, and his first attempt to draw on wood was a sort of washy design which the engraver, compelled to work with hard-edged lines, would have had no chance of turning into an effective engraving; we have only to compare two versions of 'The First Kiss' (figs. 99, 100) to see how Linton could never have worked with Leighton's cloudy images. The solutions were nevertheless simple ones. Smith urged Leighton to draw in a linear style, and surviving tracings show how carefully he emphasised the outlines of his designs, transforming his sketches into hard-edged drawings on wood. Smith did not want Leighton's designs to be transferred photographically – since he thought, probably correctly, that the process would allow him to duck the

14 Huxley, p. 140.

problems of linear conversion – but he did arrange for the finished design, once it was drawn onto the block, to be photographed. This photographic image acted as a record: as Smith comments, the next time Leighton complained of an 'injustice. I produced my photograph, and the two fought it out together'.[15]

This combative model was replaced, nevertheless, with a growing trust and willingness to collaborate. Leighton became more accustomed to drawing on wood, and, despite his over-sensitive critique of many of the engravings, he finally accepted the need to work in a professional partnership. Like many of his contemporaries, the artist realized that confrontation was not necessarily the most effective means of getting his own way.

Artist, Engraver and the Question of Control

Artists struggled to manipulate their images through a process of direction and bullying, or by entering into a creative conversation with the engraver. The end result is a synthetic image, an illustration mediated through another hand or series of hands. All Sixties designs are, in this absolute sense, 'after' the artist, rather than 'by' him. In most of the illustrations – a vast canon of some thousands of pictures – the effect is one of equilibrium, of creative fusion between craft and art, technology and interpretation. There are, however, many cases where the process is biased, as it were, in the craftsman's favour, producing a result in which the printed design is more the work of the engraver's expertise than it is of the originating artist. Put simply, the master engravers often 'improved' their source material, converting non-viable designs into effective prints. This transition is partly realised, as we have seen, in Leighton's early dealings with Linton, and many others were similarly dependent on the contributions of their engravers. Rossetti's designs for the 'Moxon Tennyson' were famously translated by the Dalziels, and Keene, generally known as an outstanding draughtsman, was almost entirely reliant on the engravers' craft. Like Rossetti, he lacked the discipline of drawing on wood: his illustrations were often handed in on rough slips of paper, and were frequently drawn in a washy style that was difficult to turn into print. As M. H. Spielmann explains, his work typically produced the effects of 'fleeting … Impressionism',[16] a mode 'wholly foreign to the art of the wood-cutter'.[17] Keene always accused his engravers of being difficult and unable to see what he was trying to achieve; on the other hand, his art would be unreadable

15 ibid.
16 Spielmann, p. 482.
17 ibid, p. 488.

111. Burne-Jones, 'King Sigurd, the Crusader'.
Good Words, 1862, p. 248.
Engraved by the Dalziels.

without the diligence of Swain and the Dalziels.[18] The same judgement can be made of several of Keene's contemporaries.

In some cases, the process of 'improvement' and 'interpretation' is taken much further. Presented with poor material, the engraver *appropriates* the image, creating a print which bears some relationship to its designer's intention, but is fairly comprehensively refigured, as a work that is discovered and materialised anew, in the engraver's style. A good example is provided by the case of Burne-Jones. In Jones's designs for *Good Words* the 'look' of his images is heavily influenced by the character of the cutting: the artist stressed a neo-medieval linearity, but the final prints were re-cast by the Dalziels, who turned them in bold contrasts of absolute black and white, blocked passages and heavy outlines. 'King Sigurd' (*Good Words*, 1862, fig. 111), especially, is as much the work of the engravers as it is of the artist. Houghton's scenes of domestic uproar in *Good Words* (figs. 49, 50) are similarly subjected to the Dalziels' treatment, and comparison between the prints and his drawings tellingly reveals the Brothers' enhancement of his original effects. Houghton's designs (Tate Britain, London) are sensitively drawn, with delicate effects of light; the Dalziels' versions, by contrast, are far more dramatic, characteristically emphasising strong juxtapositions of white and black. The same sorts of transformations can be traced, moreover, in graphic readings of Simeon Solomon. In the Dalziels' hands, Solomon's designs are sweet combinations of lyricism and light modelling, an approach typified by their interpretation of his work in *Good Words* (1862, fig. 112). Treated by Butterworth and Heath, on the other hand, his illustrations are dark, impressionistic and brooding, with a strong emphasis on hatched darkness and a febrile line. Engaged to cut Solomon's 'Jewish Ceremonies and Customs' in *The Leisure Hour* (1866), the engravers produced an image which bears only a limited resemblance to Solomon's style as it is widely understood. There is a marked contrast between the figure-drawing in *Good Words* and the illustration for 'The Feast of Dedication' (*Leisure Hour*, 1866, fig. 113); and differences can also be traced between this engraving and the Dalziels' brusque treatment of 'The Marriage Ceremony' in *Once A Week* (1862, fig. 114). Both sets represent the 'Jews in England' and were drawn in the same poetic style. However, the Dalziels reveal the artist's essential character – making clear visual connections between his illustrations and the psychological intensity of his paintings – while Butterworth and Heath create an anomalous alternative in which his characteristic approach is overwhelmed by a somewhat lugubrious treatment. This has the effect, essentially, of replacing the designer with another maker: Solomon's signature does appear on his *Leisure Hour* designs

90
91

18 Exemplified by unbelievably uncooperative letters between Keene and his engravers, now in the John Rylands Library, University of Manchester.

112. Simeon Solomon, 'The Veiled Bride'.
Good Words, 1862, p. 592.
Engraved by the Dalziels.

(a practice unusual in this magazine), although the illustrations should rightly be signed 'Butterworth and Heath'. Placed in a continuum, the engravings are at the extreme end of a process which begins with some form of neutrality with the engravers as ciphers, embraces mediation and compromise, and ends with the cutters assuming the role of image-maker. Like it or not, artists often had to submit to the requirements of the engravers as surely as they accept the strictures of the publisher, the editor and the author.

Opposite (above): 113. Simeon Solomon, 'The Feast of Dedication'.
The Leisure Hour, 1866, p. 73. Engraved by Butterworth and Heath.
Opposite (below): 114. Simeon Solomon, 'The Marriage Ceremony'.
Once a Week, 9 August 1862, p. 192. Engraved by the Dalziels. Private Collection.

CHAPTER SIX

Artist, Editor, Publisher, Author, Engraver

In the previous pages I have shown how the working collaborations of Sixties designers were largely expressed as a series of intense partnerships. In contrast to the artist who toiled in romantic isolation in front of a canvas, the designer of illustrations was forced to respond to the influence of the publisher, or the editor, or the author or the engraver. He was sometimes drawn into a complex web in which *all* of his collaborators had to be heard, and everyone demanded a response. In these situations, the artist struggled to accommodate what were often competing claims, with one influence having the affect of contradicting or cancelling another. Constrained on all sides, and forced to produce a piece of work which somehow synthesised a number of suggestions or demands, many felt that their hands were tied. A good example, already discussed, is provided by Leighton's response to 'Romola'. This work exemplifies the artist's difficult position; placed at the centre of a number of overlapping demands, he was required to produce illustrations which satisfied everyone. These pressures can be conceptualised as a sort of job-description, a list of criteria in which

Smith wanted a high profile artist to build sales and expected Leighton to produce work of 'fine art' quality which would invoke the academic standards of his paintings;

Thackeray needed to have illustrations that would comply with *The Cornhill Magazine*'s genteel tone, and avoided any 'coarseness';

the author, with only limited ideas on the role of illustration, pressurised Leighton into following her instructions, rather than her text; and

the engraver, unable to process the artist's sketchy designs, refused to accept any responsibility for alleged failures and, with the assistance of the publisher, persuades Leighton to re-draw in a more linear form.

Faced with these multi-dimensional tasks, Leighton felt there was little room for manoeuvre. The situation is worsened, of course, by the instructions' glaring contradictions. How, for example, could he preserve the cool academic quality of his painting while illustrating a text which contains a number of comic passages? How could he maintain *The Cornhill's* moral

restrain and represent the story's emphasis on sexuality and sexual love? How could he be a 'fine' artist, one of the leading painters of the day, and comply with instructions from an author whose aesthetic judgements were gauche and unworkable? And how could he maintain 'academic' modelling in light and shade and still create an effective series of woodblock translations? Leighton's responses, as we have seen in earlier discussion, were inventive: he accommodated what he could, deflected what he saw as irrelevant and re-figured whatever he could use. Driven forward by professionalism – as well as by the hefty salary – he re-cast his designs to meet the engraver's requirements; inscribed the text's eroticism in a coded form; retained the conventions of academic drawing; followed the text as he saw it; and only used those aspects of Eliot's advice that he found useful. In classic fashion, he navigated a passageway through his instructions, arriving at a solution which, by and large, was satisfactory to all. I have already suggested that the illustrations for 'Romola' were the product of two pairs of hands, but if we take a broader perspective, we can see how they are really the product of five: Leighton's, Smith's, Eliot's, Thackeray's and Linton's.

This type of multi-faceted collaboration can also be traced in the making of a variety of serials. One of the most interesting is Trollope's 'Framley Parsonage' (1860–61). Used to launch *The Cornhill Magazine*, the illustrations for this novel were produced by Millais in response to the influence of the author, to Smith, Thackeray and to the Dalziels. Usually analysed only in terms of the artist's partnership with Trollope, the images for 'Framley Parsonage' provide another example of the artist's negotiation of conflicting demands, and is worth considering in detail.

193

SIX:
ARTIST,
EDITOR,
PUBLISHER,
AUTHOR,
ENGRAVER

Creative Partners: The Artist and His Collaborators

Smith commissioned Trollope to write a specific type of novel. Unimpressed by the author's offer of a story with an Irish theme, the publisher directed him to produce an 'English tale with a clerical flavour',[1] an account of everyday failings and frailties which included some 'Christian virtue and some Christian cant'.[2] This approach, Smith reasoned, would appeal to the middle-class audience, reaffirming *The Cornhill Magazine's* bourgeois credentials. However, he also understood that the written text, with its prosaic valuing of the mundane, was not enough. Trollope's descriptive style was not especially visual, at least not by the pictorial standards of the Victorian novel,

1 Trollope, *An Autobiography*, 1, p. 190.
2 ibid, p. 191.

194

SIX:
ARTIST,
EDITOR,
PUBLISHER,
AUTHOR,
ENGRAVER

115. Millais, 'The Miller's Daughter'. Engraved by Williams.
116. Millais, 'Locksley Hall'. Engraved by Thompson.
Tennyson, *Poems*. London: Moxon, 1857, pp. 86 & 267.

195

SIX :
ARTIST,
EDITOR,
PUBLISHER,
AUTHOR,
ENGRAVER

117. Millais, 'Dora'. Engraved by Thompson.
118. Millais, 'Edward Gray'. Engraved by Thompson.
Tennyson, *Poems*. London: Moxon, 1857, pp. 213 & 340.

and would benefit, so the publisher believed, from illustrative support. What was needed was an intense visualisation, a showing of his bourgeois milieu that would fix the novel's imagery firmly in the reader's mind's eye. With these considerations in mind, Smith cast around for an appropriate artist. His first choice was Millais.

196

SIX:
ARTIST,
EDITOR,
PUBLISHER,
AUTHOR,
ENGRAVER

Smith selected Millais, it can be argued, because his imagery forms an obvious equivalence with Trollope's. By 1860 Millais's Pre-Raphaelite days were well behind him; his paintings were largely concerned with reading the everyday, and in the 'Moxon Tennyson', for example, he had demonstrated a keen interest in the intense situations of middle-class life. Smith was particularly impressed by his illustrations of 'The Miller's Daughter' (fig. 115) and 'Locksley Hall' (fig. 116), both of which are small-scale, intimate showings of respectable characters in crisis. The publisher also scrutinised his reading of 'Dora' (fig. 117) and 'Edward Gray' (fig. 118).[3] By turns tender and prosaic, these images convinced Smith that Millais would be an ideal interpreter of Trollope. All he needed to do was re-create the fusion of the everyday and passionate that he had applied to his reading of Tennyson. With that in mind, Smith engaged the artist with the expectation that he would foreground the novelist's emphasis on relationships, the topical and the matter of fact.

Smith highlighted the need to appeal to the shared, 'modern' experience of his readers, and Millais visualised this emphasis by stressing the contemporary. Trollope's descriptions of faces and interiors are given what N. John Hall has dubbed 'meticulous attention',[4] and there are many moments where the illustrations are an exact mirror of the text. More telling, however, is the way in which the artist stresses the novel's realism by visualising details which are *not* given in the letterpress, but might reasonably be expected to appear if the scenes and characters were 'real'. Aiming to convey the novel's vivid sense of the bourgeois milieu, he foregrounds details of contemporary dress: Mark, Lucy and Fanny are all endowed with precisely the well-appointed clothes that would have been worn by *The Cornhill Magazine's* readership, and the Crawley family, a type of genteel poverty, are shown with parallel exactitude (fig. 119). He takes the emphasis on modern costume to an absolute extreme in his showing of Lucy's crinoline, 'Was It Not a Lie?' (fig. 13). Figured as if it were an informal glimpse of a fashion-book, the illustration locates the text at the exact historical moment (1859–60) when extravagant 'bounce' was the latest fad. 'Framley Parsonage' is thus transformed from the story of a quaint backwater into a journalistic tale of middle-class life as it was

3 The artist's illustrations can be judged as whole by examining the reproductions in Paul Goldman's *Beyond Decoration: The Illustrations of John Everett Millais*. Pinner: Private Libraries Association, 2005.
4 Hall, p. 64.

197

SIX:
ARTIST,
EDITOR,
PUBLISHER,
AUTHOR,
ENGRAVER

119. Millais, 'The Crawley Family', 'Framley Parsonage',
The Cornhill Magazine, August, 1860, facing p. 129.
Engraved by the Dalziels.

generally understood. In the words of one observer, the artist's emphasis on fashion placed the novel absolutely in its period, representing 'the *manners* of the time in which it is written'.[5] Such currency provided Smith with the directness that he was looking for.

Millais was pressurised, all the same, by the need to preserve an overall sense of propriety and decorum. *The Cornhill Magazine* was a family magazine, and his response to Trollope was constrained – as all of its artists were constrained – by the need to mediate the more 'adult' themes into an acceptable form. We know that the editor Thackeray was intolerant of coarseness, and would have told Millais of the need to preserve a certain level of gentility. At all times, it was necessary to assure the female reader that there would be no controversy. Yet, interestingly, Millais found this directive more difficult to maintain than one might think. In the case of 'Was It Not a Lie?' (fig. 13), he misread his capacity to show the 'real', illustrating Lucy's crinoline as the main subject while suggestively noting her foot, which peeps out from under the extravagant folds of the material. The dress, Trollope said, could be seen as a sort of after-image even after he had averted his gaze: a curious comment, and one which suggests how studiously he had scrutinised its textures, thinking not of its surfaces, but of what lay beneath. Put another way, Millais inadvertently stretched the limits of his instructions, providing male readers with a female object and introducing sexuality where they should only have been romance. He was more successful, however, in maintaining the novel's social proprieties. Practised in the representation of unusual faces – the sort that Thackeray would certainly condemn as coarse – his portraits of Trollope's personae are rigorously controlled. Trollope writes of good stock, and Millais reinforces *The Cornhill Magazine's* appeal to the middle-class by showing the characters idealistically, with well-formed chins, noble brows, large eyes and clear expressions (fig. 120).

This neo-classicism is markedly at odds with the realism of the costumes, and in several places we can see how Millais struggled to accommodate the inherent contradictions of his brief. The effect is sometimes one of disunity. In the scene showing 'Lord Lufton and Lucy Robarts' (fig. 121), the high idealism of the characters' antique profiles seems curiously at odds with the prosaic mapping of gaiters, jacket, muffler and dress. This clash would never be allowed in Millais's painting, and yet in his illustrations he is compelled to absorb his employers' demands. He was also constrained by the author. Several critics have noted how in the early years 'there was not enough communication … to permit an active collaborative'.[6] Trollope was still a distinct influence; he disliked the artist having independence, and brought pressure

5 J. A. Sharpe, review of the novel in the *London Magazine*: quoted in Hall, p. 15.
6 Michael Mason, 'The Way We Look Now: Millais' Illustrations to Trollope'. *Art History*, 1:3, September 1978, p. 328.

SIX:

ARTIST,

EDITOR,

PUBLISHER,

AUTHOR,

ENGRAVER

3

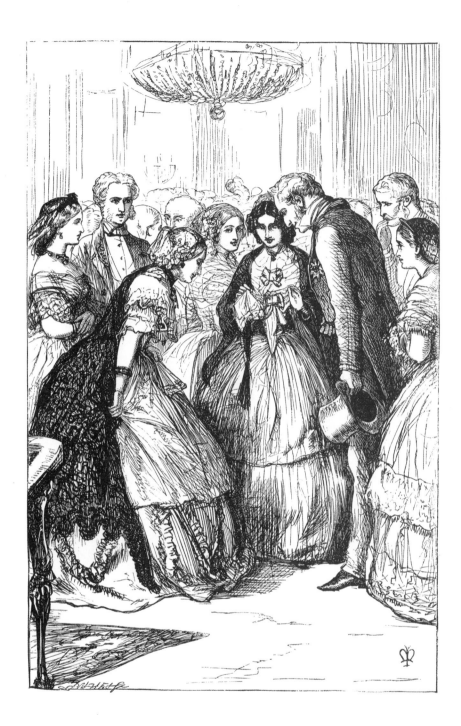

199

SIX:
ARTIST,
EDITOR,
PUBLISHER,
AUTHOR,
ENGRAVER

120. Millais, 'Lady Lufton and the Duke of Omniun', 'Framley Parsonage',
The Cornhill Magazine, October 1860, facing p. 472.
Engraved by the Dalziels.

200

SIX:
ARTIST,
EDITOR,
PUBLISHER,
AUTHOR,
ENGRAVER

121. Millais, 'Lord Lufton and Lucy Robarts', 'Framley Parsonage',
The Cornhill Magazine, April 1860, facing p. 449.
Engraved by the Dalziels.

to bear by suggesting scenes and criticising his interpretations. But Millais correctly understood that Trollope was principally interested in the writing of character. Trollope wanted his characters to live, and Millais was able to deflect the author's criticisms by offering him 'true' representations of Lucy, Mark, Fanny and Lord Lufton. In Trollope's terms, as reported in his *Autobiography*, Millais presented every 'figure' as the embodiment of the writer's 'views', as 'delineations'[7], which lived in the mind (figs. 119, 120, 121) and, by and large, satisfied the author's exacting requirements. This approach came naturally to Millais; the writer's emphasis on character was matched by the artist's, and the end result was genuinely harmonious.

Millais made a dramatic accommodation, on the other hand, in his dealings with the engravers. In his earlier work for the Dalziels, he had preserved many of the essentials of his painting. In 'The Parables' (1863) he re-created the monumental forms of his figure drawing, and in the 'Moxon Tennyson' (1857) he offered dense fields of pictorial detail. Working on 'Framley Parsonage', however, his approach is far more economical. Seemingly intent on presenting the Dalziels with drawings that would make an efficient translation, he changed his approach to suit the engravers. Indeed, his surviving designs suggest an absolute understanding of the need for linearity and unambiguous modelling, for clean outlines and clear details. This purging of everything but essentials is epitomised by the original pencil drawing for 'Lord Lufton and Lucy Robarts' (Arents Collection, New York Public Library). Tersely drawn, the image reduces the two figures to static, monumental forms, framed against the stark geometry of the opened door; stripped of needless complications, it offers the sort of graphic directness that was easily transferable to the printed page. Little needed to be changed, and a comparison of the original design and the finished print reveals few tangible differences between them. For the Dalziels, who were used to the tedium of endless revisions, this was simple work, allowing them to complete the engraving in record time.

Of course there were revisions, but Millais did his best to accommodate the engravers' requirements by offering succinct instructions. Dissatisfied with the proof for 'Lady Lufton and the Duke of Omnium' (fig. 120), he wrote to the brothers in September of 1860 offering a series of clarifications:

There are a few things necessary which I trust you will be able to do before going to press. Miss Dunstables mouth wants clearing between the nose & upper lip, & you may want to make her skirt broader by cutting away some of the little lines… Cut away more of the lines of Lady Lufton's headdress … make it broader, also the back lady's chin & throat require fining…[8]

201

SIX:
ARTIST,
EDITOR,
PUBLISHER,
AUTHOR,
ENGRAVER

7 *Autobiography*, I, p. 199.
8 Lutyens, 'Letters from Sir John Everett Millais', *Proceedings of the Walpole Society*, p. 37.

He helped the process along by sending corrective drawings which emphasised the need for directness and economy. Taken, it seems, with a new desire not only to illustrate but also to become an effective illustrator on wood – an ambition ignored or derided by so many of his contemporaries – Millais presents the Dalziels with exemplary treatments for them to work with. The Dalziels later spoke of the artist's satisfaction with the quality of their engraving,[9] and the equation cuts both ways: they satisfied him because he was drawing designs which they could work with, and he initiated the process by responding to their need for suitable material.

202

SIX:

ARTIST,

EDITOR,

PUBLISHER,

AUTHOR,

ENGRAVER

The Artist and Self-Expression

Millais absorbed the pressures that were placed upon him, and the illustrations for 'Framley Parsonage' clearly reflect his versatility. Of course, the images are not without their contradictions, and the effect is always one of synthesis and fusion. Created in an unstable and changing context, they encapsulate the multiple functions, practical, moral and aesthetic, that were demanded of Sixties designers by their fellow professionals. Used to working on his own, yet always willing to engage with others, Millais creates a genuine piece of collaborative design. However, the 'Framley' illustrations are far from impersonal, and could never be read as the anodyne art of the panel or the pressure-group. The anonymity that sometimes characterises the over-careful design of *The Leisure Hour* had no place in striking pages of *The Cornhill Magazine*. On the contrary, Millais continues the Sixties tradition of artistic self-expression, of finding ways to work *within* the directives and manage, nonetheless, to present an interesting slant on the source material. Heavily constrained by instructions and pressures, he still presents an idiosyncratic interpretation of Trollope's text, enriching some aspects of the writing and refiguring others. This process is realised by accentuating details, adding others and generally enhancing and changing the *mise-en-scène* of Trollope's original prose.

Millais deepens the novel's psychological resonance by emphasising gesture. Trollope makes only passing reference to pose, being more concerned with authorial commentary and dialogue. Millais, by contrast, puts a heavy emphasis on what, at the time, were regarded as significant attitudes. These are placed at the most important moments, allowing him to suggest the characters' underlying feelings not by what they say, but by how they move or stand. A prime example is provided by the scene between Mark and Fanny,

9 *The Brothers Dalziel: A Record of Work, 1840–1890.* 1901; new ed., with a foreword by Graham Reynolds, London: Batsford, 1978. 81–4.

203

SIX:
ARTIST,
EDITOR,
PUBLISHER,
AUTHOR,
ENGRAVER

122. Millais, 'Mark, she said.', 'Framley Parsonage',
The Cornhill Magazine, March 1861, facing p. 342.
Engraved by the Dalziels.

204

SIX:

ARTIST,

EDITOR,

PUBLISHER,

AUTHOR,

ENGRAVER

when the debtors arrive. Trollope describes the event in the barest terms; however, the illustration conveys the characters' suffering by highlighting their gestures (fig. 122). Mark's anguish is suggested by showing him with his hands digging deeply into his pockets, a sign which hints at his defensiveness – almost as if he wished he could disappear into himself – and also his desire to find the money, which seems to be hidden away in some secret domain. With his head down, his gaze averted and his back resting awkwardly against the mantlepiece, Mark's feelings of shame are vividly embodied in his outer form. Fanny's gesture, which is literally a matter of supporting him as if he might fall, is likewise a telling sign of her psychological profile. Figured as the Angel in the House, Fanny is represented as the necessary foil to Mark's foolishness. Trollope treats her conventionally, but Millais (whose paintings reflect a fascination with female psychology) endows her with an underlying strength.

Another enhancement, which builds on the use of significant gesture, is presented in the form of emblematic detail. Such emblems are partly borrowed from the text, and partly Millais's invention. Like pose, they are used to deepen the novel's effect; always looking for underlying meanings, the artist deploys a variety of signs to suggest the presence of a universal theme. In his treatment of the Crawley Family (fig. 119), he tellingly highlights the image of the cradle. This appears in the text as an incidental detail, but Millais's placing of the cot at the base of a compositional triangle, with Crawley at the head, is surely intended to visualise an allegorical message. The bottom of the design implies the beginnings of life, and its apex implies what life becomes in adulthood: a process which leads from youth to age, from innocence to experience, from hope and possibility to the failures of maturity. At face value, no more than a naturalistic representation, 'The Crawley Family' can be read, in other words, as a universal representation of the cycle of life. Recalling the emblem books which were popular at the time, such as Pigot's *Life of Man* (1866), Millais's static, dignified, melancholy image is charged with a personal reflection on life and mortality. It has the gravitas of a painting and, significantly, was re-painted as an independent work of art.

Such seriousness also features in the illustration of 'Lord Lufton and Lucy Robarts' (fig. 121), although his focus, this time, is on the imagery of romance. As Hilary Gresty has observed, Millais extends the author's theme by including symbolic items which are not mentioned in the text, but suggest the 'idea of forthcoming love'.[10] Foremost among these is the dovecot with fluttering doves, a sign of mutuality and affection that features in spoony Victorian paintings such as Madox Brown's *An Autumn Afternoon* (Birmingham City Art Gallery, 1852–55). The gate similarly connotes the opening of

197

200

10. 'Millais and Trollope, Author and Illustrator'. *Book Collector*, 30, 1981, p. 46.

a new life, and David Skilton reads the dead game as the emblems of sexual conflict, the evidence that 'Lucy has received a hit in the battle of the sexes'.[11] There are other emblems as well: the chickens to the bottom left represent (forthcoming) domesticity; the lightly registered ivy surrounding the gate is a mid-Victorian emblem of fidelity, memory and enduring love; the battered stones of the gateway are the tokens of fortitude; and the opening sky a metaphor of optimism and happiness. Most obvious of all – though I have never seen it analysed in modern criticism – is the ring. Nominally a naturalistic detail of a metal ring in the far wall, it hovers mysteriously over their hands, the sure sign of marriage and commitment. Indeed, every item in Millais's apparently straightforward design is significant, charging the scene with a depth and complexity which is otherwise missing from Trollope's bare text. The author is cryptic, the artist expansive, infusing his designs with a passionate depth of love and longing, yearning, the fear of loss and the desire for mutuality.

These emphases extend the novel's expressive range. Millais always manages to 'promote the views of the author', as they are expressed in the text, and he adds other dimensions of his own. The end result is one of the Sixties outstanding collaborations, a matching of writer and artist which parallels the unities of Dickens and Phiz, and Dickens and Cruikshank.

Speaking more generally, we can see how the 'Framley' illustrations are the visible signs of partnership. Produced as part of a creative nexus in which the artist responded to varying influences, they epitomise the process of creative sharing, of arguing, agreement, resentment and downright defiance. Reid and White may have read the illustrations aesthetically, as experiments in the pursuit of visual charm, but the artist was probably less concerned with 'beauty' than he was with the pragmatic need to get the job done, satisfy his professional work-mates *and* get paid.

Of course, Victorian magazines can be interpreted in a wide variety of ways. Lyn Pykett speaks of how we might explore them in terms of their

ideological, semiotic, cultural, social, political and psychological functions and determinants . . .[12]

In the case of illustrated magazines of the sixties they are best understood, as I have tried to show in the pages of this study, as the products of collaboration and conflict.

205

SIX:
ARTIST,
EDITOR,
PUBLISHER,
AUTHOR,
ENGRAVER

11. 'The Centrality of Literary Illustration in Victorian Visual Culture: the example of Trollope and Millais from 1860 to 1864'. *Journal of Illustration Studies*, 1:1, December 2001. www.jois.cf.ac.uk/articles.
12. Lyn Pykett, 'Reading the Periodical Press: Text and Context'. *Victorian Periodicals Review*, 22:3, Fall 1989, p. 104.

APPENDIX ONE

Collecting: Some Personal Reflections

Illustrated magazines of the 1860s have never been easy to collect. Commonplace in the twenties and thirties, many are becoming decidedly rare, and anyone starting a collection in the twenty-first century will be hard-pressed to achieve a reasonable level of completeness. It is interesting to consider why this situation has arisen, and how the modern collector can still assemble a representative library. I also make a few parting comments on my own progress as a collector, a minor compulsion developed over many years.

Viewed historically, there are several reasons for the unusual scarcity of many of the titles. Part of the problem lies in their status as ephemera; never regarded in the same terms as gift-books or other publications of the Sixties, periodicals have always been treated with scant respect. Some periods have been more destructive than others. In the 1940s vast quantities of seemingly valueless works were pulped or burned – one process being used to help with the production of war-time utility paper, and the other to fuel industry. Fashion has similarly played a part. The post-war vogue for Beardsley and Art Nouveau led to a further discounting of the art of boxwood. Regarded as backward looking in a progressive age, the artists of the Sixties sat uneasily within the new taste of reconstructed Britain. Millais, Sandys and the rest were suddenly old-fashioned, particularly in the period after 1960. Who wanted the clutter of mid-Victorian design when one could have the smooth eroticism of Beardsley? Dominated by the iconoclastic taste of youth, the pop movement's emphasis on the psychedelic made Sixties illustration seem very dull indeed. The very density of wood-engraved surfaces seemed at odds with the 'white heat' of Britain's post-modern design. Condemned as 'square', the books of a redundant generation, many of the rarer periodicals have entirely disappeared because no one thought they were worth the bother of conserving.

Underlying these influences, however, was the disastrous policy of 'cut and mount' advocated by White and Reid. Writing in a period (1897–1928) when there were plenty of survivors and it was more than possible to assemble a full library, these respected authorities encouraged collectors to *destroy* the periodicals for the sake of only a few of the outstanding illustrations. Reid's own collection is now in the Ashmolean, Oxford, and parallel collections by enthusiastic amateurs can be viewed in institutions such as the Barber Institute, University of Birmingham; Birmingham Museum and Art Gallery; the Fitzwilliam Museum, Cambridge; the Hunterian Gallery,

University of Glasgow; the National Gallery of New Zealand; and the University of Wales, Aberystwyth. Each print is lovingly mounted and labelled, and collectors unquestionably cherished their portfolios; and yet the overall effect is one of vandalism. Reid and White meant well, believing it was their patriotic duty to preserve the best in British art; but they endangered the survival of the very periodicals they so wanted to preserve.

A more enlightened approach was adopted by another great collector, Harold Hartley. Hartley collected proofs rather than electrotypes, and his vast collection is preserved in the Museum of Fine Arts, Boston. Hartley's importance particularly lies in his preservation of touched proofs, where the artists wrote corrections in the margins or manipulated the image. For those who would prefer to see the images in their original context, however, I would recommend some of the following strategies.

Collecting periodicals still depends, like the acquisition of all Victorian material, on a combination of diligence and luck. The normal sources can still be mined: Addall on the internet will at any time contain listings of hundreds of items, although it is fairly unlikely that the collector will chance upon a complete set, say, of *Good Words*, or *Once a Week*, and not likely at all that he will find *The Shilling Magazine* or any of the rarer titles. It is likelier that the beginner will assemble his library piece-meal. It is possible to find odd volumes of most of the main periodicals in second hand bookshops, and any aspiring collector should search carefully in the less-visited shelves of the surviving vendors. Few items will be found in their original bindings, and the novice should be prepared to assemble his library in the form of disparate volumes.

This piece-meal approach informed my own collecting habits. Starting in the late seventies, when I was an undergraduate reading English with the History of Art at Birmingham University, I became interested in Sixties gift-books, and quickly progressed to the periodicals. Of course, this was a time well before the internet: books were located in shops or listed in catalogues, and the pleasure of the chase, of hitting on a rare item in an unexpected setting, was still a prime motivation. In true undergraduate fashion – the mentality that makes everyone think they can conquer the world – I imagined myself to be a book-hunter on some sort of quest, and there were several occasions when I satisfied my bibliomania by uncovering a scarce number in a grubby box, hidden under 'boring' material. Using this hit and miss approach, and financed with nothing more generous than a small student grant, I quickly assembled sets of *The Cornhill Magazine*, *Once a Week* and *Good Words*, as well as numerous odd volumes of *The Leisure Hour*, *The Sunday Magazine* and *The Quiver*. The foundation stones of my collection were in place by the mid-eighties, and in subsequent years I have filled many of the gaps.

Good relationships with booksellers, notably Simon Weager and Ian Hoy at Hodgkins and Co, have helped in this endeavour. The process of collecting the magazines was also a learning experience. In the early days, from the seventies into the eighties, there were few reliable books on which to base any research. Reid and White were useful but old-fashioned, and it was not until the mid-nineties, with the appearance of Goldman's publications, that the field of Sixties illustration was re-established as a period worthy of investigation. There is still no book entitled *Collecting the Sixties* or *How to Make a Magazine Collection from Victorian Periodicals*, but that is part of the challenge of collecting.

The pages preceding this appendix are part of my own attempt to make sense of the Sixties as a cultural event, although it is only one perspective. Of course, much remains to be said and discovered: the illustrated magazine may have come close to destruction, yet it remains one of the most fascinating examples of the art of the Victorian book. Speaking more personally, my collecting of this material has satisfied disparate aspects of the heart and mind. It feeds the intellect, it has nourished my scholarship, and it has maintained my sanity in many periods of stress and difficulty. It is also an emblem of the past, of my own youthful endeavours and of people and places that now only exist in the memory. On a strictly personal note, my collection always makes me think of my father, an enthusiast with a keen eye, who, in the days when the mainstream periodicals were relatively easy to find, would finish work and talk excitedly of renewing the chase, of going from our home in Hereford over to Hay, 'to see if we can find some more *Cornhills*'.

APPENDIX TWO

Periodicals, Publishers, Editors, Artists and Engravers

Details of the primary artists of the period are contained in two outstanding publications: Goldman's *Victorian Illustration* (1996), and Simon Houfe's *Dictionary of Nineteenth Century British Book Illustrators* (Woodbridge: Antique Collectors' Club, 1988). Goldman also identifies the artists' periodical contributions. His listing is a comprehensive record of dates, issues and page numbers. The present listing is much narrower, being functionally related to my own analysis. In order to fill in some of the historical detail, I provide a simple catalogue of the principal illustrators, engravers, publishers and editors. I also provide a short list of the key periodicals. This focuses on their physical attributes and includes brief details of price, publisher, editor and business address.

THE PRIME ARTISTS MENTIONED IN THE TEXT

Barnes, Robert (1840–95). Painter of genre scenes, illustrator of Hardy and Reade, and specialist in children's books.

Birket Foster, Myles (1825–99). Landscape watercolourist and influential illustrator of sentimental genre.

Burne-Jones, Edward (1833–98). Celebrated second generation Pre-Raphaelite; disciple of Rossetti and leader of the Aesthetic Movement.

du Maurier, George (1834–96). *Punch* cartoonist, graphic satirist, illustrator of Gaskell, Braddon and Reade, and author of *Trilby* (1895).

Houghton, Arthur Boyd (1836–75). Watercolour painter, illustrator of oriental scenes and troubled representations of street-scenes and family life.

Hunt, William Holman (1827–1910). Founder member, along with Rossetti and Millais, of the Pre-Raphaelite Brotherhood. Leading exponent of 'symbolic realism', and famous for his moralising scenes.

Keene, Charles (1823–91). *Punch* cartoonist and extraordinarily versatile illustrator.

Leech, John (1817–64). Not a Sixties artist but figured in *Once a Week*. *Punch* cartoonist who followed Gillray but moderated his tone, creating polite satires of middle-class life in the fortiess and fifties.

Leighton, Frederic, K.C.O (1830–96). The doyen of the Victorian art world, P.R.A., and leading figure in the neo-classical revival of the 1860s.

Millais, John Everett (1829–96). Founder member of Pre-Raphaelite Brotherhood; celebrated painter and illustrator; P.R.A. Highly influential and perhaps the greatest British artist of his time.

Morten, Thomas (1836–66). Illustrator and painter. A tragic suicide, beset by financial problems.

Pinwell, George (1842–75). Landscape and idyllic painter, best known for his images of the rural poor.

Rossetti, Dante Gabriel (1828–82). Painter and poet; Pre-Raphaelite; founder of the Aesthetic Movement; influential illustrator and one of the most important cultural figures of the nineteenth century.

Sandys, Frederick (1829–1904). Rossettian artist and one of the greatest draughtsmen of his age.

Small, William (1843–1929). Under-rated painter and versatile illustrator whose work spanned five decades.

Solomon, Simeon (1840–1905). Painter and illustrator of Oriental and Biblical scenes; tragic victim of 'straight' orthodoxy.

Tenniel, John (1820–1914). Orientalist, painter, *Punch* cartoonist and famous illustrator of *Alice*.

Walker, Frederick (1840–75). Idyllic water-colourist and celebrated illustrator of Thackeray.

Watson, John Dawson (1832–92). Painter of genre and neo-realist rural scenes.

Whistler, James McNeill (1834–1903). Practitioner of 'Arrangements' and 'Symphonies' in colour; one of the leaders of the Aesthetic Movement in the Sixties.

211

APPENDIX
TWO:
PERIODICALS,
PUBLISHERS,
EDITORS,
ARTISTS &
ENGRAVERS

Argosy, The, 1865–1901. Published by Alexander Strahan at 56 Ludgate Hill, London. Issued monthly, price sixpence. Half-yearly volumes in brick-red publishers' cloth gilt. Ed. Mrs. Henry Wood, 1867–87.

Churchman's Family Magazine, The, 1863–73. Published by James Hogg at 49 Fleet Street, London, E.C. Issued monthly, price one shilling. Monthly volumes bound in a sand coloured limp wrapper, with a design by John Leighton. Yearly volumes in embossed blue publishers' cloth gilt. Ed. John Hogg.

Cornhill Magazine, The, 1860–1944. Published by Smith Elder at 65 Cornhill, London. Issued monthly, price one shilling. Original parts in limp orange wraps; half-yearly bound volumes bound in maroon embossed red publishers' cloth gilt, repeating Geoffrey Sykes's design of the sower. Eds: Thackeray, 1860–62; Frederick Greenwood & G. H. Lewes as joint eds, 1862–64; Greenwood, sole ed., 1864–68. Smith acted as editor during several of the gaps.

Good Words, 1860–1906. 'Good Words are Worth Much and Cost Little'. Published by Alexander Strahan at 32 & 56 Ludgate Hill, London. Issued monthly, price sixpence. Original parts in pink-brown wrappers with elaborate design. Half-yearly volumes bound in navy blue embossed publishers' cloth gilt. Ed: Norman Macleod, 1860–72.

Leisure Hour, The, 1852–1905. Published by the Religious Tract Society at 56 Paternoster Row and 164, Piccadilly, London. Weekly, price one penny, in plain wrapper. Yearly volumes in embossed blue publishers' cloth gilt. Editorial panel.

London Society, 1862–98. 'An Illustrated Magazine of Light and Amusing Literature'. Published by James Hogg at 49 Fleet Street, London, E.C. Issued monthly, price sixpence. Half yearly volumes in scarlet red publishers' cloth gilt. Ed. James Hogg.

Once a Week, 1859–80. 'An Illustrated Miscellany of Literature, Art, Science, & Popular Information'. Published by Bradbury & Evans at 11 Bouverie Street, London. Issued weekly, price three pence. Original parts in plain paper wraps with rustic frame, possibly designed by Richard Doyle. Half-yearly bound volumes in navy blue embossed publishers' cloth gilt. Eds: Samuel Lucas, 1859–65; Edward Walford, 1865–69; E. S. Dallas, 1869–73.

212

APPENDIX

TWO:

PERIODICALS,

PUBLISHERS,

EDITORS,

ARTISTS &

ENGRAVERS

Quiver, The, 1861–1926. Published by Cassell, Petter and Galpin at La Belle Sauvage Yard, E.C., London. Issued weekly and monthly (one penny and sixpence) in limp wrappers. Half-yearly bound volumes in blue publishers' cloth gilt. Ed. John Cassell.

Shilling Magazine, The, 1865–66. Ed. Samuel Lucas. London: Thomas Bosworth. Conceived by Lucas as a continuation of *Once a Week*, the title-page describes it as 'A Miscellany of Literature, Social Science, Fiction, Poetry, Art, etc'. Not to be confused with Douglas Jerrold's magazine of the same title, published in the 1840s. Monthly; never issued in bound volumes but later bound up by owners.

Sunday Magazine, The, 1864–1905. Published by Alexander Strahan at 56 Ludgate Hill, London. Issued monthly, price sixpence. Original parts in limp wrappers, weekly, price sixpence. Half-yearly volumes bound in burgundy publishers' cloth gilt. Ed: Norman Guthrie, 1864–73.

PUBLISHERS

Bradbury, William (1800–69) & Evans, Frederick Mullet (1803–70). The celebrated publishers of Dickens and Thackeray, and the proprietors of *Punch*. The company was also a firm of printers.

Cassell, John (1803–70). Evangelical publisher.

Hogg, James (1817–65) & John. General publishers. Originated in Edinburgh but (like Strahan) moved to the capital at the end of the 1850s.

Smith, George Murray (1824–1901), of Smith Elder. Smith took control of Smith Elder when it was in financial difficulties and turned it into the most successful publisher of its time, publishing, among others, the Brontës, Thackeray, Ruskin, Gaskell and Trollope.

Strahan, Alexander (1833–1918). The great evangelical publisher. In additional to his periodicals, Strahan published some of the most interesting children's books.

Lucas, Samuel (1818–68). Lawyer, scholar and critic, one of the driving forces of the revolution in the illustrated periodical. (*Once a Week.*)

Macleod, Norman (1812–72). Celebrated divine in the Church of Scotland; social reformer and author, notably *The Golden Thread* (1861). (*Good Words.*)

Guthrie, Thomas (1803–73). Divine in the Church of Scotland; outstanding preacher and social reformer. (*The Sunday Magazine.*)

Thackeray, William Makepeace (1811–63). Celebrated novelist, the only serious rival to Dickens. (*The Cornhill Magazine.*)

ENGRAVERS

Rodney Engen's *Dictionary of Victorian Wood Engravers* lists some hundreds of practitioners. The following are the dominant master-craftsmen.

Dalziel, Edward (1817–1905) & Thomas (1823–1906). Known as the 'Brothers Dalziel'. The most influential wood-engravers of the century, the Dalziels commissioned work as well as engraving it. Famous for their periodical commissions, but more for their elaborate series of gift-books, published at the Camden Press.

Linton, William James (1812–97). A Victorian polymath: engraver, poet, writer, supporter of radical causes and Chartist sympathiser. One-time occupant of Ruskin's house at Brantwood and celebrated émigré to United States, where he contributed to the further development of engraving.

Swain, Joseph (1820–1909). Head of engraving at *Punch* and principal engraver at *The Cornhill Magazine*.

214

APPENDIX

TWO:

PERIODICALS,

PUBLISHERS,

EDITORS,

ARTISTS &

ENGRAVERS

Select Bibliography

MANUSCRIPT SOURCES

Manuscript material relating to Victorian periodicals is dispersed and fragmentary, a situation which generally reflects the uneven quality of publishers' archives. Gathering and interpreting the records is no easy task and much of the material is surprisingly unrevealing. The following is a list of the mss. consulted in the preparation of this study.

BUSINESS RECORDS AND ASSOCIATED

Business correspondence of James Hogg relating to *London Society*, part of the Bentley Papers, British Library, London.

Once a Week ledger, The *Punch* Archive, British Library, London.

Ledgers of *The Cornhill Magazine*, National Library of Scotland, Edinburgh.

LETTERS

Correspondence of Harriet Martineau, the Heslop Room, University of Birmingham.

Correspondence of Charles Reade, The Huntington Library, San Marino, California, USA.

Correspondence of Sandys, Lucas and Leech, MA 4500, The Pierpont Morgan Library, New York, USA.

Correspondence of Sandys, Walker, Simeon Solomon, Keene and others, the Fairfax Murray Collection, John Rylands Library, University of Manchester.

Correspondence from George Smith to sundry artists and writers, The Murray Archive, National Library of Scotland, Edinburgh.

Letter by Leighton, The Leighton House, New Holland Park, London.

Letters by Samuel Lucas, Author's Collection, Coventry.

ORIGINAL ARTWORK

The original artwork of Sixties periodicals has largely survived and can be found in many institutions, national and international. Proof engravings and prints are equally plentiful. I have not attempted to view everything. However, I have drawn heavily on collections in the following:

Author's Collection of proofs and photographs, Coventry.

Birmingham City Art Gallery and Museum.

The Barber Institute, University of Birmingham.

The Dalziel Collection and Archive, British Museum, London.

Du Maurier Archive, Special Collections, University of Exeter.

The Hartley Collection, Museum of Fine Arts, Boston, Mass., USA.

The National Gallery of Canada, Ottawa, Canada.

The Victoria & Albert Museum, London.

PUBLISHED SOURCES

PERIODICALS

PRIMARY SOURCES

The illustrated periodicals cited in this study are listed in Appendix Two. I have also drawn on contemporary material in a number of periodicals.

All the Year Round.

The Art Journal.

The Examiner.

The Literary Gazette.

The Saturday Review.

The Times.

Details of individual citations are given in the footnotes.

OTHER PRIMARY BOOKS MENTIONED IN THE TEXT

A Round of Days, ills. by Houghton, Walker, Pinwell, etc. London: Routledge, 1866.

Allingham, William. *The Music Master*, with ills. by Rossetti, Millais and Hughes. London: Routledge, 1855.

Birket Foster, Myles, with poems by Tom Taylor, *Pictures of English Landscape*. London: Routledge, 1863.

Cruikshank, *George Cruikshank's Table Book*. London: The Punch Office, 1845.

Eliot, George. *Romola*. 2 vols. London: Smith Elder, 1880.

Houghton, Arthur Boyd. *Home Thoughts and Home Scenes*. London: Routledge, Warne & Routledge, 1865.

Millais, *The Parables of Our Lord*. London: Routledge, 1864.

Pictures of Society Grave and Gay, ills by du Maurier, Walker, etc. London: Sampson Low, 1867.

Tennyson, *Poems* (the 'Moxon Tennyson'), with ills. by Rossetti, Millais & Holman Hunt. London: Moxon, 1857.

Trollope, *Orley Farm*, illustrated by Millais. 2 vols. London: Chapman and Hall, 1862.

Willmott, Robert Aris, ed. *The Poets of the Nineteenth Century*. London: Routledge, 1857.

SECONDARY BOOKS AND ARTICLES

The following is a list of the most useful publications consulted in the preparation of this study.

Barringer, Tim & Prettejohn, Elizabeth, eds. *Frederic Leighton: Antiquity, Renaissance, Modernity*. New Haven: Yale University Pres, 1999.

Barrington, Mrs. Russell. *The Life, Letters and Work of Frederic Leighton*. 2 vols. London: Allen, 1906.

Black, Clementina. *Frederick Walker*. London; Duckworth, n.d.

Boardman, Kay. 'Charting the Golden Stream: Recent Work on Victorian Periodicals'. *Victorian Studies*, 48: 3, 2006, 505–17.

Bronkhurst, Judith. *William Holman Hunt: A Catalogue Raisonne.* 2 vols. New Haven: Yale University Press, 2006.

Buckler, William E. '*Once a Week* under Samuel Lucas'. *PMLA*, 67, 1952, 924–41.

Burns, Wayne. *Charles Reade: A Study in Victorian Authorship.* New York: Bookman, 1961.

Burton, Anthony. 'Thackeray's Collaborations with Cruikshank, Doyle, and Walker'. *Costerus*, 2, 1974: 141–87.

Carnell, Jennifer. *The Literary Lives of M. E. Braddon: A Study of Her Life and Work.* Hastings: The Sensation Press, 2000.

City of Birmingham Museum and Art Gallery Catalogue of the Permanent Collection of Drawings. Derby: Bemrose, 1939.

Coleman, John. *Charles Reade.* London: Treherne, 1903.

Cooke, Simon. 'A Forgotten Collaboration of the 1860s: Charles Reade, Robert Barnes, and the Illustrations for *Put Yourself in His Place*'. *Dickens Studies Annual* 30, 2001, 321–42.

—. 'A Man of Sound Judgement and Sure Taste: Samuel Lucas, *Once a Week* and the Illustrators of the 1860s'. *Studies in Illustration* 23, Spring 2003, 12–20.

—. 'George du Maurier's Illustrations for M. E. Braddon's *Eleanor's Victory*'. *Victorian Periodicals Review,* Spring 2002, 89–106.

—. 'Illustrated Gift Books of the 1860s.' *The Private Library.* Fifth Series, 6:3 (Autumn 2004): 118–38.

Crane, Walter. *An Artist's Reminiscences.* London: Methuen, n.d. [1907].

Curtis, Gerard. *Visual Words: Art and the Material Book in Victorian England.* Aldershot: Scolar, 2002.

Dalziel, George & Edward. *The Brothers Dalziel: A Record of Fifty Years' Work, 1840–1890.* London: Methuen, 1901. New ed, with a foreword by Graham Reynolds, London: Batsford, 1978.

Dalziel, Gilbert. 'Wood Engravings in the "Sixties" and Some Criticisms of Today'. *Print Collector's Quarterly*, 15:1, 1928, 81–84.

David, Deirdre, ed. *The Cambridge Companion to the Victorian Novel.* Cambridge: CUP, 2001.

de Maré, Eric. *The Victorian Woodblock Illustrators*. London: Gordon Fraser, 1980.

[Dickens, Charles]. 'Book Illustration'. *All the Year Round*, 10 August 1867, 151–55.

du Maurier, Daphne, ed. *The Young George du Maurier: A Selection of His Letters, 1860–67*. London: Peter Davies, 1951.

du Maurier, George. 'The Illustrating of Books from the Serious Artist's Point of View'. *Magazine of Art*, 1890, 349–53; 371–75.

Elwell, Stephen. 'Editors and Social Change', *Innovators and Preachers: the Role of the Editor in Victorian England*, ed. Joel H. Wiener. Westport, Conn: Greenwood Press, 1985.

Elzea, Betty. *Frederick Sandys, 1829–1904: A Catalogue Raisonné*. Woodbridge: Antique Collectors' Club, 2001.

Engen, Rodney. *Dictionary of Victorian Wood Engravers*. Cambridge: Chadwyck-Healey, 1985.

—. *Pre-Raphaelite Prints*. London: Lund Humphries, 1995.

—. *Sir John Tenniel: Alice's White Knight*. Aldershot: Scolar, 1991.

Ewart, Henry C. *Toilers in Art*. London; Isbister, n.d [1891].

Feltes, N. N. *Modes of Production in Victorian Fiction*. Chicago: University of Chicago Press, 1986.

Flint, Kate. *The Victorians and the Visual Imagination*. Cambridge: CUP, 2000.

Fredeman, William E., ed. *The Letters of Dante Gabriel Rossetti*, 4 vols. Cambridge: Brewer, 2002

Garrett, Henrietta. *Anny: A Life of Anne Thackeray Ritchie*. London: Pimlico, 2000.

Garrison, Laurie. 'The Seduction of Seeing in M. E. Braddon's *Eleanor's Victory*: Visual Technology, Sexuality, and the Evocative Publishing Context of *Once a Week*'. *Victorian Literature and Culture*, 36, 2008, 111–30.

Gresty, Hilary. 'Millais and Trollope: Author and Illustrator'. *Book Collector*, 30, 1981, 43–61.

Gettman, Royal. 'The Serialization of Reade's *A Good Fight*'. *Nineteenth Century Fiction*, 6:1, June 1951, 21–32.

Glynn, Jenifer. *Prince of Publishers: A Biography of the Great Victorian Publisher, George Smith.* London: Allison & Busby, 1986.

Goldman, Paul. *Beyond Decoration: The Illustrations of John Everett Millais.* Pinner: The Private Libraries Association, The British Library & Oak Knoll, 2005.

—. Taylor, Brian, eds. *Retrospective Adventures: Forrest Reid: Author and Collector.* Oxford: Ashmolean Press, 1998.

—. *Victorian Illustrated Books, 1850–1870: The Heyday of Wood Engraving.* London: British Museum, 1994.

—. *Victorian Illustration: The Pre-Raphaelites, the Idyllic School and the High Victorians.* Aldershot: Scolar, 1996, revised and enlarged. London, Lund Humphries, 2004.

Gray, Basil. *The English Print.* London: A. & C. Black, 1937.

Hall, N. John. *Trollope and His Illustrators.* London: Macmillan, 1980.

Hardie, Martin. *Catalogue of Modern Wood Engravings in the Victoria and Albert Museum.* London: HMSO, 1919.

Harrison, Antony A., ed. *The Letters of Christina Rossetti*, 5 vols. Charlottesville: The University Press of Virginia, 1997.

Hartley, Harold. *Eighty-Eight Not Out.* London: Muller, 1939.

—. 'George John Pinwell'. *Print Quarterly*, 11:2, 1924, 163–89.

Harvey, J. R. *Victorian Novelists and Their Illustrators.* London: Sedgwick & Jackson, 1970

Hodnett, Edward. *Five Centuries of English Book Illustration.* Aldershot: Scolar, 1980.

Hogarth, Paul. *Arthur Boyd Houghton.* London: Gordon Fraser, 1981.

Houfe, Simon. *John Leech and the Victorian Scene.* Woodbridge: Antique Collectors' Club, 1984.

—. *The Work of Charles Samuel Keene.* Aldershot: Scolar, 1995.

—. *Dictionary of Nineteenth Century British Book Illustrators.* Woodbridge: Antique Collectors' Club, 1988.

Hudson, Derek. *Charles Keene.* London: Pleiades Books, 1947.

Hunt, William Holman. *Pre-Raphaelitism and the Pre-Raphaelite Brotherhood.* 2 vols. London: Macmillan, 1905.

Huxley, Leonard. *The House of Smith Elder*. London: Printed for Private Circulation, 1923.

Jackson, Arlene M. *Illustration and the Novels of Thomas Hardy*. London: Macmillan, 1981.

Jordan, John O. & Patten, Robert L. *Literature in the Marketplace: British Publishing and Reading Practices*. Cambridge: CUP, 1995.

Kelly, Richard. *The Art of George du Maurier*. Aldershot: Scolar, 1996.

Layard, G. S. 'Millais and *Once a Week*'. *Good Words*, 1893, 552–58.

—. *Tennyson and His Pre-Raphaelite Illustrators*. London; Elliot Stock, 1894.

—. *The Life and Letters of Charles Samuel Keene*. London: Sampson Low, 1892.

Life, Allan R. 'The Periodical Illustrations of John Everett Millais and Their Literary Interpretation'. *Victorian Periodicals Review*, 9:2, June 1976, 50–68.

—. '"Poetic Naturalism": Forrest Reid and the Illustrators of the Sixties'. *Victorian Periodicals Newsletter*, 10:2, June 1977, 47–68.

Logan, Deborah Anna, ed. *The Collected Letters of Harriet Martineau*. 5 vols. London: Pickering & Chatto, 2007.

Lutyens, Mary, ed. 'Letters from Sir John Everett Millais, Bart, PRA (1829–1896) and William Holman Hunt, O.M. (1827–1910) in the Henry E. Huntington Library, San Marino, California'. *Proceedings of The Walpole Society*, 1972–74, 1–93.

Macdonald, Margaret F. *James McNeill Whistler: Drawings, Pastels and Watercolours*. New Haven: Yale University Press, 1995.

McLean, Ruari. *Victorian Book Design*. London: Faber & Faber, 1963.

Marks, George John. *Life and Letters of Frederick Walker*. London: Macmillan, 1896.

Mason, Michael. 'The Way We Look Now: Millais' Illustrations to Trollope'. *Art History*, 1:3, September 1978, 309–40.

Maunder, Andrew. 'The Effects of Context: Christina Rossetti, "Maude Clare", and *Once a Week* in 1859'. *The Journal of Pre-Raphaelite Studies*, 8, 1999, 34–49.

Maxwell, Richard, ed. *The Victorian Illustrated Book*. Charlottesville: University of Virginia Press, 2002.

Millais, J. G., ed. *The Life and Letters of Sir John Everett Millais*. 2 vols. London: Methuen, 1899.

Mitchell, Rosemary. *Picturing the Past: English History, Text and Image, 1830–1870*. Oxford: OUP, 2000.

Muir, Percy. *Victorian Illustrated Books*. London: Batsford, 1971; rvd 1985.

Newell, Christopher. *The Art of Lord Leighton*. London: Phaidon, 1990.

Nowell-Smith, Simon. *The House of Cassell*. London: Cassell, 1958.

Ormond, Richard and Leonée. *Lord Leighton*. New Haven: Yale University Press, 1975.

—. *George du Maurier*. London: Routledge & Kegan Paul, 1969.

Pantazzi, Sybille. 'Author and Illustrator: Images in Confrontation'. *Victorian Periodicals Review*, 9:2, June 1976, 39–49.

Parrish, M. L. *Wilkie Collins and Charles Reade; First Editions Described with Notes*. New York: Burt Franklin, 1968.

Pennell, Joseph. '*Once a Week*: A Great Art Magazine'. *Bibliographica*, 3, 1897, 60–82.

—. *The Work of Charles Keene*. London: Fisher Unwin, 1897.

Phelps, Sarah Hamilton. 'The Hartley Collection of Victorian Illustration'. *Boston Museum Bulletin*, 71, 1973, 52–67.

Pykett, Lyn. 'Reading the Periodical Press: Text and Context'. *Victorian Periodicals Review*, 22:3, Fall 1989, 100–108.

Ray, Gordon N. *The Illustrator and the Book in England from 1790 to 1914*. Oxford: OUP, 1976.

—., ed. *The Letters and Private Papers of W. M. Thackeray*, 4 vols. London: OUP, 1946.

Reid, Forrest. *Illustrators of the Sixties*. London: Faber & Gwyer, 1928; rpt. New York: Dover, 1975.

Reynolds, Jan. *Birket Foster*. London: Batsford, 1984.

Shattock, Joanne & Wolff, Michael, eds. *The Victorian Periodical Press: Samplings and Soundings*. Leicester: Leicester University Press, 1982.

Simmonds, Jack. *The Victorian Railway*. London: Thames and Hudson, 1991.

Spielmann, M. H. *The History of Punch*. London: Cassell, 1895.

Srebrnik, Patricia. *Alexander Strahan: Victorian Publisher*. Ann Arbor: The University of Michigan Press, 1986.

Staley, Allen, Evans, Martha & Fletcher, Pamela, eds. *The Post-Pre-Raphaelite Print*. New York: Columbia University Press, 1995.

Sullivan, Alvin, ed. *British Literary Magazines: The Victorian and Edwardian Age, 1837–1913*. Westport, Conn: Greenwood, 1984.

Suriano, Gregory R. *The Pre-Raphaelite Illustrators*. London: British Library & New Castle, Delaware: Oak Knoll, 2000.

Sutherland, John. *Victorian Novelists and Publishers*. London: Athlone Press, 1976.

Thomas, Julia. *Pictorial Victorians: The Inscription of Values in Word and Image*. Athens, Ohio: Ohio University Press, 2004.

Trollope, Anthony. *An Autobiography*, 2 vols. London: Blackwood, 1883.

Turner, Mark W. 'Gendered Issues: Intertextuality in *The Small House at Allington* in *The Cornhill Magazine*'. *Victorian Periodicals Review*, 26:4, Winter 1993, 228–34.

Wakeman, Geoffrey. *Victorian Illustration: The Technical Revolution*. Newton Abbot: David & Charles, 1973.

Wheatley, Vera. *The Life and Work of Harriet Martineau*. London: Secker & Warburg, 1957.

White, Gleeson. *English Illustration, 'The Sixties': 1855–70*. London: Constable, 1897.

Witemeyer, Hugh. *George Eliot and the Visual Arts*. New Haven: Yale University Press, 1979.

Wynne, Deborah. *The Sensation Novel and the Victorian Family Magazine*. London: Palgrave, 2001.

Allingham, Philip V. 'The Technologies of Nineteenth Century Illustration: Woodblock Engraving, Steel Engraving, and Other Processes'. *The Victorian Web*. George P. Landow, ed. www.victorianweb.org.

Database of Mid-Victorian Wood Engraved Illustration. www.dmvi.cf.ac.uk

'Illustration'. *The Victorian Web*. www.victorianweb.org.

Skilton, David. 'The Centrality of Literary Illustration in Victorian Visual Culture'. *Journal of Illustration Studies*, 1, December. 2007 www.jois.cf.ac.uk see articles

The Oxford Dictionary of National Biography. www.oxforddnb.com.

'Victorian Illustration'. www.myweb.tiscali.co.uk/speel see Victorian Illustrations.

87. Leighton, Initial letter showing
the Piazza della Signoria, Florence.
The Cornhill Magazine, October 1862, p. 433.
Engraved by Swain.

Select Index

References to illustrations are in italics and can be tracked by artist, periodical or literary text. Titles of texts that first appeared in periodicals are cited in inverted commas.